3D Automotive Modeling

3D Automotive Modeling

An Insider's Guide to 3D Car Modeling and Design for Games and Film

Andrew Gahan

AMSTERDAM • BOSTON • HEIDELBERG • LONDON
NEW YORK • OXFORD • PARIS • SAN DIEGO
SAN FRANCISCO • SINGAPORE • SYDNEY • TOKYO

Focal Press is an imprint of Elsevier

Focal Press is an imprint of Elsevier
30 Corporate Drive, Suite 400, Burlington, MA 01803, USA
The Boulevard, Langford Lane, Kidlington, Oxford, OX5 1GB, UK

Notices

Knowledge and best practice in this field are constantly changing. As new research and experience broaden our
understanding, changes in research methods, professional practices, or medical treatment may become necessary.

Practitioners and researchers must always rely on their own experience and knowledge in evaluating and using any
information, methods, compounds, or experiments described herein. In using such information or methods they
should be mindful of their own safety and the safety of others, including parties for whom they have a professional
responsibility.

To the fullest extent of the law, neither the Publisher nor the authors, contributors, or editors, assume any liability
for any injury and/or damage to persons or property as a matter of products liability, negligence or otherwise, or
from any use or operation of any methods, products, instructions, or ideas contained in the material herein.

Library of Congress Cataloging-in-Publication Data
Gahan, Andrew.
3D automotive modeling : an insider's guide to 3D car modeling and design for games and film / Andrew Gahan.
 p. cm.
ISBN 978-0-240-81428-5 (pbk.)
1. Computer graphics. 2. Automobiles—Design and construction—Data processing.
3. Three-dimensional imaging. 4. Computer games–Design. 5. Computer animation. I. Title.
T385.G34 2010
006.6'93–dc22 2010040116

British Library Cataloguing-in-Publication Data
A catalogue record for this book is available from the British Library.

For information on all Focal Press publications
visit our website at www.elsevierdirect.com

10 11 12 13 5 4 3 2 1

Printed in Canada

Working together to grow
libraries in developing countries

www.elsevier.com | www.bookaid.org | www.sabre.org

ELSEVIER BOOK AID International Sabre Foundation

To the members of the www.3d-for-games.com/forum and the rest of my friends.

Contents

Acknowledgments

Thanks to . . .

Laura, Anais Chris, and everyone else at Focal Press

Anthony O'Donnell for the technical edit and awesome work on the forum

Will Snowdon for tech reviews, suggestions, and awesome work on the forum

Nick Igoe for support and awesome work on the forum

The guest writers: Brook Banham, Tim Brown, Johal Gow, Tom Painter, Robert Forest, David Griffiths, and Paul Cartwright for their amazing work

Alexej Peters for the fantastic work that we couldn't include

The superstars of www.3d-for-games.com/forum: Frap, Cyphris, Willster, Kinesis, HarryP, Nathdevlin, Jeskalade, Henry Ham, Mr.Bluesman, Drecks, Swiss, Sanguine, Ruchitajes, Elliot, Dave, Theia, Stocko2k, Aidyfuzz, A.Cherry, SebastianK, Ashley, Jtec, Fossman, Tokyogamer, Caio1985, McMonkeyBoy, Punnuman, Glode, Jason-NivEous, Seth, Neil_P, XaKu, Thudo, Airone, Jono23, DexterXS, Abubaker, Thomas, Dav, Ibrahim, Starfrogsplash, Jamie, Boffy, Commandercloin, EddyBrown, Memorex, Bogas, Gheist, Timex, and everyone else who makes this all worthwhile—thanks all!

Everyone at Autodesk, www.autodesk.com

And a special thank you to everyone else who helped me along the way

Finally, thank you for picking up the book. I hope you enjoy it.

Foreword

What a decade of advancements in interactive game technology—to think that only 10 to 15 years ago we were pushing the envelope with car models for PC games that could today run glitch-free in many mobile phone games. We're certainly experiencing an exciting era in game development! However, this never-relenting progression in games technology has a double-edged-sword effect.

Sure, we can now achieve spectacular-looking in-game graphics that almost rival 3D movie content, but at exorbitant costs in time, artist resources, and money. The vehicle models that took 1 week to produce 10 years ago now often take 6 or more weeks to produce. One only need look at the seemingly never-ending delays in the release of GT5 to understand how the eye-candy aspect of game design has spiraled to almost out-of-control levels.

We're almost at the plateau where movie content crosses over into game applications. Although they are still vastly different mediums and still require totally different approaches, we are seeing more artists jumping ship and switching between the mediums without too much difficulty.

To me, one of the most rewarding challenges of creating vehicles for real-time applications has been in using the least amount of geometry to achieve the best possible effect . . . optimization and balance being the critical areas of the design with the desired outcome to produce clean, refined meshes that look pleasing in-game. The advent of bump maps and, more important normal maps has helped add fine detail to models instead of using geometry or relying on texture maps to simulate details. Material shaders, specular maps, ambient occlusion, and advances in lighting technology help provide more realistic-looking metals, rubber, plastics, and glass and in many instances have replaced the use of a diffuse texture map altogether.

Modeling aids such as CAD, 3D scanned data, and digitized data can remove much of the guesswork from modeling and help produce very accurate models, although at the expense of removing much of the creative or artistic challenge, and thus making the modeling process a more sterile experience.

As for vehicle artists themselves, what makes them so passionate about wanting to create digital vehicles?

From my own personal experience, it was my love of cars, motorsports, racing games, and art that prompted me to look into 3D modeling apps and teach myself how to model vehicles.

Foreword

I see this same passion in many of the vehicle artists who have worked with me over the years: their love of all things automotive, often combined with a need to express themselves (artistically) initiated their delving into 3D. For many this passion eventually leads to pursuing a career as a 3D artist.

My 3D modeling quest began almost 20 years ago, and, as I've already mentioned, technology has progressed in leaps and bounds since then, as have learning aids, such as online tutorials, Internet forums, videos, and the modeling tools themselves. Finally we have a book that is dedicated to the subject. Whether you are a professional artist or a beginner, I hope you learn from this book and, more important, enjoy the experience.

Chris Wise

Managing Director,

Virtual Mechanix

Introduction

Important Information About this Book

First of all, I'd like to start off with a little bit of important information about this book.

First, this is not a book for complete beginners. If you are new to modeling for games and are looking for simple tutorials to get you up to speed, start off with *3ds Max Modeling for Games* (2008) by Andrew Gahan or the training videos *Max in Minutes* and *Maya in Minutes* from Focal Press.

This will give you all of the basics to get your modeling up to speed. You should also have registered at www.3d-for-games.com/forum. This is a dedicated forum designed to help you through the tutorials of all the books and tutorials I've written, as well as answer any questions you may have about 3D, Games, CGI, or anything else. Just log in and we will be on hand to help you with anything you may need. There are also regular competitions and threads to showcase your work and post your work in progress for help and advice, among a myriad of other topics.

Why This Book Was Written

This book is designed to bring the two important skills of design and modeling together and to feature some of the best designers and modelers in the industry. I have produced this book to showcase how ideas start from nothing, go through a design phase, move on to blueprints, and then finally finish rendered as 3D models. I want to show you exactly how the professionals work, in their words, revealing exactly how they work, how they solve problems, and how they earn a living designing and modeling vehicles for games, films, and the vehicle manufacturers themselves.

Having worked in the games industry for almost 20 years and worked on lots of titles with scores of professional designers and modelers, I knew exactly who to ask to help me with this project.

About the Guest Writers

Let me introduce you to the guest writers and let them tell you a little about themselves in their own words. These guys are at the top of their game and a pleasure to work with. They always amaze me with their talent, skill, and dedication, and it's an honor for them to be part of this project.

Brook Middlecott Banham

I was born in Abilene, Texas, and raised in the United Kingdom. My mother is Texan and my father is English. I adopted my father's passion for cars and my mother's artistic talents and started drawing cars at the early age of three. To the horror of my mother, my very first word was "Pontiac."

I got my first degree at Coventry University in transport design in 2000 and since have worked with an international range of clients, including Volkswagen, Microsoft, Hewlett Packard, Puma, BMW, Frog Design, Astro Studios, Hot Wheels, Motorola, and Disney.

Since 2007 my wife and partner in crime, Judith Banham, and I have run our own design studio, Middlecott Design. I am also currently in the first year of a master's degree program in transport design at the College for Creative Studies (CCS) in Detroit, Michigan.

Tim Brown

I've been obsessed with cars for about as long as I can remember and was always drawing cars as a kid, so I didn't have to think too hard about which career path to follow! After studying transport design at the BA level, I obtained a master's degree in vehicle design at the Royal College of Art in London.

I began my career at the celebrated product design agency Seymourpowell, also in London. Here I worked on a diverse portfolio of projects from helicopter interiors, to consumer electronics, to sex toys (yes, really!). Following on from Seymourpowell, I started working as a designer at Ford Motor Company in the south-east of England and am now based in Germany at Ford's European design studio. I have been lucky also to work on many freelance projects over the past decade, as a designer, concept artist, and illustrator in the product, games, and media industries. Clients have included Sony Computer Entertainment Europe, Evolution Studios, and BBC's *Top Gear* magazine. My favorite tool of the trade is Photoshop, in case you hadn't guessed!

Johal Gow

I am the Lead Vehicle Artist at Simbin Development Team with responsibility for design document creation, creating specifications for upcoming games, managing outsourced artwork and artists, creating in-game and front-end artwork and renders, as well as inputting on all game graphics decisions.

I started out playing around with 3D artwork as a hobby at the age of 14. This seemed like a good way to pass the time compared to what I then considered boring schoolwork. Eventually this turned into a passion and I gained a scholarship for the Diploma of Screen at Qantm (specializing in animation) in Brisbane, Australia.

Shortly after finishing my schooling in 2004, I started in the industry with Virtual Mechanix, producing vehicles for the games Project Gotham Racing 3 and 4 (Bizarre Creations/Microsoft).

I then took the opportunity to work for Simbin Development Team on a contractual basis, which lasted two years before taking the plunge and moving from Australia to be in-house with the Swedish company in 2008. With Simbin, I have helped produce RACE (Simbin/Eidos), Caterham Expansion Pack (Simbin/Eidos),

RACE 07 (Simbin), STCC – The Game (Simbin/Atari), GTR Evolution (Simbin/Atari), Race Pro (Simbin/Atari), Volvo – The Game (Simbin), and Race On (Simbin).

In 2010 I am still enjoying a happy relationship working at Simbin Development Team, but often take contractual work to improve my skills and keep up-to-date with all the latest technologies, the latest such game being Blur (Bizarre Creations/Activision).

Tom Painter

After working with 3D for more than 10 years, and with a firm foothold in the advertising, videogames, and VFX industries, I founded Big Man in 2008 in order to develop my own vision of the future of 3D.

Big Man specializes in the production of stylish 3D content. We have produced complex animations, environments, characters, and graphics for a very wide range of purposes. From cartoon, to realism or hyperreality, we are always looking to raise the bar.

Robert Forest

Born in Trinidad and raised in England, I studied design at Coventry University and the Royal College of Art and trained in Germany and Japan at Honda and Toyota. I since worked as contract designer on a number of transport projects before joining Princess Yachts, where I assumed responsibility for the styling and layout of their latest products, including their forthcoming superyacht.

During this time I continued designing vehicles for Sony PlayStation games and writing for *Car Design News*, this love for all things automotive taking me back to Tokyo where I have spent the past three years working in Honda's advanced design studio.

Finding something new is the biggest challenge for a designer, as consumer values are always evolving. My sensitivity to the tastes of clients and customers plus my innate curiosity have led me to designing a wide array of well-received products, and I continue to relish any opportunity to create.

David Griffiths

I have been in the games industry now for over 12 years. I graduated from Blackpool & The Fylde College (part of Lancaster University) with a degree in technical illustration. I started my career in the automotive industry working freelance on site for a company called I.V.M. in Germany. I then moved naturally into games, first starting out with flight simulators.

Some of my notable roles in the games industry have been working as a Lead Artist for Pandemic Studios in Santa Monica, California, when I worked on Star Wars: The Clone Wars. On Clone Wars I was able to add to the Star Wars Universe where I designed the TX-130s Fighter Tank and the G.A.T. vehicles (among many others), which were used in other games, comics, and story books and have even been made into toys, models, and official Lego kits. The Fighter Tank has a very strong fan base, which is cool. Mercenaries was another great game to work on for Pandemic and Lucas Arts, which hit every major console.

I have also had the privilege to work on WRC title games like WRC: Rally Evolved on PS2 and on the well-received franchise PS3 games MotorStorm, MotorStorm: Pacific Rift, and the upcoming MotorStorm: Apocalypse.

Paul Cartwright

In the past I have worked in many areas of art and design, wall murals, sign making, fine art, and footwear design to name a few. In 2007, after spending six years in graphic design, I made the move to freelance and set up Zero 9 Studio to offer my illustrative design services.

I am now completely converted to digital art; the main software I use is Photoshop and Painter. I create artwork in whatever style is required for books, comics, and games. More recently I have been working as a contract concept artist in the video games industry, and this is the work I enjoy the most.

Some of my clients include Sony Computer Entertainment Europe, Evolution Studios, RARE, Microsoft, Corel Painter Magazine, Digital Artist Magazine, Insomnia Publications, and Twenty to Six Comics.

About the Author

I'll keep this short and sweet, as I know your primary interest is how to model the vehicles in the gallery. ☺

I started in the games industry in 1992 as a Junior Artist for Digital Image Design. They came to my college and, after seeing my graphic design work, offered me a summer job making games. I jumped at the chance and, without any portfolio or experience at all, started training on my first game. I progressed to Senior Artist developing flight simulators and military training systems until the studio was bought by Infogrammes around 1998. I became Lead Artist when Infogrammes sold the studio to Rage. I then left and became Art Director at a small start-up called Lightning Interactive. I switched again to join my old friends from Digital Image Design at Evolution Studios (Evolution was set up when Infogrammes bought Digital Image Design with Martin Kenwright leaving, taking six people with him). I progressed through the ranks again at Evolution Studios, becoming Art Manager on some of the later World Rally Championship games on PlayStation 2 and then to Producer/Outsource Manager. I'm now a Senior Development Manager at Sony Computer Entertainment Europe and have been hard at work on the MotorStorm series on PlayStation 3 including MotorStorm, MotorStorm: Pacific Rift, and the newly announced MotorStorm: Apocalypse.

I've written *3ds Max Modeling for Games* (2008), Focal Press, and I edited *Game Art Complete* (2008), Focal Press. I also founded www.3d-for-games.com and www.3d-for-games.com/forum, which has now grown into an extremely friendly and vibrant 3D community where everyone helps out with any 3D-related issues and showcases their work. Specific help and support are given to anyone who registers and logs in. I've also just completed the *Max in Minutes* and *Maya in Minutes* video tutorials for Focal Press, so be sure to check them out to help you master the software in short, bite-size videos.

If you're interested, here is the list of games I have helped to develop:

Robocop 3 (Amiga)

TFX (PC)

Inferno (PC)

EF2000 (PC)

F22—Air Dominance Fighter (PC)

Total Air War (PC)

Wargasm (PC)

GTC Africa (PS2)

World Rally Championship (PS2)

WRC II Extreme (PS2)

WRC 3 (PS2)

WRC 4 (PS2)

WRC 5—Rally Evolved (PS2)

MotorStorm (PS3)

Pursuit Force 2 (PS2)

MotorStorm: Pacific Rift (PS3)

Pacific Rift DLC (PS3)

MotorStorm Apocalypse (PS3)

OK, enough about me, let's get on to the good stuff....

Chapter 1

Duster Concept

Brook Banham

Initial Idea

The Duster is a no-nonsense, four-wheel-drive sports hybrid with an off-road pedigree. Brave in its reckless attitude, bold in its rebellious nature, and American as apple pie, the Duster is a country girl's/ boy's dream.

It has a recharging facility from clear solar panels integrated into the glass and roof panels. Safety features, including integrated roll cage with exposed roll bars, play a key role in Duster's legacy of keeping occupants alive.

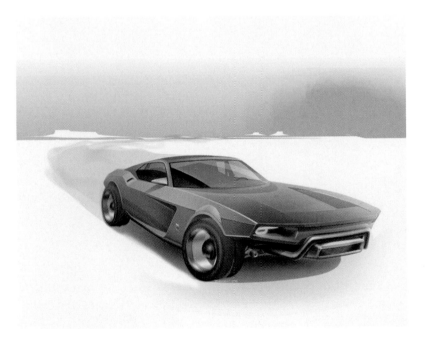

Figure 1.1 *Duster—another American legend.*

3D Automotive Modeling. DOI: 10.1016/B978-0-240-81428-5.00001-X

Design

For the design of this car I was strongly inspired by classic American muscle cars like Dodge Chargers, Challengers, and Pontiac Trans Ams.

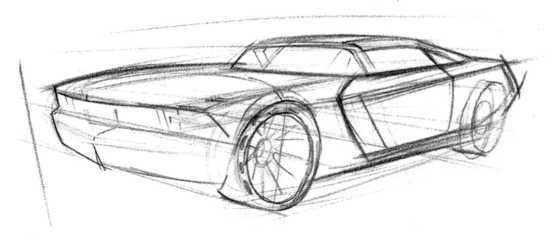

Figure 1.2

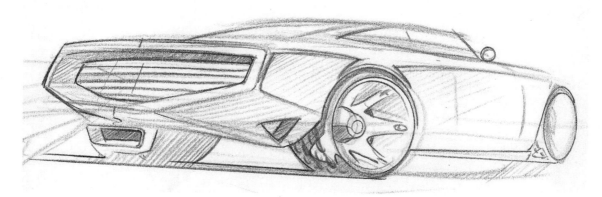

Figure 1.3

I started to get down as many quick ideas as possible, and when there was something I particularly liked, I worked a little more in that direction and continued to produce some very quick ideas.

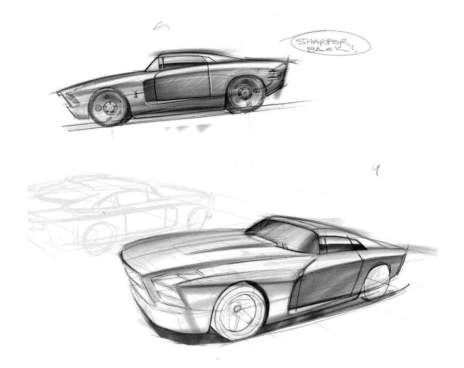

Figure 1.4

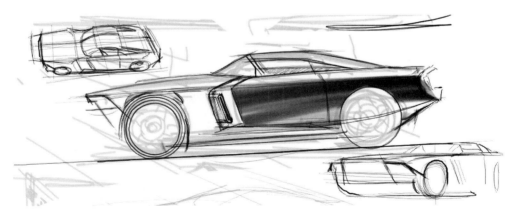

Figure 1.5

Part of the inspiration was coming from classic road movies and shows like *The Dukes of Hazzard*, *Smokey and the Bandit*, *Vanishing Point* and *Thelma and Louise*. Imagine it, driving on dirt roads and through the desert.

Figure 1.6

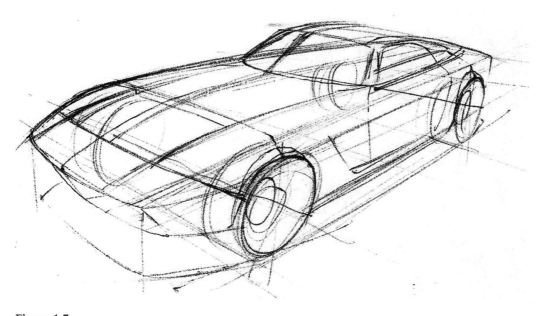

Figure 1.7

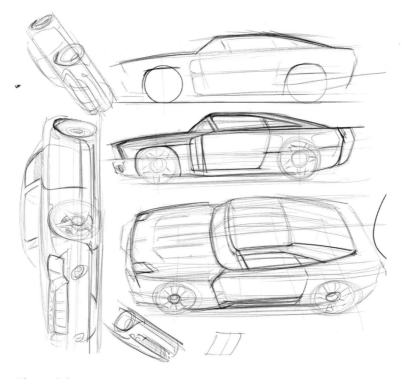

Figure 1.8

For this reason I started to think about details like the roll bars and the front deer guard to add protective qualities to the car, enabling it to drive fast through brush and cacti without getting damaged.

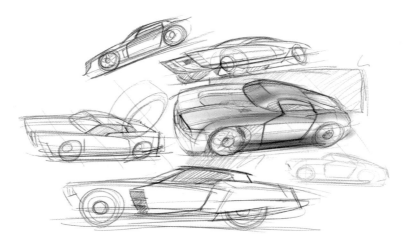

Figure 1.9

This vehicle was also inspired by European rally and Baja car racing, where the cars take a real beating doing jumps and taking knocks.

The Duster is meant to be thrashed and still come out looking okay. This is where much of its styling is coming from, to look rigid and strong, but still sleek and fast.

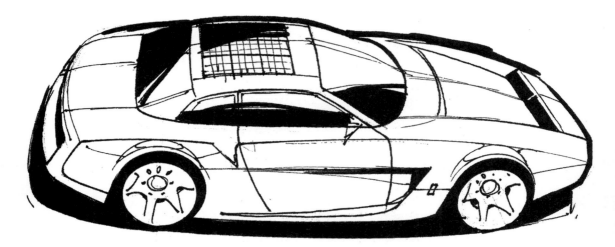

Figure 1.10

Attention is paid to the environment by being hybrid drive—electric and gas. So if it gets stuck in the desert out of petrol/gas, hopefully the windows, which double as solar panels, can help to recharge its batteries and, of course, to reduce the CO_2 emissions.

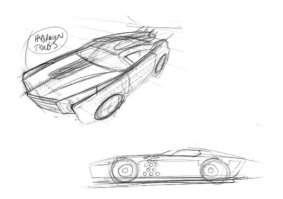

Figure 1.11

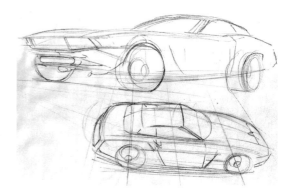

Figure 1.12

The front end has a down force wing incorporated into the bonnet/hood. This is possible due to the reduced size of the engine, allowing room for it.

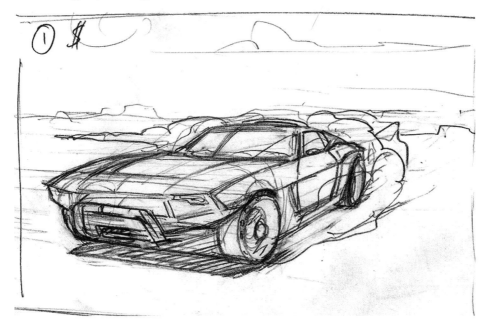

Figure 1.13

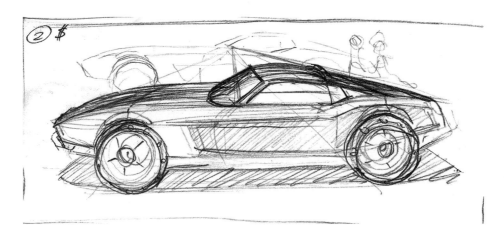

Figure 1.14

It has a reduced gas engine size because it also has electric motors in the rear to compensate. Also the front wing theoretically may help it to fly better when hitting a jump, helping it to land squarely back on its wheels.

Concept

Once I was happy with the basic front and side sketches, I set about rendering the vehicle to make sure I was happy with the overall design.

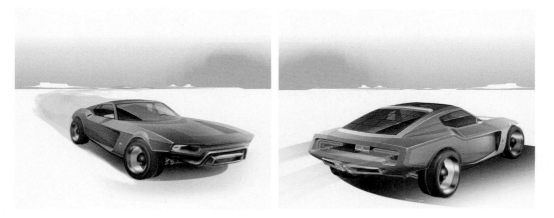

Figure 1.15

I then produced some design sheets to hopefully answer some of the questions that the 3D modeler might have. Quite often these ¾ views are enough for the modeler, depending on the polygon count of the vehicle, but to make the build a whole lot easier, I set about producing the design sheets and then a set of blueprints.

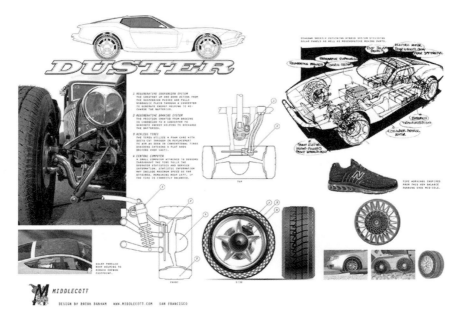

Figure 1.16

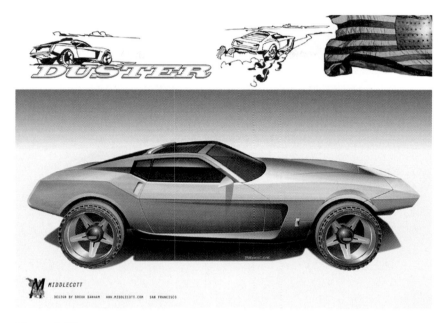

Figure 1.17

I first produced the orthographic projections for the modeler as a sketch.

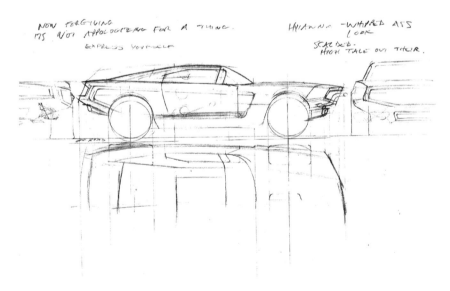

Figure 1.18

Then as a finished sheet.

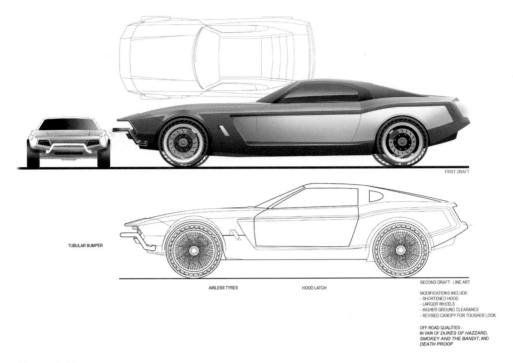

Figure 1.19

That completed the design.

Thanks for reading through this Duster tutorial. I hope you found it interesting and I hope it gave you a bit of insight into how I design vehicles.

Thanks

Brook Banham

www.Middlecott.com

Chapter 2

Modeling the DUSTER in 3ds Max

Andrew Gahan

Welcome to the first modeling tutorial of the book. Hopefully you'll have already been through Chapter 1 with Brook Banham and are familiar with the Duster concept. If not, flick back to Chapter 1 and have a look.

I'd like to stress the fact that this is not just a tutorial and that this is not just a book. Let me explain.

I'd like you to think of this book as an invitation to an exclusive community. Think of this community as a group of friends, amateurs, and professionals who are all ready to help you out on your 3D journey.

With this in mind I decided to host this chapter on the website and the forum that supports this book. So, to find the tutorial, you'll need to log onto www.3d-for-games.com and follow the 3D Automotive Modeling link and download the chapter.

While you're online, register on the forum www.3d-for-games.com/forum and introduce yourself. There are a lot of really friendly and helpful people on hand to answer your questions and help you with your work, as well as regular competitions and a place for you to show off your work and also see what other people are doing.

This forum is unlike most others as it is extremely friendly, supportive, and run by a close-knit group of regular people, just like you.

OK, once you've logged onto the website and downloaded the chapter, here's what we'll be building: the Duster—another American legend.

3D Automotive Modeling. DOI: 10.1016/B978-0-240-81428-5.00002-1

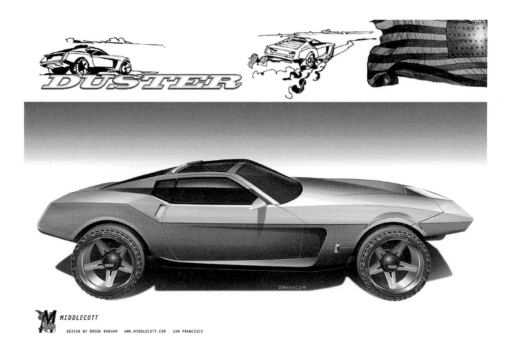

Figure 2.1

This build will be what I would call a mid-poly car or game-res car. It will be weighing in at around 15,000 triangles, but don't worry, we'll be adding them a few at a time and step by step.

If you have any problems at any point, I have provided a save file for each step of the process, so if you don't quite understand what I'm explaining, have a look at the save file for that image and I'm sure it will be clear. The adage "A picture is worth a thousand words" is usually true on a project like this.

This will be a static car. By that, I mean that it will not be rigged and the suspension will not need to be built accurately in order to move. It won't need to have a driver, and it will be modeled with a very simple interior behind darkened glass. Once you've completed the model, feel free to go to work on improving it by building an interior or cutting in some openings so that you can see inside the engine bay or open the doors.

Are you ready to get started?

Great, just log onto www.3d-for-games.com and follow the 3D Automotive Modeling link and download the chapter.

And I look forward to talking to you online. Bye for now!

Chapter 3

Chicago-Styled Hot Rod Concept

Brook Banham

The "Gangster Car" was a project for a contest to design a car specifically for the city of Chicago for Local-Motors (www.local-motors.com). Instead of a commercially producible car design, my entry was done more as a fun spin-off from the competition brief.

The intention was to create a nearly comical approach to the design of this car with respect to Chicago's heritage of gangsters from the 1930s, like Al Capone. Hence the styling is obviously retro, harking back to vintage cars of the time with modern touches and some outrageous features like a Gatling gun in the nose.

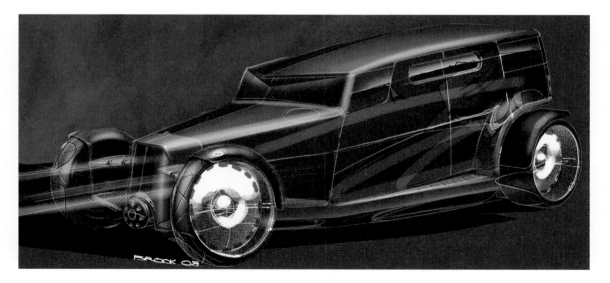

Figure 3.1 *The Chicago-Styled Hot Rod concept front ¾ view.*

3D Automotive Modeling. DOI: 10.1016/B978-0-240-81428-5.00003-3

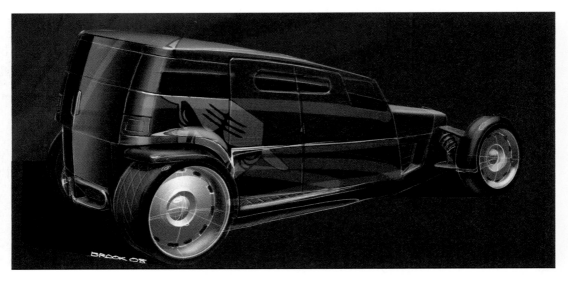

Figure 3.2 *The Chicago Styled Hot Rod concept rear ¾ view.*

The summary was:

- Five-seater sports sedan
- Front engine layout
- Rear wheel drive
- 4 + 2 door sedan. Suicide side doors layout, perfect for drive-by shootings.

The overall design of the Gangster Car is a throwback to Prohibition-era car shapes. It could be looked upon as a modern-day hot rod like the Model A hot rods.

The front end of the car was inspired by the Fairchild A-10 Thunderbolt II, or "Warthog" as it was affectionately known by the pilots and crews of the United States Air Force attack squadrons who flew and maintained it. I also took inspiration from handguns and I also included a sight integrated on the front grille.

The supercharger was designed around the GAU-8 Avenger, which is the heavy automatic cannon that serves as the aircraft's primary armament. The front suspension was designed with the idea of wings in mind.

The front windshield is raked horizontally to help deflect incoming bullets from the front, if the vehicle were in pursuit of a rival's car.

The graphics on the side of the car were inspired from the Chicago Bulls basketball team. The elliptical windows on the side offer added protection for the occupants in the rear, whereby they can shoot out of the thin windows without being too exposed to return fire.

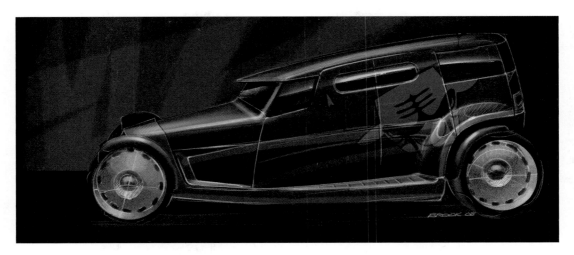

Figure 3.3 *The Chicago-Styled Hot Rod concept side view.*

The Design Process

This was a fairly quick design, which took at most maybe two or three days to complete. These weren't full work days, so I fast-tracked the design process.

As you can see, I did just a few thumbnail sketches to get a flavor of what I wanted to achieve.

Figure 3.4

Figure 3.5

Figure 3.6

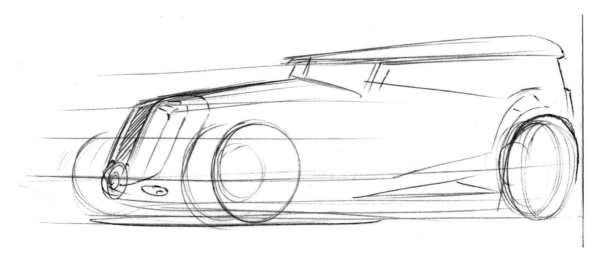

Figure 3.7

Figure 3.8

Figure 3.9

Figure 3.10

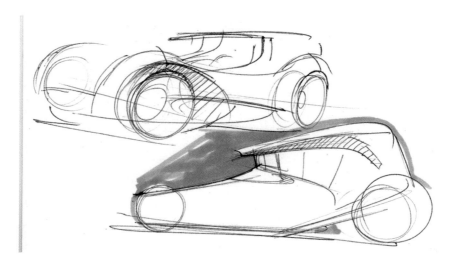

Figure 3.11

For this design I avoided a lengthy exploration process, as I already had an idea of what I wanted to produce from the beginning.

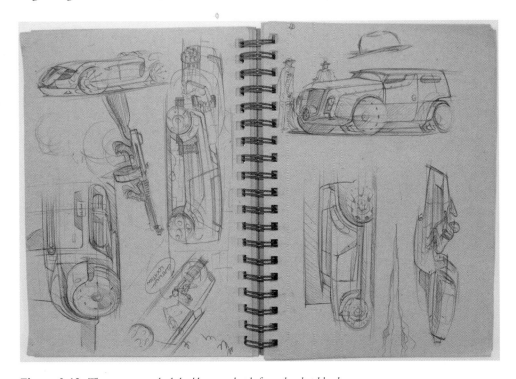

Figure 3.12 *The raw, untouched double page sketch from the sketchbook.*

I was thinking retro shapes and silhouettes with a modern twist. The sketches were done with Bic® ballpoint pen medium. I like to use only Bic brand ballpoint pens because they hardly ever leak, have a great tactile feel while sketching, and are less oily, so less smearing occurs.

I am using a coarse spiralbound sketchbook measuring 18 cm × 26 cm. The paper is recycled with a fibrous look, which looks good when it is scanned and coloration is added afterward. It gives the sketch an added layer of texture, especially when shading and color are added on top.

For these sketch pages I actually photograph the pages instead of scanning them. I normally do this for work done in sketchbooks for two reasons:

1. Laziness. It is much faster to stand over the pages and take a snap of each page than to use a scanner.
2. A scanner casts weird shadows when scanning something uneven like a spiralbound sketchbook. I find I get much better results when I use our Leica camera with the flash turned on.

While I sketch, sometimes my mind wanders a little and other seemingly unrelated vehicles may appear on the page. I find that sometimes I need a slight departure from the job at hand and treat this as a kind of break. Besides, many times, elements from those "unrelated" vehicles appear later on in the designs of the vehicles.

As this sketchbook is sometimes awkward to draw on in certain areas due to the thick spiral binding, I must rotate the sketchbook around to find my most comfortable sketching position. That is why each sketch is in a different orientation to the other.

After getting the images onto my computer I load them into the desired software, which in this case is Alias Sketchbook Pro 2010. I use this program for quick and dirty sketches. If I want to do something tighter I would use Photoshop. So for this stage I simply block in the dark areas with flat color as a base from which to add light and shade.

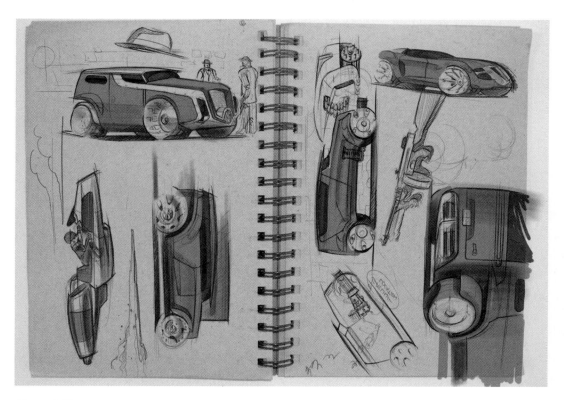

Figure 3.13

I start to add darker tones of shade as well as a few color pops using mainly an airbrush tool.

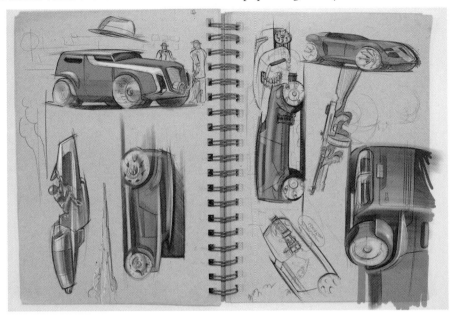

Figure 3.14

At this stage I add white reflections, once again with mainly the airbrush tool.

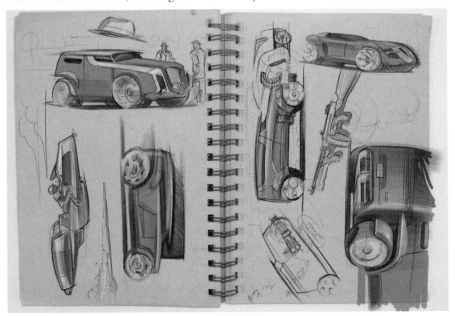

Figure 3.15

Here I'm adding a few more color pops, like red in the taillights and some blue sky reflections. With a white pencil tool I start to add sharp and more detailed reflections. Each part of these processes I do in a separate layer. This is so one can edit more easily the elements later on.

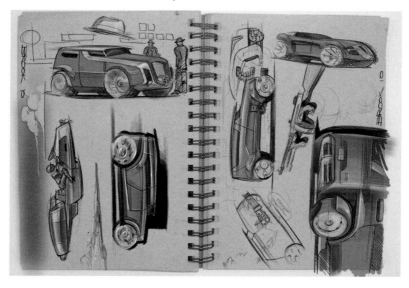

Figure 3.16

On a separate layer I add details with black and white pencil tools, working in details like shut line definition, sky and backgrounds and ultimately my signature.

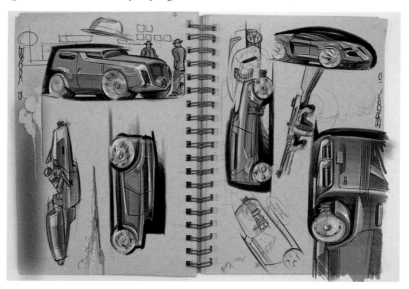

Figure 3.17

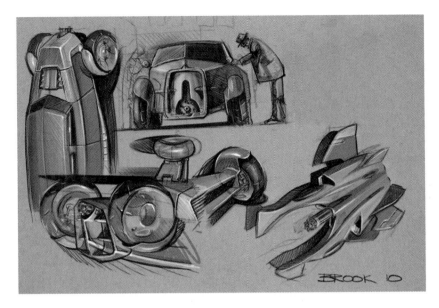

Figure 3.18

This shows a final tidy up, extracting the pages from the sketchbook. I do this in Photoshop by cropping out the spiral binding as well as tidying up and deleting messy areas.

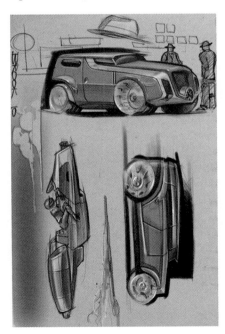

Figure 3.19

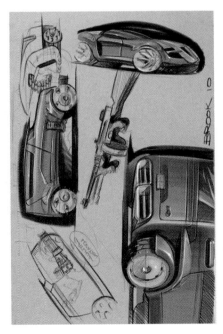

Figure 3.20

To illustrate the process in a little more detail, here's another step-by-step walkthrough focusing on one of the pages.

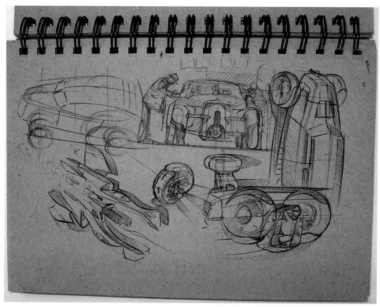

Figure 3.21 *The raw sketchbook image.*

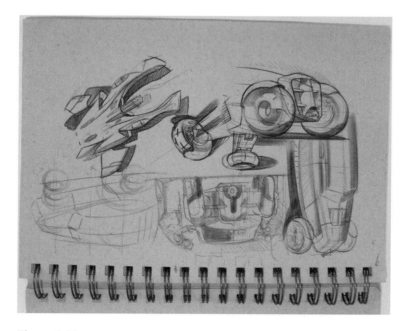

Figure 3.22

Figure 3.23

I start to add base color from which later on I can overlay reflections and shade. I am using Sketchbook Pro 2010 and using black with the paintbrush tool on a layer turned down to 50%.

Figure 3.24

I add a base window color on a new layer turned down to 50%.

Figure 3.25

Figure 3.26

I start to add more black on another layer for tires, intakes, shadows, and generally darker areas.

Figure 3.27

I start adding whites and sky tones. I am using white pencils for sharp reflections and an airbrush for larger surface areas.

Figure 3.28

I start to go into more details with light and shade, and then once I'm almost at the last stage, I add my signature.

Figure 3.29 **Figure 3.30**

After I produced the initial sketches I went straight into Rhino 3d to do a quick sketch model.

I then used the basic 3D form of the sketch model as an underlay and took it into Photoshop to produce a quick render.

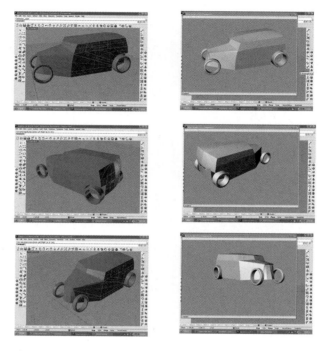

Figure 3.31

Once I was happy with the shape, I experimented with the paintwork and the style of the graphics on the side of the vehicle.

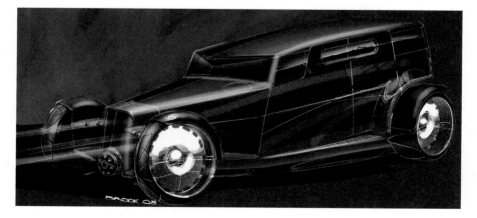

Figure 3.32

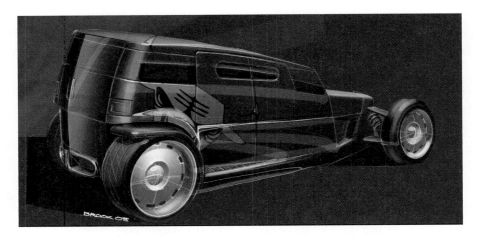

Figure 3.33

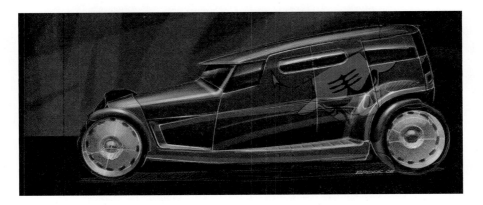

Figure 3.34

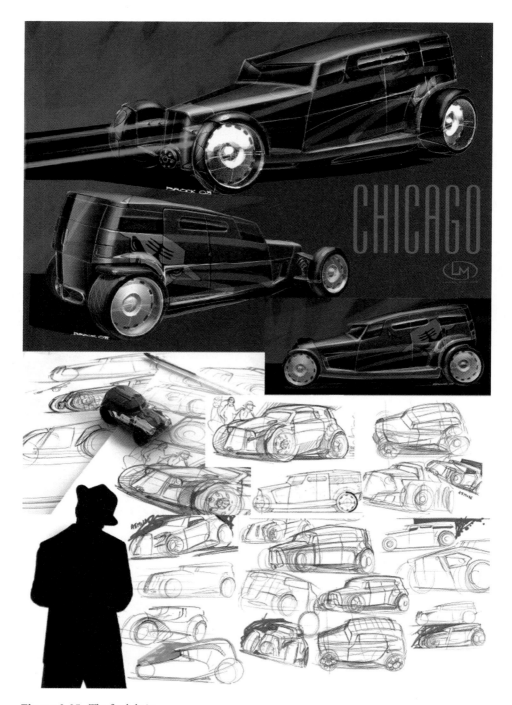

Figure 3.35 *The final design.*

Chapter 4

Modeling the Chicago-Styled Hot Rod

Andrew Gahan

Welcome to the modeling tutorial for Brook Banham's Chicago Gangster-Styled Hot Rod.

Once again, we will be aiming this build to be suitable for "in game" and although it's not technically a low-poly vehicle build, it isn't a high-poly build either.

I hope you enjoy yourself on this build and if you have any problems or questions, log onto www.3d-for-games.com/forum. Once you've registered, we'll happily answer all of your questions.

You can also post "works in progress" for comments or show off some of your finished work for comments and critique.

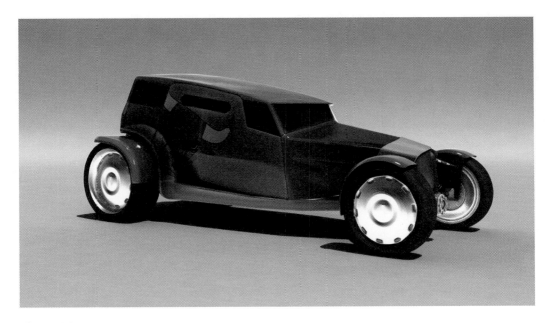

Figure 4.1

3D Automotive Modeling. DCI: 10.1016/B978-0-240-81428-5.00004-5

OK, let's get started!

Modeling

Step 1

First of all we will start off by building a standard primitive Plane in the left viewport.

There are a couple of different ways to set the size of your plane. You can match it to the same pixel dimensions of the image, so that you know it's got the correct pixel ratio, or you can use a real-world measurement for the length and height of the car. If you are using blueprints, these dimensions are usually on the illustrations.

Figure 4.2

Step 2

Next we need to assign the side concept drawing Side.jpg to it. You should find this in the additional files provided on the website in the Chapter 4 folder. There are a few ways to do this. We can drag and drop from the Explorer window or we can use the material editor with the concept image in the diffuse slot. If you drag and drop the image, you may need to flip it if it is facing the wrong direction, or you could flip the image first in Photoshop if you prefer.

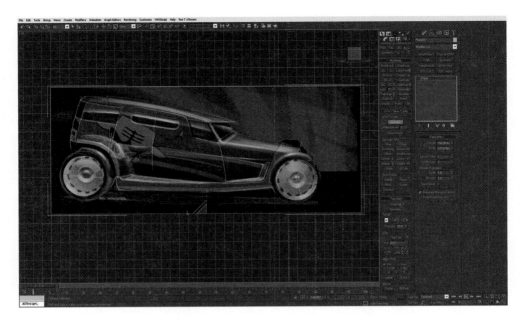

Figure 4.3

Step 3

In the object properties, make sure that Show Frozen in Gray is not selected and Freeze the object so we don't move it accidentally.

Figure 4.4

Step 4

Next, we need to create a new Plane, using Alt + X to make it transparent, allowing us to see the concept image clearly.

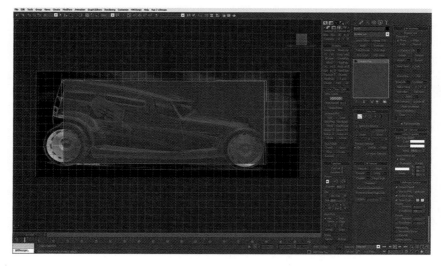

Figure 4.5

Step 5

Convert your plane to an Editable Poly and add a few cuts to define the basic shape. Next, cut out the rear wheel arches and delete the surplus polygons.

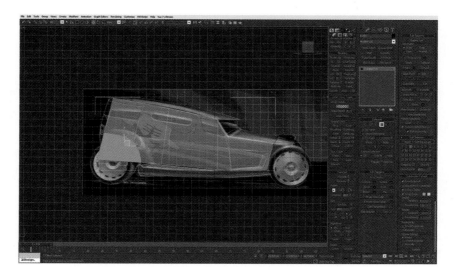

Figure 4.6

Step 6

Now we need to add some depth to our vehicle. You can Extrude the faces if you like or you can select a group of Edges as I have done here and, holding down Shift, Drag them out to create new faces.

Figure 4.7

Step 7

Now we need to position the vertices so they will match the concept accurately. Just select each one and move it into place to match the image.

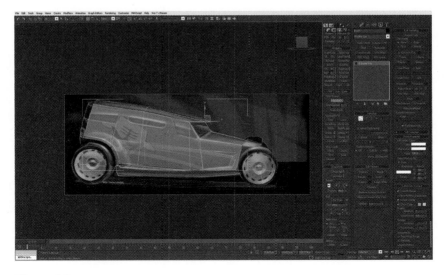

Figure 4.8

Step 8

Next, add a Symmetry Modifier so we can get a better look at the overall shape. In the wheel arch reduce the number of vertices by welding the two vertices closest to the corners to remove them. Also add three sets of cuts up the side panel and roof. This will leave a vertex on its own, and we'll connect that up in the next step. Next we'll adjust the left vertex at the corner of the roof to match the roof contour better. The side panel should now be made up of seven polygons.

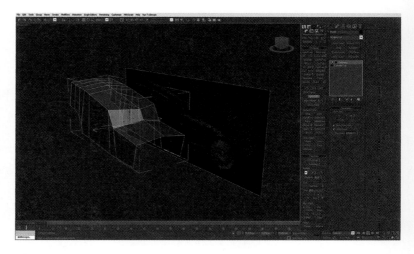

Figure 4.9

Step 9

We can now connect the lonely vertex by connecting two cuts up to the roof line, making the side panel consist of eight polygons. Next select the Edges of the wheel arch.

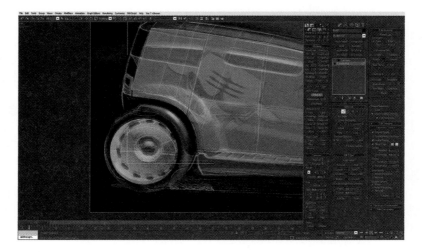

Figure 4.10

Step 10

The mudguard can be started by selecting the edges and Shift + Dragging them down and to the back. Use a Scale tweak on them to shape them in slightly.

We need to create new cuts to create the shoulder of the wheel arch and also add cuts lengthways along the body to create two new subdivisions along the side of the body panel. If need be, clean up any surplus geometry that you don't need once you've adjusted the new geometry.

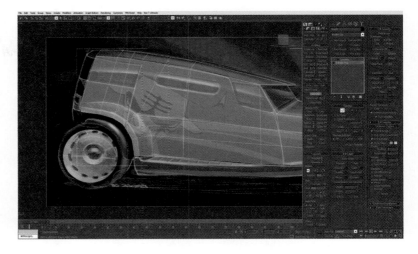

Figure 4.11

Step 11

Follow the same edge drag process on the back section of the car and close up the mesh so that it joins up with the arch at the bottom.

Figure 4.12

Step 12

Now we can start adding edges, which will help to define the position of the windows. We'll start with the rear ones first. I've made a cut across the middle so that the Chamfer in the next step will work.

Figure 4.13

Step 13

Chamfer the newly created edge and adjust it to make the edges of the rear window into the correct shape.

Figure 4.14

Step 14

Next we'll move down to the front section to continue to refine the form of the vehicle. The shape of the front is started by scaling and moving the geometry. The easiest way to do this is to Extrude the front edges and then Scale and Move them into place. Adjust the edges step by step until it matches the blueprint.

Figure 4.15

Step 15

Next we will add an extra set of edges down the length of the vehicle to mark out the thickness of the pillars and the curve of the bodywork. To do this I selected the front edge in Editable Poly mode and used Ring to select all of the other edges along the length of the vehicle. I then used Connect to create the extra geometry and made sure that the edges were roughly where I wanted them. We can also add a cut along the top of the windshield and build up the geometry around the window and roof to match the window geometry.

Figure 4.16

Step 16

Then we need to roughly cut in the windows using the Cut tool to match the concept art. If you're not familiar with Cut, it can be found in Editable Poly > Edit Geometry, next to Quick Slice. Just select Cut and then Left Click at the corner of the oval window, and then continue to Left Click and trace the shape following the concept art. Once you've traced right round the window, just Right Click to end the Cut process. As with

Figure 4.17

most processes in 3ds Max, there are different ways to perform this, so feel free to use the tools you are comfortable with.

Step 17

To help get the rounded shape of the side windows right, we can use a Cylinder as a guide. Just create a cylinder and scale it to the correct size, and then use it as a guide to line up the edges or vertices that make up the window. Remember to delete the cylinder once you have the curves looking nice and round. We can also cut in new edges from the corners of the windows up to the roof.

Figure 4.18

Step 18

To create the front ledge above the windshield, we can simply Extrude the selected faces.

Figure 4.19

Step 19

Once again, we just need to adjust the vertices to match the concept art.

Figure 4.20

Step 20

To smooth off the edges down the side of the car, down past the windshield, just select the edges and use Chamfer on them to create the curve. We will use Chamfer twice on both Chamfer actions as a smoother edge is required. You may find that you get better results if you Chamfer the bottom edge of the windscreen and round the body before chamfering the side edge of the windshield and along the hood.

Figure 4.21

Feel free to add and remove a TurboSmooth modifier from time to time to see how it looks at a higher resolution and to help you see any areas that may need attention.

Step 21

If you chose to use Chamfer twice on the previous step without cleaning up the geometry in between each step, you'll need to tidy this up. This is because when two chamfered edges intersect, the modifier will create some extra, messy geometry in the form of excess polygons. Zoom in to have a closer look at your model if you did choose to Chamfer twice (or more). We just need to tidy up the geometry by welding or collapsing vertices, to remove all of these excess

Figure 4.22

polygons. Remember this whenever you Chamfer twice or more in succession, as it will always create extra geometry you don't need.

Step 22

The FFD modifier is used to shape and fine-tune the main shape of the car. FFD 3x3x3 is going to give us enough control as we only need to push the top part inward a little. If you've not used this before, this can be found in the Modifier List. Just select it and adjust the Control Points to adjust the shape of the vehicle.

Step 23

Figure 4.23

The side cooling intake can now be started in the same way in which we started the windows, by cutting in the required shape using Cut and adjusting the vertices to match the concept.

Figure 4.24

Step 24

To make the inner rear arch area, hold down the Shift key and use Scale to Scale to copy the faces. Then adjust the new faces to the required shape and weld any extra vertices you don't need.

Next we can fill out the detail across the whole mesh and refine it a little. First we can make the back end of the car more rounded.

Then we can make the roof slightly more curved.

We can add some extra geometry detail to define the wheel arch curves.

Let's add a simple running board (ledge) along the bottom of the car.

Then we can sculpt some of the existing geometry by pushing in the side intake slightly, sculpting the nose slightly and we can reduce the subdivisions on the round fillet between

Figure 4.25

the windshield and the hood from four to two.

Finally we can create a simple underside for the car.

Have a look at the .max file if you need to see each step exactly, or feel free to be creative. Remember that you don't have to follow every step of this tutorial to the letter; it's a guide to how I chose to model this vehicle, so feel free to experiment and make it your own.

Step 25

The running boards (ledges) at the bottom are made using the same modeling techniques we have been using. You might find it easier to select the whole bottom row of edges, move them, and then apply a Chamfer to create the curve as before.

We can optimize around the wheel arch slightly at this point too.

Figure 4.26

Step 26

OK, back to the front ventilation scoop. Select the vertices that define the basic shape and push them inward into the bodywork.

Figure 4.27

Step 27

For the front radiator we will be copying faces and moving them into position to match the concept. In the front view, scale the new faces down to create the thickness and create another line of polygons by pulling the loop inward.

We can also add a division along the roof down to the hood, near the center line.

Figure 4.28

Step 28

Next, go back to the back bottom of the vehicle to optimize. Weld the extra vertices and collapse the edge.

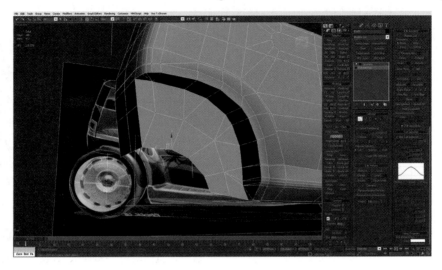

Figure 4.29

Step 29

Next we need to add details to the car with extra cuts where the body panels are connected together. To do this, select a Ring of edges, use Connect to create the extra edges, and move them to the right place to match the concept. Remember to optimize any extra geometry that you don't need. You can see a few added edges in Figure 4.30.

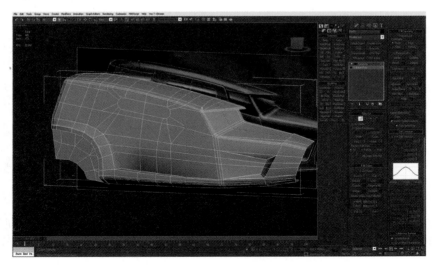

Figure 4.30

Step 30

We can now start to build the front radiator. Start off by creating a rectangular spline with rounded corners in the top viewport and apply an Extrude modifier to it. Then Collapse to Editable Poly and you should have a nice rounded rectangular block, which we will use as the starting point for the grill.

Figure 4.31

Step 31

Next we need to Delete the left half of our newly created rectangular block, and then remove the back half and finally remove the top and bottom polygons. Then adjust it to fit into the bodywork of the car and then add some horizontal subdivisions to it using Connect.

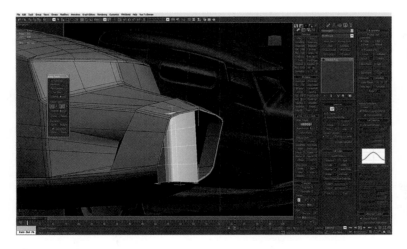

Figure 4.32

Step 32

From the front view, we can use a basic cylinder as a template, using Cut to create a cylindrical shape into our mesh, just as we did earlier. We only need to do this to half of the object as we are going to use

symmetry to create model changes on both sides. We can also add a Chamfer on the lines we just cut and use Connect to create extra horizontal edges to connect the corners of the cylinder. We can also add mode sub divisions to the front and bottom of the radiator.

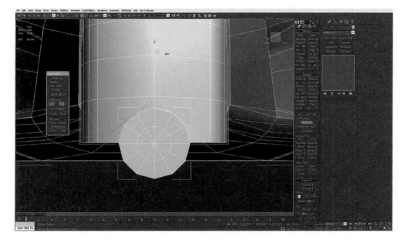

Figure 4.33

Step 33

The bottom of the radiator is finished off by extruding the edges and closing it up. Remember that we're still using the Symmetry modifier to create the other half of the vehicle. We can add that in the next step.

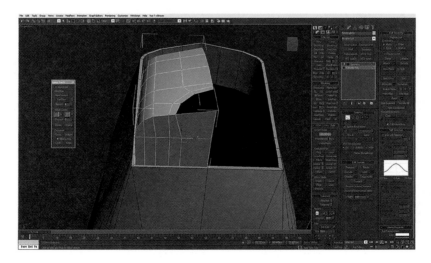

Figure 4.34

Step 34

The hole in the middle of the radiator can be closed up as well, as we are going to build in the machine gun later on. We can also tidy up the bottom of the radiator slightly.

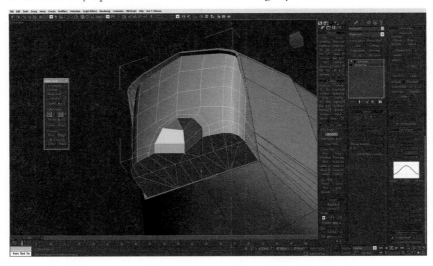

Figure 4.35

Step 35

Next we need to delete the symmetry modifier from the radiator, select the car, and in Editable Poly mode Attach the radiator to the car. Once again, we select the top modifier in the stack and we should see the radiator is now mirrored also by the Symmetry modifier.

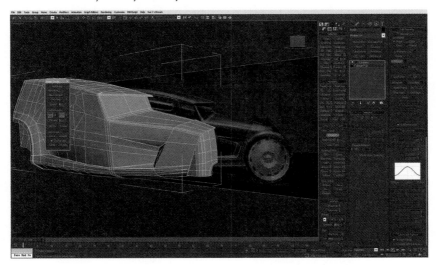

Figure 4.36

Step 36

Now we need to close up the hole in the geometry at the back of the car. Remember to optimize any surplus geometry and that's it, we've completed the basic shape of the car.

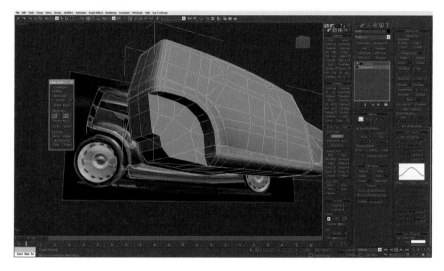

Figure 4.37

Well done for making it this far. As always, if you get stuck at any point, you can refer to the save files or log onto www.3d-for-games.com/forum and you can ask for help or explanations for any of the stages covered.

Next, we'll continue the build by creating the wheels.

Step 37

As with most wheels, we will start by creating a Cylinder and we will add some subdivisions to the outer end.

Feel free to make your cylinder with as many polygons as you like, but don't go wild as the body geometry will look odd next to high poly wheels.

I started off with a primitive Cylinder that had 20 sides, 3 Height Segments, and 4 Cap Segments. This gives us a basic form that will look smooth enough without any obvious edges. Next, just Convert to Editable Poly and scale the cap segments to roughly match Figure 4.38. We can also adjust the height segments, moving them closer to the edge of the rim.

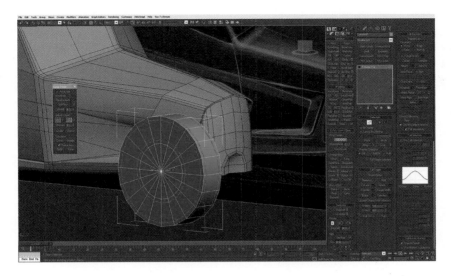

Figure 4.38

Step 38

Since tires don't have sharp edges we can delete the corner loops to give us a smoother transition from the tire tread to the tire wall. Be sure to use Backspace rather than the Delete key.

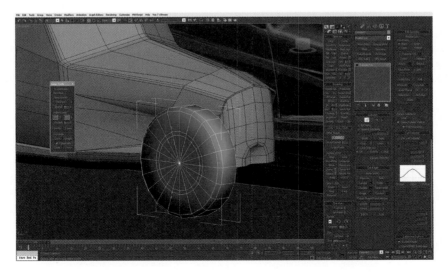

Figure 4.39

Step 39

Continue to add more details to the wheel by adding loops and moving them in. We can do this by select-ing a ring of edges and Connect with three segments. We can then use the Slide and Pinch controls to posi-tion the new loops into the correct position.

Figure 4.40

Step 40

Next, we need to adjust the central set of polygons so that they are connected horizontally as shown in Figure 4.41, rather than to a central point. The basic shape of the wheel is now complete.

Figure 4.41

We also need to create the extra hub loops and we can start to form the shape of the hub by pushing in and pulling out the edges.

Step 41

Next, we need to create the detail on the rim. First, select the loop of polygons where the detail is to be added and use Inset from the Edit Polygons menu in Editable Poly. I used the setting of 0.48 cm with the Inset Type set to By Polygon. Then just move the newly created inner polygons inward slightly.

Figure 4.42

Step 42

Optionally, if you prefer to match the concept more closely by having fewer holes in the rim, try selecting every other polygon in the loop before applying the Inset modifier. Feel free to customize this feature as you like.

Figure 4.43

Step 43

As the back wheel is very simi-
lar to the front one, we just
need to Copy it, Scale it up,
align it with the ground, and
make it wider. It's better to
widen it by selecting the outer
vertices of the wheel and mov-
ing them separately. This way
we won't degrade any of the
spacing of the rim detail we
created. Take care here as the
concept art isn't level, and cre-
ate accordingly.

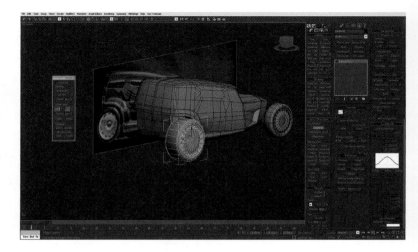

Figure 4.44

Step 44

Then just push the central faces inward to give the rim some depth, as shown in the concept. Take care not
to select any polygons on the other side of the wheel by mistake.

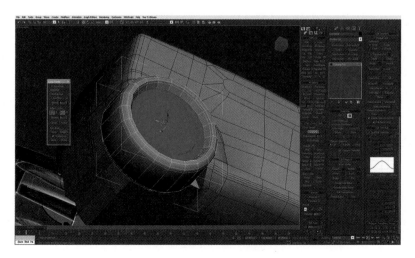

Figure 4.45

Step 45

Next we'll create the front mudguard. To do this, select the part of the tire, as shown in image Figure 4.46.

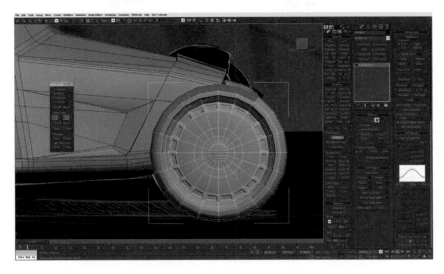

Figure 4.46

Step 46

Now clone the selected polygons by Shift-Scaling them out slightly to create the starting point for the mudguard and then round off the edges. The advantage of using the tire as the starting point is that we get the exact profile of the wheel. Widen the mudguard slightly so that it covers the wheel.

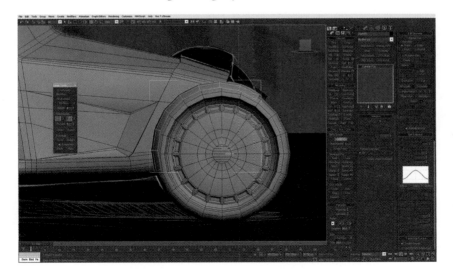

Figure 4.47

Step 47

To create the inside of the mudguard, we need to pull down the inside vertices of the mudguard. It's a good idea to UV map it in this state, as it will save us a bit of work if we map it before complicating the geometry. Once mapped, apply a shell modifier to give the mudguard some thickness.

Figure 4.48

Step 48

The rear mudguard is created in a similar way to the front one, with the exception that the back part will be closed by using Bridge.

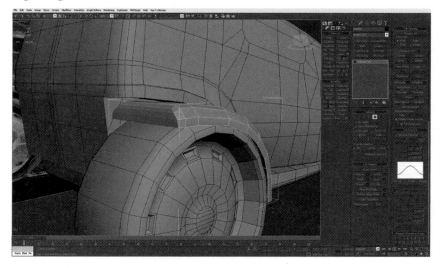

Figure 4.49

Step 49

The exhaust is created from a cylinder, with the end polygons deleted.

Figure 4.50

Step 50

Pull half of the vertices toward the center axis of the car and the second half toward the wheel to form the exhaust shape. Next Delete any unnecessary edges, and then select the outermost ring of edges and apply a Cap Holes modifier from the modifier list. Selecting these edges will ensure that only the end of the exhaust is capped. Next, collapse the stack, detach this newly created polygon and move it aside, as we will use this to fill the exhaust later.

Figure 4.51

Step 51

To create the slight curve on the exhaust, we need to apply an FFD modifier to the mesh and bend it slightly, so that it matches the shape of the rear of the car and then just add a Shell modifier to give it some depth.

Figure 4.52

Step 52

Convert the exhaust to an Editable Poly to collapse all the modifiers on it. Next, just add a Chamfer to the end to round off the edges nicely.

Figure 4.53

Step 53

Now we need to Move the center part of the exhaust end that we saved earlier and position it inside the pipe. Then we need to Attach the exhaust parts together if they're not already and Attach the whole exhaust to the bodywork. The second exhaust will be created automatically by the Symmetry modifier.

Figure 4.54

Step 54

Next we'll move onto the machine gun on the front of the car. We will make the main shape using a Cylinder. We need to use the same techniques as we did with the wheel rims to get the details required.

Remember to delete the hidden end cap of the cylinder that is buried in the car body to save polygons.

Figure 4.55

Step 55

The machine gun barrels are next. Create another Cylinder, adjust it to the right shape, and then copy this around the rest of the gun. You could move the pivot point of the object to the center of the gun, and then with angle snap toggled on, clone it with Shift + Rotate.

Figure 4.56

Step 56

Next we can move onto the struts that link the wheel and mudguard assembly to the rest of the car. Start with a primitive Box, Delete the end polygons, and then divide the front and back faces down the middle horizontally. Then pull these edges out to create the "wing" shape. Finally, position the end vertices to match the concept art from above and position the whole strut in between the mudguard and bodywork. Remember to remove the ends of the struts that are buried in the car and not visible.

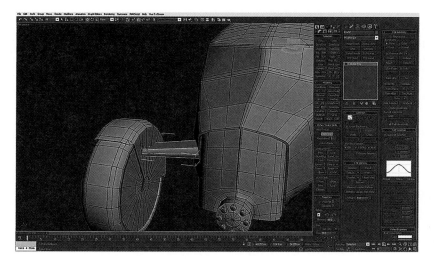

Figure 4.57

Step 57

Then we just need to make a clone of the strut we've just created by shift + moving it down to create the bottom strut and attach it to the existing geometry. The struts on the opposite side will be created automatically as everything else is by the Symmetry modifier.

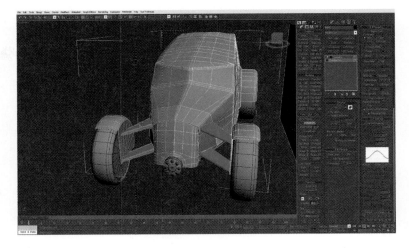

Figure 4.58

Step 58

We will now move on to the front wheel dampers. Again, these are created from Cylinders, with the spring being created from a Helix spline. Set the values and turn on Show in Viewport; this will add volume to the spline. Remember to check the Generate Map Coordinates. If you forget I will show you how to fix it later.

We can add some extra detail to the upper struts and another set of arms that stretches out to a block that the damper attaches to.

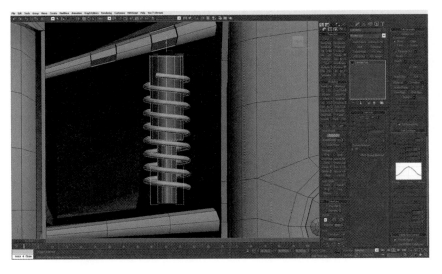

Figure 4.59

Step 59

The rear axle is made from a Cylinder. Scale it to fit and Attach it to the bodywork. There's no need to stretch the whole pipe across the geometry as Symmetry will take care of half of it and it will use up less texture space if it is shorter. Most of the axle won't normally be visible either, so keep it simple. Remember to delete the end caps to save polygons.

Figure 4.60

Step 60

Finally, let's move back to the bodywork and finish off the finer details.

Let's have a look at the windows and the panel seams. Select the edges that make up the windows, doors, and any other seams and Extrude them with a negative value to push the edges inward. Then zoom right in and go around all of the seams and clean up the geometry.

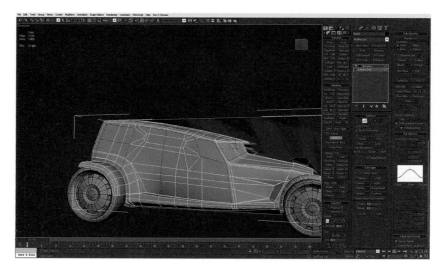

Figure 4.61

Step 61

The rounded windows can be created by selecting the faces and Beveling them inward. Use the same method for the front side glass.

Figure 4.62

Step 62

The rear lights are created by cutting the edges of the lights into the geometry and using Inset to move the faces inward. This will create a loop of polygons which can then be Bevelled out to create the lenses. Before this step can be completed, two end loops have been moved apart to form the gap that the lights go into.

Figure 4.63

Step 63

Finally we need to detach the mudguards and apply a Shell modifier. Don't forget to check Copy UV's. Then just attach it again to the rest of the car.

Congratulations, the model is now complete.

We will now move on to UV mapping the model. In this case the process should be fairly simple, and we can manage it with only a few functions in the unwrap modifier. We will

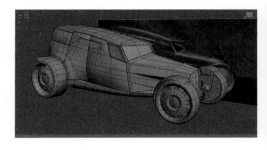

Figure 4.64

need to assign the checkerboard pattern to the car, as we will need it for checking the proportions of the sides and for rotating the UV islands.

UV Unwrapping

Step 64

Assign the checker pattern with 10×10 tiling to the car and apply an Unwrap UVW modifier. Inside the Unwrap UVW modifier we can start to arrange the UVs. At this point we just want to make sure that none of the UVs is overlapping each other.

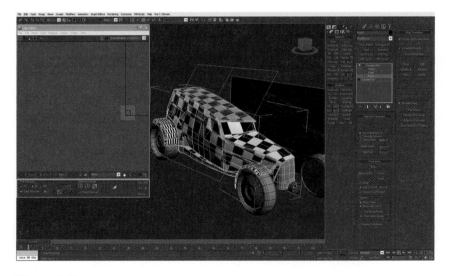

Figure 4.65

Step 65

We need to start off by selecting the relatively flat parts of the car, like the roof, the side of the car, the hood, and the doors. Don't worry about getting everything perfect to begin with, as we can make finer adjustments when everything is laid out.

For now we are just trying to work out which parts can stay together and which need to be split due to distortion in the texture. We should be able to identify these areas by looking at the checker pattern.

Start off by selecting the roof, for example: apply some planar mapping, and then adjust with the Relax tool. You will need to try both Relax by Face Angles and Relax by Edge Angles.

You can select the element or group of polygons you want to map in the Editable Poly, and then with those polygons/elements selected you can work with those parts only in the Unwrap UVW, making it easier to work without clutter. Remember to collapse the stack before selecting a new part though.

The best Relax method will depend on a number of different conditions, including the complexity and topology of the mesh, so you will need to experiment to get the best results. Remember that Relax is undoable, so if one method doesn't work, undo and try another until you are happy with the results.

For a complete explanation of Relax, go into the Help section of 3ds Max (F1 key), and under Search (which is the third tab at the top left of the screen) search for Relax Tool.

Try to remember that 3ds Max has an amazing Help section where every tool is explained in full, so don't be afraid to use it. Just search for the command or process you want clarity on and everything will be explained to you.

After we have separated all of the sections of the mapping, we can recombine specific areas that we'd like to stay as one piece using the Stitch tool. This can be found under Unwrap UVW > Edit button (on Parameters rollout) > Tools menu > Stitch Selected. Again, if you want to double check that you understand how this works fully, go back into the Help section (F1) and search for Stitch Tool.

Figure 4.66

I really want to reinforce the benefits of using the Help section, so I am deliberately not spelling everything out for you here. Once you get into the habit of teaching yourself, you'll improve at a much faster rate than if you were to just follow tutorials.

OK, back to the model. Watch out for distortions in the checkerboard pattern on our model. We are aiming to have nice regular squares across the whole of the model. Pay particular attention to any rectangles you see, as this indicates distortion. The reason we use a checker pattern is so we can see very clearly which parts of the mapping are distorted. If we have neat squares across the whole of the object, we will know that when we come to color the car, there won't be any stretching if we apply logos or text. It's far easier to spot these distortions by looking at a checker pattern than on a detailed texture map.

You can check the accuracy of your unwrapping in the unwrap window. Every time you move something, you will see it instantly updating on your model, so use this to help you get it right.

Step 66

The hood is a good example of a relatively flat surface and a good place to continue. Apply a Planar Mapping modifier and use Relax to adjust.

Figure 4.67

Step 67

The rear mudguard can be unwrapped just as we did with the hood. Apply Planar mapping and then Relax. Remember to check that the pixel ratio (or checker pattern) is the same size on the parts you have unwrapped; if not, Scale the unwrapping so that it is.

Figure 4.68

Step 68

A slightly more difficult part is the front mudguard where we have shelled geometry. Here's the fix for the springs that I mentioned earlier.

First, collapse the whole stack to an editable poly, and then select the polygons around the outside that define the thickness and delete them—delete the inside part too.

The mudguard with no thickness can be mapped the same way with Planar mapping and the Relax tool. The parallel edges should be straightened too. There is a function for this in Max 2010 or you can use the Polyboost plug-in. The advantage of mapping the mudguard this way is that, when we assign thickness to the mudguard again, the UVs will be copied too.

Figure 4.69

Step 69

Next we are going to unwrap the spring. If you, like me, forgot to generate UVs automatically, we can do them now fairly easily.

Select a loop of edges alongside the spring and use the function Create Shape From Selection under the Edit Edges rollout. This will make an exact copy of our spring, just as we did when we created the original from a spline. Then turn on the option that will show us thickness in

Figure 4.70

the viewport and this time don't forget to check generate map coordinates. Then just align it over the original and delete the original. Finally, just attach the newly mapped one to the rest of the car. Manually unwrapping this would be a chore and unnecessary.

Step 70

The struts that hold on our mudguard will be mapped in a similar way to the flat sections of the car, with one exception. Instead of using Planar Mapping, use Box Mapping. Again, use Relax on the newly created pieces and then join them together with the stitch tool. Be careful to create the seams on the less visible places—hiding them on the bottom, for example.

Figure 4.71

Step 71

As you can see, UV Unwrapping can be a straight-forward job—it just takes some time.

We need to try to think ahead about the layout of our UVs, as they can make our texturing a lot easier if they are laid out well.

Next we need to map the wheel hubs. Follow the same procedure as before, Planar Mapping and Relax.

Figure 4.72

The tires will be slightly different. Here we can use Cylindrical Mapping and relax them until they straighten up. Ensure that you fix any issues with the borders, which can sometimes cause problems.

Step 72

Straighten up the UVs (with Polyboost or 3ds Max 2010). If you don't have either of these you can select one loop and scale it manually to 0 in one axis.

Figure 4.73

Step 73

OK, now we should have everything mapped. I hope you didn't find it too difficult.

Now we are going to perform a small trick to improve things slightly.

Collapse the bodywork of your car together with the Symmetry modifier, and Weld the vertices in the middle.

For every part that is connected in the middle, there is a risk of having an ugly seam, so we're going to map the middle sections separately.

Apply a new UVW Unwrap modifier and select one half of the middle part of the UVs, flip it and stitch it to the second mirrored part. Do not move the side edges as they have to stay perfectly aligned.

We will need to do this on the roof, front windshield, rear door, undercarriage, and front parts.

Finally, we need to pack the UVs manually by moving the groups around the texture space as optimally as we can, to get the most out of the texture space.

A good tip is to use a texture with some text on it when packing the UVs. We will see where the top and bottom are, and the following work in Photoshop will be much easier. The same applies to the wheels.

OK, now let's move on to the final part of the build, which is the texture mapping stage.

Texture Mapping

Step 74

In Photoshop, Create a new file the size you want your texture map to be. I'm using 2048 × 2048 pixels.

Figure 4.74

Step 75

Then insert the template and ambient occlusion map HotRod_AOC.jpg that I have prepared for you and set the layer to multiply.

Figure 4.75

Step 76

Next, render the ambient occlusion map in the scanline renderer in 3ds Max and bake it to the texture.

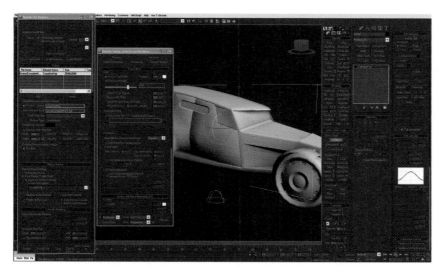

Figure 4.76

Step 77

Render the wire of the model too using Render UVW Template.

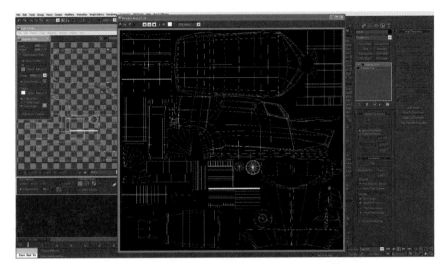

Figure 4.77

Step 78

Add both of these renders to your texture page and set them both to multiply.

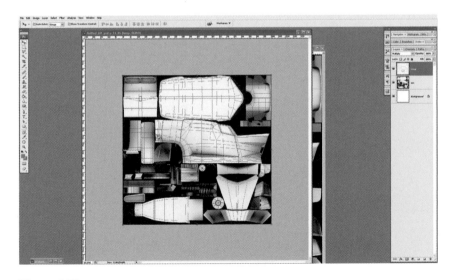

Figure 4.78

Step 79

Add the basic colors on a new layer for each, deleting the excess color with a layer mask where it's not needed.

Figure 4.79

Step 80

Save your image as a .psd and assign the .psd to the material on our car.

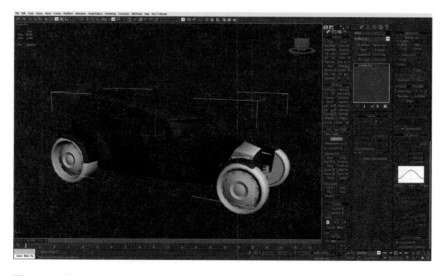

Figure 4.80

Step 81

Continue to add the other basic color blockouts by creating a new layer for the glass and a new layer for the chrome parts.

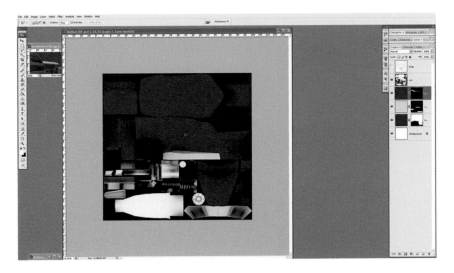

Figure 4.81

Step 82

Add the chrome look to the texture where applicable.

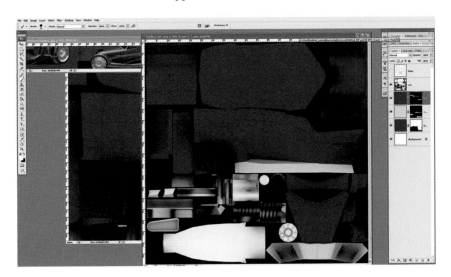

Figure 4.82

Step 83

In Polyboost there is a great tool—cavity render. Or in later versions of 3ds Max you will find Cavity Map, under the Rendering menu > Render Surface Map. Having the concave parts of the map being darker is very useful for creating dirt maps. If you don't have 3ds Max 2010 or newer, skip this step; it's a nice detail, but not essential.

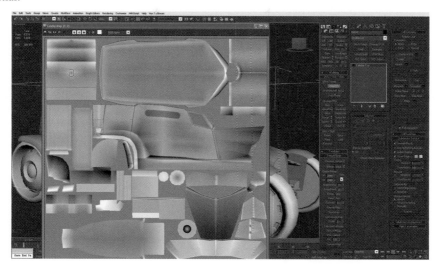

Figure 4.83

Step 84

Just insert the cavity map into your texture and set the layer to Overlay. It will add some nice detailing.

Figure 4.84

Step 85

Next you need to either create a logo or graphic for the side of the car. I found one I liked and used that as a base.

Remember, if you are using images found on the Internet for commercial work (work that you're paid for) you must always gain permission from the owner of the image. For personal work, you don't need to.

Figure 4.85

Step 86

I needed to Desaturate mine slightly and adjust the levels to get the look I was looking for.

Figure 4.86

Step 87

I then change the image to grayscale.

Figure 4.87

Step 88

Then I set the layer to Overlay.

Figure 4.88

3D Automotive Modeling

Step 89

Next we need to take a look at the concept to see what other details we need to add.

Figure 4.89

Step 90

I then create a gray texture to use on the engine parts. A good starting point is to use a section from a photo, draw in some scratches, and texture and blur it.

Figure 4.90

Step 91

Create a new file for the front of the machine gun. Next, draw a hexagon and add it to the texture, using some nice blend modes to get the impression of the barrels.

Figure 4.91

Step 92

Next we need to make the lights. Paint the required parts and use Bevel and Emboss in Layer Effects to give them a bit of shape. This can be found in the bottom right corner of Photoshop, in the Layers tab. Just Left Click the FX icon at the bottom of the panel.

Figure 4.92

Step 93

Then Color the front lights by picking the color from Concept.

Figure 4.93

Step 94

Next we need to find a wire mesh reference shot. If you don't have one in your texture library, have a look on the Internet.

Figure 4.94

Step 95

We need to make a copy of it, clean it up if necessary, and cut it to shape to fit the back of the exhaust.

Figure 4.95

Step 96

Then we need to color the dampers. Once again we need to pick the color from the concept art.

Figure 4.96

Step 97

Do the same for the running boards. Find an appropriate photo, cut the part that you want to use, and use the Bevel and Emboss effect from the Layers tab (bottom right of Photoshop) and Left Click the small FX icon to use.

Figure 4.97

Step 98

On the back door add a line that's not in the mesh.

Figure 4.98

Step 99

The next step is to create a gray layer and add Noise.

Figure 4.99

Step 100

Use this layer as a subtle overlay to get a metallic flake effect for the paint layers. You will need to stack them accordingly below the noise layer for this to work properly. Also, find a suitable reference photo for the underside of the car, modify it so that it matches our template, and move it into position.

Figure 4.100

Step 101

Now we need to go back one more time to tidy up the border for the windows. We need to color the edge and add an Emboss layer effect to give it the impression of having a convex form.

Figure 4.101

Step 102

At this point, have a good look around the vehicle. If you notice any stretched parts in the texture you can adjust this slightly in the model's UVs in 3ds Max.

Figure 4.102

Step 103

Next, we need to go back into Photoshop and add a highlight for the seams in between metal sheets using the Burn tool.

Figure 4.103

Step 104

Repeat this process on the boot/trunk.

Figure 4.104

Step 105

For the wheels we need to follow the same method as we did with the body of the car. Render the wireframe, bake the ambient occlusion to the texture, and insert them into a new file in Photoshop. Make this texture map 1024 × 1024. Make sure you make both a front and rear wheel.

Figure 4.105

Step 106

Just as before, block out the base colors, which for the wheels are rubber and chrome.

Figure 4.106

Step 107

Next we need to find a suitable tire tread pattern to use.

Don't worry about finding a great tread pattern as we will blur it; we just want something with a rubber look. Then use the Stamp tool to make a basic pattern which we use as a base for our tire. Don't worry about the tiling for now.

Figure 4.107

Step 108

Cut out this part and copy it onto our tire texture.

Figure 4.108

Step 109

Then just collapse all parts of the rubber and use Motion Blur from Filters to blur it.

Figure 4.109

Step 110

Next we need to add the details for the side part of the wheel, which is the same for all of the wheels. To do this, cut out the rounded shape from the ambient occlusion layer and center it to the middle of the hub, add another layer filled with a gray color, and add Inner Glow and Outer Glow from Layer Effects.

Figure 4.110

Step 111

On a new small texture, create a circle, and move the bottom half to make an S-shape which we will use for the tire pattern.

Figure 4.111

Step 112

Copy the S-shape a few times, making sure it overlaps and is seamless, and place it on the outer part of the tire texture. Then take a copy of this and mirror it to complete the pattern.

Figure 4.112

Step 113

Copy this pattern and add some middle lines, and then apply Inner Glow and Outer Glow FX. This will give the tire some of the cut-in detail you find on most tires.

Figure 4.113

Step 114

Next, we are going to make a kind of fake anisotropic metal for around the outside of the hubs.

Make short white lines and use Radial Blur to blur them. Copy these for the second wheel and flatten the image. Have a look and see if any of the blend modes gives us a nice effect, or just tone down the opacity. You can select the area to Blur quite easily by using the Elliptical Marquee tool while holding Shift down to force a 1:1 aspect ratio.

Figure 4.114

Step 115

Repeat this process for the chrome strip of the back wheel (draw lines, Motion Blur, layer blend).

Figure 4.115

Step 116

Next we can add some more details for the inner side of the wheel. Use the layer that already has the layer effects and create some holes on it.

Figure 4.116

Step 117

Next, move all the layers into one folder/group, make a copy of the group, and rename it to SPC (specular for short). This is our new group for the specular map. Then we need to go through the whole texture map layer by layer, changing any parts that should be shiny toward the white or lighter end of the spectrum and any that aren't shiny to black or the darker end of the spectrum. Use desaturate or levels as required to adjust this. On a specular map the lighter or whiter the texture details are, the shinier they will be on the model.

Figure 4.117

Step 118

Next we need to go back to our bodywork texture and do the same, making shiny parts bright and non-shiny dark. Don't forget to switch off the ambient occlusion.

Figure 4.118

Step 119

Finally, we need to save the specular textures as .TGAs and assign them to our vehicle in 3ds Max.

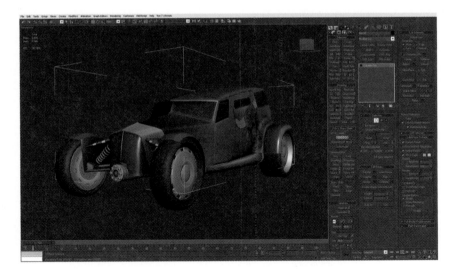

Figure 4.119

This concludes the modeling and texturing of Brook Banham's Gangster Car. I hope you enjoyed reading through it and, if you worked through step by step, well done.

Here are a couple of renders of the finished vehicle.

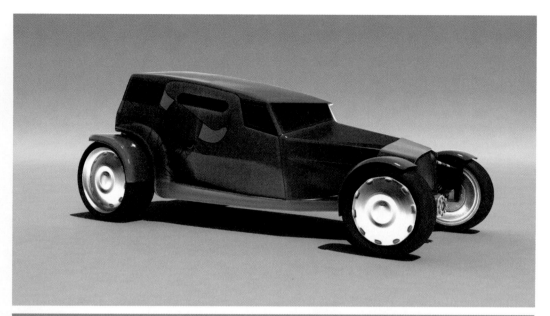

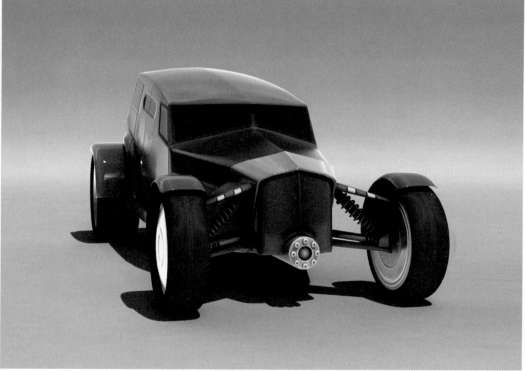

Figure 4.120

Chapter 5

Team Hizashi Racing Concept

Tim Brown

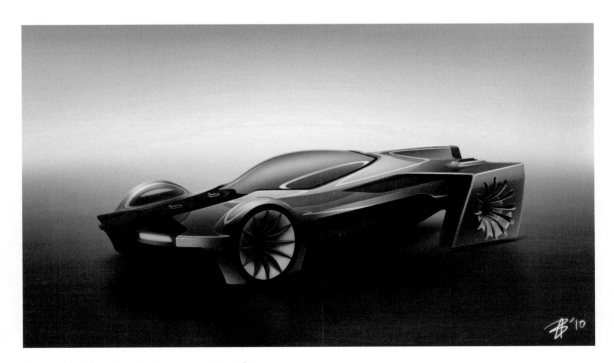

Figure 5.1 *Team Hizashi Racing concept, front ¾ view.*

3D Automotive Modeling. DOI: 10.1016/B978-0-240-81428-5.00005-7

Part 1
Inspiration

Introduction

In this chapter I will be designing the Team Hizashi Racing Concept ("Hizashi" meaning "ray of sunlight") and showing you my methods of developing a vehicle from the first ideas to the finished orthographic drawings (otherwise known as blueprints). Bear in mind, there aren't really any right or wrong ways to do this, but here is what works for me!

When Andy asked me to contribute to this book, I really wanted to design a concept that was fast, sleek and high-tech looking. At the same time, in our current social and economic situation I feel designers should be creating visions of a sustainable future, so I decided to design an environmentally conscious vehicle. But don't worry—there's no reason why a *green* concept can't be awesome and sexy!

Notes on Workflow

Before I talk about my workflow, I'd like to point out that the whole development process is exploratory and iterative. By this I mean that, although there is a set order to working, it's not a case of finishing one process and then moving on to the next. Many processes run side by side with other ones, particularly rough/fast sketching. This is the foundation of design and you should not be afraid to keep going back to your sketch pad up until the design is completely finalized. The reason for this is that, as a design becomes more complete, you often have better ideas or face problems you hadn't considered that need to be resolved. This is also the case with the research, rendering, and wireframe phases of development. In fact, the only independent stage of my workflow is creating the blueprint images, as this is done only when the other design processes are completely finished.

Concept Behind the Ideas

To find an interesting and original angle for a concept, I like to do some basic research to give me ideas and starting points. A bold *vehicle architecture* or styling feature that has a reason or back story really fleshes a concept out and makes it believable.

Vehicle architecture is the basic form and size of the vehicle, and is usually determined by the positioning of the largest components such as the engine, passenger cell, wheels, etc. Thus, a Smart car (with its two occupants sitting on top of the small inline three-cylinder engine, and wheels at the corners) has a very different architecture from an Aston Martin DB9 (with the same two occupants sitting behind the large V12 engine and generous overhangs).

In general video-game concept design, you are most likely designing your car for a storyline or scenario in the game. This may or may not be decided for you already, but either way you should be thinking of the setting of your game—the geography, the light and mood, the characters—in short, what your vehicle will

be used for in the game. The answers to these questions can give you some starting points already: if it's a combat vehicle you can look at guns and armor, if it's a "speed machine" you can look at racing cars or aeroplanes, if it's for harsh environments you can look at exploration vehicles or even lunar rovers. Also, you may consider the overall feel you want the game to have—is your world a *Mad Max*-esque post-apocalyptic hell or more of a cool, clean *Gattaca* style setting?

As my concept is not for a particular game, I will start instead by looking at the technology to achieve the "green credentials," while thinking about how those technologies could inspire or shape my design. When doing this, it's important to delve deep enough to give a believable feel, but don't limit your creativity with too much realism. After all, most video-game cars have a futuristic element, so advances in technologies can be optimistic. What you're looking for is plausibility, not feasibility!

For my concept, I wanted a fast but efficient character, something aerodynamic but not aggressive. This got me thinking about *solar-powered prototype vehicles*—built for research and to compete in endurance and speed events—with surfaces which are so simple but ooze a high-tech quality. This would be my key inspiration and starting point for research.

Keeping a Log of Ideas

Once you've found your key inspiration, it's time to do some research. Don't worry, it may sound boring but really it's one of the most fun parts of a project, as you never really know where it might lead you. And that's a good thing, because to be original you have to be outward looking and soak up ideas from wherever you can find them!

At this point I should reiterate that if you have any ideas along the way you should sketch them down (or even just make some notes). They may guide and focus your research even more.

Nowadays, the Internet is really the only place you need to look (at least at the beginning). You can use simple image search engines like Google or Yahoo, and don't forget photo-sharing sites like Flickr or Photobucket, as they can have some interesting stuff too. Particularly in my case, as my concept is so technology driven, I have also been looking at some web pages to try to understand the basics of new technologies so I can build them into my vehicle. If your research area is quite specialist you may want to buy some books or rent some films. Even some bad sci-fi movies can be a rich resource for ideas and settings! Really, finding inspiration is very subjective. Some people might find a visit to a modern art museum, a walk through a park, or even listening to music would give them ideas so, to sum up, sources of inspiration are unlimited and everywhere!

I usually spend a good few hours gathering resources at the start of a project, and am constantly going back when I have a new idea. If possible, you should save all the images that hold some interest for you, and bookmark any web page with written info so you know where to get more if you need to later. Also remember that the images don't have to have any direct relevance to your story; it may just be the smallest idea in an image that can spark an idea for you or be a useful reference. When looking at images, you might find it easier to break down the areas in which they may inspire you; this way you can try to analyze why

you like them and it will be easier to integrate these ideas into your concept. Below are some categories that you can think about:

- **Shape**
 What are the overall proportions like?
 Is it organic or controlled?
 Is it bulky and muscular or slim-line and elegant?

- **Surface**
 How are the surfaces handled? Are they flat, slightly crowned, or do they have negative curvature?
 Are there creases and edges or just very smooth blends?
 Does it have holes or vents or surfaces lying on top of each other?
 Is the whole surface perforated with holes?

- **Graphics**
 Are they simple or complex?
 Are they flowing or fractured?
 Do they follow the surface edges or cut across them?

Graphics are the shapes "drawn on" to the surfaces—e.g., window shapes, vent shapes, panel shapes, lamp shapes, detail shapes. They may sound unimportant compared to the shape and surfaces, but cool graphics can transform the simplest shapes and also give your vehicle its character. It may also be a good way to quickly make additional versions of the same vehicle.

- **Detail**
 Are there cool detail areas or textures?

In traditional car design, examples of detail areas would be headlamps and taillamps (especially inner workings), wheels, vents and grilles, spoilers, exhaust pipes, even the Make or Model badges. Working on a futuristic concept opens that up into any number of smart ideas—like jet intakes, camera pods, door/hatch mechanisms, gun turrets, ejector mechanisms, aerodynamic components, etc.

- **Color/Finish**
 Do the colors work together?
 Are the surfaces glossy or matte?
 Maybe they have some kind of polarized finish or patterned look?
 Perhaps the surface is weathered or corroded or maybe polished to a mirror finish?
 Do some parts glow or it does it have some kind or camouflage or partial invisibility?

Overall Feeling

Sometimes an image doesn't have a direct link but just gives the right feeling. Maybe it's the lighting or movement in the image, or maybe it relates to the scenario or characters connected to the vehicle. Just because you can't figure out how to use an image for inspiration doesn't mean you should overlook it, because you might be able to extract something from it when you do finally understand why you like it!

When you feel you've collected enough stuff, leave it somewhere easy to access so you can refer to it often. You can filter it down to the core inspirational elements, and you could even make a *mood-board* by putting your key images together onto one page. I like to print out the key images or mood-boards and pin them up around my work area to keep me focused and inspired on the direction I want to be heading in.

Ideas for My Concept

My research area of solar-powered speed record cars led me to think about future fuel options and aerodynamics. Of course, solar power is one option and makes for a compelling story as the look of my concept will be influenced by solar racers. However, solar power on its own can be limited by a lack of light, so my concept would need another energy source as a back-up. Hydrogen fuel-cells, on the other hand, aren't affected by the weather and just need a fuel tank filled with pure hydrogen. Although hydrogen is in the air all around us, the key problem lies in extracting the hydrogen and then transporting it to the customer. This gave me the idea to combine a hydrogen fuel-cell with solar power, since hydrogen is often extracted from sea water using solar power. So why not use solar cells on a vehicle to extract hydrogen for its own fuel-cell? Excess solar energy, for example, on a very sunny day or when the vehicle is parked, can then be used to generate the vehicle's own hydrogen from just water and sunlight. For now, the technology isn't efficient enough to do this, but in the future it may be possible!

To collect water to convert to hydrogen, it could be condensed from the steam by-product of the fuel-cell process or from humidity in the air, so the concept could use cooling fins (like a radiator or heat-sink) to do this. Cooling fins on a car could look really interesting, and even have an aerodynamic function since the under-tray of a racing car already has many fins to control the airflow under the car.

Now that I have a "key inspiration" in solar racers, and an interesting design feature in aerodynamic cooling fins, I really have something to get my teeth into!

Part 2
Initial Ideas

Which Tools?

Often people ask, "Which pen should I use?" or "Which paper is the best for sketching?" Just as with the process itself, the tools you use are dependent on your style of working. Your best bet is to try a range of pens, pencils, and papers to find out what suits you. One thing I should say, though, is this: even if you don't like drawing with pen and paper, I would really not recommend going digital at this stage. I love using Photoshop for 2D images, and I have used a Wacom® graphics tablet for many years, but nothing replaces good old-fashioned analog sketching for getting an idea down.

I tend to always draw with cheap biro/ballpoint pens on either marker pad or sometimes vellum. I like the Bic® ballpoints as they have a nice smooth flow, don't blot too much, are light and comfortable to hold,

and are cheap and easy to find. On a marker or layout pad, they give a rich black line but can smudge, whereas on vellum they have a hazier, slightly grainy but lighter finish, which allows you to draw a finer line weight and build up the lines as you go. As vellum is expensive and tricky to find, I generally use marker/layout pads for general sketching and vellum for more finished drawing when I need more control over line weight. Both vellum and marker/layout paper are pretty transparent so are great for using under-lays (see next section), and both take marker ink well if you want to add some color. However, I tend to not use markers anymore, so leave my sketches unshaded or hatched with ballpoint so I can scan the image into Photoshop and add color there.

Sketchbooks often use thicker paper, which doesn't allow you to underlay images, although this can help you develop your sketching skills as you need to construct each drawing from scratch. I quite like drawing on thicker paper sometimes because the ink from a ballpoint doesn't go down as fast, and lets you build up a good contrast of line weight.

Line weight means the thickness and darkness of a line. A sketch with no variation in line weight will look pretty flat and boring.

Staying Focused and Organized!

It can be easy to end up deviating from your original plan, so you must remember to check back over your project regularly. Often even the most experienced designers can spend time on a concept, only to realize it's not as good as their earlier sketches or has lost something in the process. For this reason, it's a good idea to pick out *key sketches*, meaning drawings that capture the character or some feature that you want to retain or build on, as you develop the vehicle. A key sketch might not be finished or well drawn, but when you draw it you will probably realize it's "the one."

In terms of making a record of your ideas, it can be useful to number your sketch sheets, if you're not sketching in a book. I prefer sketching on loose sheets as you can use underlays easily, and also scanning into your computer is much less hassle that way. Sometimes I sketch on random scraps of paper, but this is usually just for the throw-away working doodle, but of course if you don't have a pad or book and need to get an idea down, anything goes!

Rough Sketches

You can think of rough sketching as shorthand for drawing; the idea isn't to create a beautiful artistic vision (that comes later!) as much as to "get the idea down." Don't worry if the doodles don't look quite right or are messy; at this stage you are simply making a record of your ideas, and you need to be uninhibited. Otherwise you might forget a good idea or filter it out without thinking. So even if your skills are not as developed as you'd like, you can draw with confidence, as these sketches are really just for you—and remember that the end user is buying the ideas, not the sketch.

Having said that, some people like to see your initial sketches to understand your thought process and check that you haven't discarded some good or interesting ideas. And if your rough sketches are presentable, it's a bonus, as you won't have to redraw as many at a later stage.

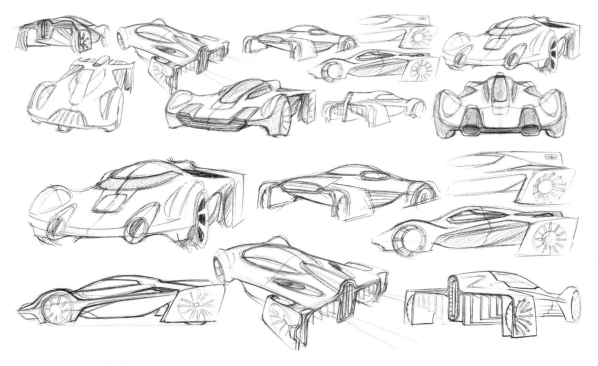

Figure 5.2 *Rough sketches.*

Work-out Drawings

These rough, untamed scribbles are great for exploratory sketches, where you work out the sketch as you go along, giving you more ideas by triggering another thought. In this sense, a poor drawing may even be an advantage, as you often get inspiration from a mistake! This is another reason why drawing in pen is popular; since you can't rub out mistakes, it forces you to live with them or start again—frustrating, but it makes you learn faster. Remember, paper is cheap!

I find it helpful to keep all my doodles, at least at the early stages of a project, because you might hit a dead-end farther in the process and need to come back to try another path. Also you often see your sketches in a different light after a few days or so, which works both ways—sometimes your opinion of it changes for the better, sometimes for the worse.

I also have pages/scraps–of–paper/backs–of–envelopes full of working doodles, which would mean nothing to anyone else, but are vital for me to figure out how one surface meets another, how a graphic fits in a

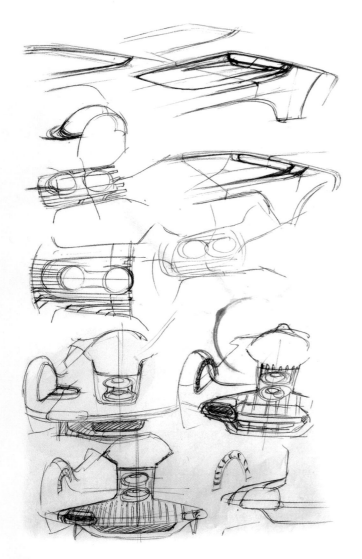

Figure 5.3 *Side intake investigative sketches.*

shape or space, or even just some notes to remind myself of potential problems or opportunities of a particular idea. As these nuts-and-bolts drawings are purely to help me to understand a problem, they have usually served their purpose by the time they are on paper, which is why I don't bother drawing them on a pad or in a sketchbook. I tend to be doing these throughout the project.

On this scrappy, coffee-stained sheet, I was working out the side intake and front detail areas (quite late in the development phase). It's really important to understand all the surface intersections; otherwise your wireframe will be vague or confusing and your modeler will have to solve your problem areas for you.

Part 3
Sketching Out Your Concepts

Now that you have a pad full of great ideas, what do you do with them? Well, a good idea is not very useful if you can't share it, so this section gives some advice for accurate, finished sketching. While you don't need to be an amazing artist— as I mentioned earlier, you're not selling drawings—it will help you explain your ideas and show them in the best light, because you *are* selling those ideas and the execution of the concept. It will also inspire confidence in your clients or team members, as you may be handing elements of your project over to them at some stage. So your sketches should ideally be easy to read as well as dynamic.

Using Underlays from a Photograph

An underlay is basically an image that you use to trace from, to speed up your workflow and make your proportions and perspective more accurate. I often underlay my own sketches, to correct the original

drawing, tidy it up for presentation, or simply to try another version or idea on it. As in the last instance, you don't even need to draw the whole car, maybe just a portion of it to see how it looks (provided you can see enough of the underlay through the paper to make a judgment).

Sometimes, though, it's preferable to get a head start and use a photograph of an existing vehicle for an underlay. You should choose something as close to your concept as possible, in terms of proportion and wheel size—although you may not be going over any of the underlay's lines, it's very useful to have for a reference. It might also be wise to choose a set of photos that work together, so you don't have to use one vehicle as a base for one view of your concept and another vehicle for another view. This will help you to make your sketched views more consistent with each other, as you can use specific reference points on the photographed vehicle for both views.

This is a pretty simple process, but there are a couple of tricks to help you. First, if your photo is digital you can apply some filters and adjustments in Photoshop to make it into a clearer underlay. You will find the Find Edges filter (in the Filter > Stylize menu) very useful as it creates lines from the image, which you can emphasize by desaturating and increasing the contrast of the image (using Saturation and Levels, Curves or Brightness/Contrast, all in the Image > Adjustments > menu). Then you can print it out at your preferred size (I like A4/8.5 × 11 in.) and fill in any lines that are missing or faint on the printout.

Figure 5.4 *An example of an outline traced from an underlay image.*

If your chosen underlay is not digital—i.e., a page from a magazine—you can draw over the main lines with a black pen or white Tippex/white-out pen depending on the image, to get a clearer underlay. Photocopy it first, unless you're happy to ruin the original!

Creating Your Own Underlays

Sometimes it's not possible to find a suitable underlay, especially with futuristic concepts that might have unusual architectures or body shapes. If I have time, I always make my own underlays from a 3D wireframe. A wireframe is a collection of curves floating in 3D space, so whatever view you see it in, it is accurate. You

can create a basic wireframe in just a few minutes in pretty much any 3D modeling program, such as 3ds Max, Rhinoceros 3D, or Autodesk AliasStudio. The biggest benefit of using a wireframe as an underlay is you can choose any view and any perspective you like, and it will be consistent with any other view. Also, making a wireframe will help you to pin down the proportions and provide a starting point for a more detailed wireframe later on, so you may even want to make your underlay to scale. You can easily find many vehicle dimensions (on the web or in the back pages of some car magazines) and make a box, using those dimensions, as a guide.

You can add as many curves as you need to for a wireframe underlay, but it's probably best not to get carried away with the details, as your design is still probably moving and changing all the time. As a minimum, I always start by drawing a circle for the front and rear wheels in a side view and then move them outward and duplicate them to show the thickness of the wheels and the distance apart. When combined with the side-view silhouette of the vehicle, you have a pretty effective underlay! As your design progresses you can tweak your curves and add more details and contours as you begin to make your concept more concrete.

Flick forward to the opening stages of Part 5 for an illustrated, in-depth guide on creating a wireframe.

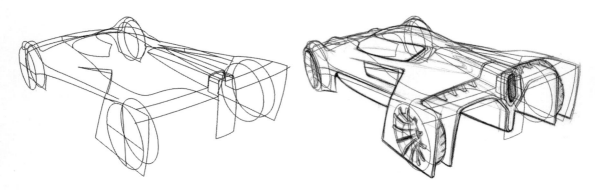

Figure 5.5 *Creating my own underlay.*

You could also make an underlay from scratch, using manual methods or Photoshop. This is more time consuming and less accurate, but if you're not comfortable with a 3D package you can do it this way; however, it does require some knowledge of traditional two-point perspective. Build up the shape of the vehicle using boxes and flat planes, and remember that the axles of the car should be in line with the minor axis of the ellipse of the wheels.

Figure 5.6 *Creating a 2D underlay.*

Tips for Sketching

Now you have your underlays you can really get stuck into the sketching phase! Everyone has a unique style when it comes to sketching, but there are a few general techniques that should help you draw clear and stylish sketches.

Use long, flowing strokes where possible, not little scratchy strokes to make up a line, unless you want it to look hairy! This is difficult at first but with a little practice becomes much easier.

Don't be afraid to draw light construction lines and contours. As you work the actual lines in, the construction lines will not be so noticeable and will add to the character of the sketch.

Don't feel you have to draw everything. Sometimes the key to a great sketch is its simplicity, or "economy of line." I especially do this around wheels and tires, as you can read the tire shape without drawing the whole thing.

Too much detail will make it hard to see what's going on, so prioritize your line-work and be careful to focus the viewers' attention to the right areas. Build up the line weight around the key features of the sketch (e.g., around windows, lights, and lower body) and leave contours or smaller details lighter and thinner. Also you can thicken up the lines as they get closer to the viewer and thin them out as they trail into the distance; this gives the sketch a real feeling of depth.

If you need to show more detail, show more sketches!

If the underlay is moving about, tape down one edge with some masking tape. This way you can still lift it from the other edge if you need to check the underlay.

To check your perspective, turn your paper over and hold your drawing up to the light so you can see the reverse image. It will make it easier to spot errors in perspective. If your paper is transparent enough, you can even sketch on the back and make corrections directly. You can also flip a digital image in Photoshop (Image > Rotate Canvas > Flip Image Horizontal) and work on it digitally (more on this later).

Underlay your underlaid sketch—if it's not right you can use each successive sketch as an underlay. Just be careful not to distort the wheels, as each time you overlay it you will probably be less accurate (like the game Chinese Whispers!).

Experiment and have fun!

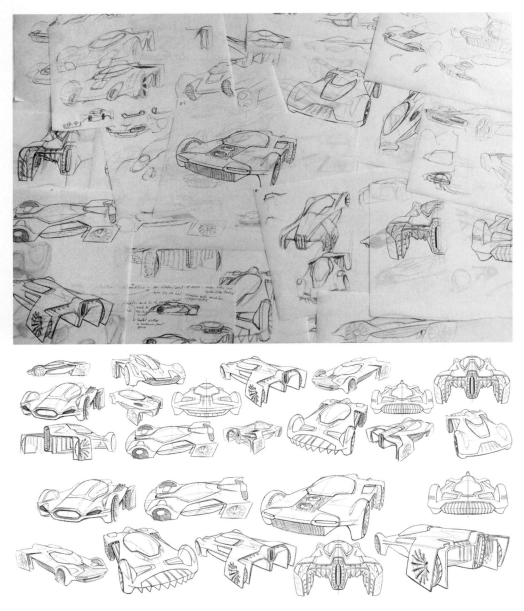

Figure 5.7 *Slightly neater sketches using underlays.*

Part 4
Rendering and Layouts

Preparing Images—Scanning and Retouching

I try to scan my best sketches as I go along, which not only makes them easy to access but is a good time to filter out the key images from the reserve ones. Even if you're not planning to render them, it's good to have your sketches on your computer so you can flick through them, sketch over them in Photoshop, or use them as a basis for a wireframe model. Also you can easily send the file to someone who needs to see a work in progress or WIP image.

Below are the processes I usually go through when scanning a sketch. Obviously, you should take more time or less time doing this depending on what you intend to do with the sketch. If you want to do a fantastic rendering, a high-res scan and diligent retouching will be worthwhile, but for just showing sketches, a quicker approach would be fine.

When I scan a sketch I tend to reset all the automatic adjustments, as scanning software is generally less effective than manually processing an image. For a high-quality scan that could be used for a final rendering, I would follow these guidelines:

- Scan the page at a high resolution (300–1200 dpi, depending on original image size) with no automatic adjustments.
- Desaturate the image (as it will pick up some subtle colors that may become stronger as you process the image): Image > Adjustments > Hue/Saturation or Ctrl + Shift + U.
- Adjust the contrast using Curves; you can find this in Image > Adjustments > Curves or Ctrl + M. First I drag the upper right point slowly to the left, until 99% of the grain on the page background disappears. Then I drag the bottom left point slowly to the right, until just before the dark grays become black. Then I place a point roughly in the middle of the curve and move it up or down until it looks right.

Next I duplicate the layer (to lift it off the background layer), fill the background layer black, then erase around the edges of the sketch layer with a large soft brush at 100% opacity (the hot-keys [and] are really useful for changing brush sizes). This ensures that if the area around the sketch isn't completely white, at least it has soft edges so it won't look so obviously cut out. The background layer is black, so you can see the transparency of the sketch layer and make sure it is fully deleted before returning the background layer to white.

Any smudges, dust, or other unwanted marks on the sketch can be carefully erased or covered with the Stamp tool (hot key S) or healing brush (hot key J, both found on the main tools panel).

Another trick is to use the Dodge tool around the lines to clean up fuzzy or grainy edges. Set the mode to Highlights and then carefully brush over the lines at a low opacity. This will make only the lighter gray pixels white, leaving a higher contrast and crisper edge for the line.

Finally, I set the sketch layer's blending mode to Multiply, which basically applies transparency to the white areas but leaves the black lines opaque (mid-gray tones will be partially transparent).

Checking and Modifying Perspective

As I mentioned in the previous section on sketching, a good tip for checking perspective is to look at the reverse side of the image. This way you are doubling the tolerance of the error; the difference between a wheel leaning one way from its true axis, and then leaning the other will be easier to spot. You can simply check this by selecting Image > Rotate Canvas > Flip Horizontal. You might be thinking it's too late to sort out such problems at this stage, as you've already finished the drawing, but actually there are a few tools in Photoshop to improve (or even rescue!) the perspective.

First we have Free Transform (Edit > Free Transform, or Ctrl + T). This allows you to stretch and skew the whole image. You can also select a part of the image using the marquee or lasso selection tools and then apply the transform.

A slightly more complex version of this is the Warp tool (only available on later versions of Photoshop). Whereas the Transform modifies the image while maintaining straight edges, the Warp function lets you grab a point on the image and drag it into shape, so you can stretch and push the lines to where you want them. The Warp function works alongside the Transform function, and you can switch between the two before committing the changes by hitting the Enter key.

The final, and most complicated, method is the Liquify filter, found in Filter > Liquify. This is quite a resource-hungry filter, so is best used on just the area you want to modify (select it first with one of the marquee or lasso tools). The Liquify panel gives you lots of tools for modifying the image, but you really only need the top icon or Forward Warp tool. This works in a similar way to the Warp tool, but where the Warp function changes a large area of the image, Liquify allows a much more detailed or specific modification to the image. It's also really fun to play with!

You can use the Reconstruct tool on the Liquify panel just below the Forward Warp tool icon to undo parts of your Liquify process. The other tools are fairly self-explanatory, and you can alter the brush size using the hot-keys [and], just as you can with the normal brush tools. You may want to save the Liquify mesh, as it can be hard to see the effects until the filter is applied, and undoing an incorrect Liquify will reset the mesh.

Keep transforming, warping, liquifying, and checking until you're happy with the results, but bear in mind that your image quality is slightly degraded every time you stretch or skew it around.

This image (Figure 5.8) shows the original, poorly proportioned sketch on the left, with the corrected version on the right. The overlay image in the center shows how the distortion at the vehicle's front right corner was fixed and also how the cockpit area was given some more weight.

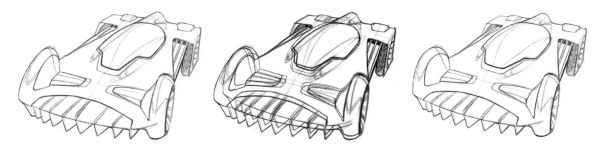

Figure 5.8

Basic Rendering

Now your sketch has been processed and it's ready for rendering. There are many techniques for this, but the Photoshop one I will show you now is fairly easy to understand and works really well. It's also a very flexible way to work, making color adjustments and environment changes very easy (more on that later).

I find that a rendering can look pretty dull and flat until the final touches are on, so don't give up or lose heart until you're done!

I often render over a scanned sketch at the earlier stages of a project, but in this example I'll be using my finished wireframe—it will be only be visible for my reference.

Background

Even for a simple rendering, I usually create a background of some description just to give the vehicle a grounding.

After opening my reference image (a wireframe screen-grab in this case, but it could be a sketch), I use some gradients and a large brush to depict a studio setting. I also overlaid a blurred noise image to get some texture on the floor (Figure 5.9 and Figure 5.10).

Figure 5.9

Figure 5.10

Base

You can think of the first stage of rendering as a base coat or primer on a real car. Even if your car should be glossy, the base coat will have a matte finish. I also stick to a mid-gray color at first for maximum control over highlights and shadows, before applying a color adjustment to the layer. While you could work in color from the beginning, I prefer adding color after the basic shading is done. I also keep my colors on separate layers from the base, which allows me to tweak or even completely change colors whenever I want (and without degrading the image quality).

Incidentally, I have settled on a rich metallic gold color for my concept, after I found some research on new Nanowire solar cells, which use a combination of gold, manganese, and copper (hence the warm, rich depth of gold color) on a flexible sheet to capture up to 92% of the energy received from the sun. Plus it's unusual, potentially futuristic, and looks great with contrasting matte black for the aerodynamic cooling fin panels!

First, on a new layer positioned underneath the sketch layer, I block the color in, either by selecting the body shape (with the polygon Lasso tool) and filling it in (with the Paint Bucket tool or Alt + backspace hot key), or just by drawing it in with a hard-edged brush. Once your shape is colored within the lines, you can select your layer on the layers tab and press the transparency icon at the top of the tab (next to where it says Lock). This means you don't need to select the shape again, as any brush strokes on that layer will stay within the shape you made (Figure 5.11).

Now, using a large, soft brush set to around 10–20% opacity, you can brush onto your gray layer with white and black to give some shape to it, lightening the upward facing surfaces and darkening the ones pointing down. For hard-edged surface transitions, select part of the layer and brush over it, or use a new layer over the top. You can then blur the edge (either using the Blur tool from the main tools palette (hot-key R), or Filter > Blur > Gaussian Blur which will not affect the edges of your shape if the transparency is locked),

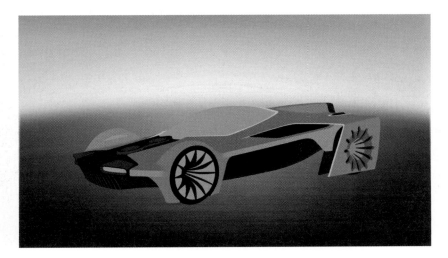

Figure 5.11 *Blocking the color in.*

to soften it a little. A nice little effect is to add a secondary, subtle highlight to the edges of the underside surfaces, to describe light bouncing upward from the floor, which makes it look more solid and realistic (Figure 5.12 and Figure 5.13).

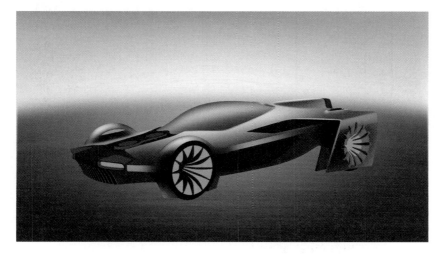

Figure 5.12

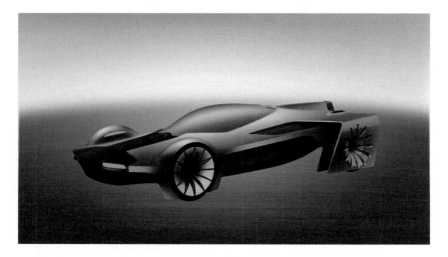

Figure 5.13

Shadows

Mastering shadows can be daunting, because if you don't get them right it makes the whole image look flat and fake. In order to render realistic shadows, you need to consider where you placed the light on your gray base layer and also remember that parts of the vehicle may cast a shadow on other parts, not just on the floor.

You can study real-life shadows to get an understanding of the nuances of light. For example, on a really sunny day the shadows under a car will not only be strong but will have sharp edges and will be cast at an angle (depending on the time of day, of course). Even though the shadows are sharp, they will become softer as the distance between the object casting the shadow and the object receiving the shadow becomes larger. The shadows on an overcast day will be soft and stay close to the underside of the car. It might be an idea to look at a photograph of a scene to try to mimic the conditions of the shadows.

Indoor studio photography will often mimic an overcast day but will add strong lights to get nice highlights on the bodywork. For this image I will stick with soft shadows to match the soft lighting I have rendered (Figure 5.14).

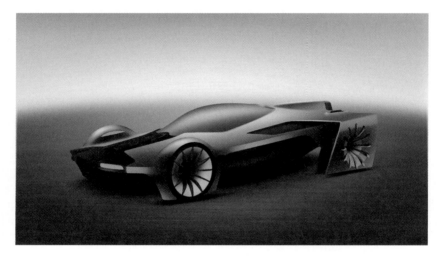

Figure 5.14

Highlights and gloss coat

Matte finish surfaces will be done by the time you reach this point (after some adjustments to the color and tone using Curves, Levels, or Brightness/Contrast). Now all that's left is to polish your bodywork up! Just like with shadows, you need to decide where the reflections are coming from, but usually they are shown on the side surfaces (to delineate the floor) and the far areas of the top surfaces (to show the background and sky/ceiling). Again, you can study a reference image to understand what's happening with the reflections.

Make a selection as before, and brush white onto a new layer, especially to the edges of the selection. Don't worry if it's too strong; you can adjust the layer opacity (look for the 100% default setting at the top of the layer tab) to suit. You can blur the edges slightly using the Blur tool, or another good trick is to apply a median filter (Filter > Noise > Median) which is meant to control noise, but when given a higher setting (i.e., 10 px) it rounds the corners of the paint on your layer nicely for that deep glossy reflection. For this rendering I used a fluorescent strip-light effect for the reflections (Figure 5.15).

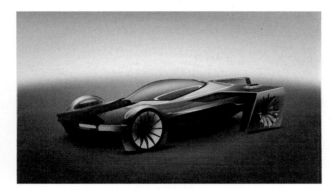

Figure 5.15

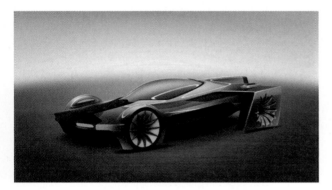

Figure 5.16

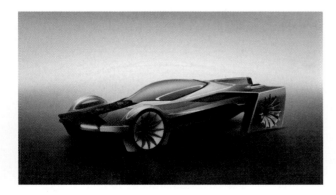

Figure 5.17

A really effective way to show satin (or semi-gloss) finishes is to create a sharp reflection, as you would for a high gloss surface, and then blur it until just before it loses its shape (using Filter > Blur > Gaussian Blur). Then tidy up the edges so the blurry reflection fits within the lines.

Highlighting the rendering is one of the final tasks, and this really is the cherry on top. Either use the line tool or create a path along the edge of your shutlines (the gaps between body panels) to make a thin white highlight (on a new layer). If you are using the line tool, you can transform and warp it into shape; if you are using paths you need to Right Click when the path is active and select stroke path. This will use your current brush or pencil setting, so be sure to set that correctly first. Once your thin white lines are in place, carefully selectively erase them, leaving them just where the light catches them (Figure 5.16).

Now the rendering is very close to completion, and just needs some detailing and final tweaks. In this rendering I've added some glows to the front light, inner wheel-arch detail, and bonnet/hood graphics, made some small color adjustments, softened the background gradient, and finally put a very soft and subtle reflection of the car onto the floor (Figure 5.17).

Sign your work, save off a .jpg—then you're done!

Advanced Rendering

I've called this section advanced rendering to differentiate it from the sketchy basic rendering process above. Essentially, both styles use the same techniques; the difference comes in the execution. The main differences are the selection methods, some neat little layer style tricks, and I'll also give some tips on compositing your car onto a background image. To get really stunning results, you just need to be willing to put in some extra time and care.

Paths and layer masks

The fastest way to make selections is using the polygon lasso tool, or erasing to the shape and locking the transparency. However, there are a couple of methods to make selections that are more accurate and flexible (but of course more complicated and time consuming!). First let's look at paths. I've touched upon paths in the sketchy rendering guide, but as they are an important tool I will explain them in more detail here. Paths, unlike the other selection tools, are a vector-based way of working. This means they are controlled not by pixels, but by a set of points on the page (much like a curve in a 3D program like 3ds Max). The main benefits of this are twofold: first, they can be scaled or transformed as much as you like and don't degrade, and second, you can constantly tweak the shape and modify it without resorting to brushes or selection tools. I use paths to make selections, create vector masks and stroke lines on the image, and if you plan ahead you can use the same path for a selection as for a stroke action.

To create a path, select the Pen tool from the main toolbar. Paths work independently of layers (until you commit them to a layer by way of a *vector mask*—more on that later), but they do have their own path layer system. If you can't see a palette labeled Paths, click Windows > Paths to bring up the tab. This works in a similar way to the regular layers tab, so click on the New Page icon to create a new path layer (labeled Create New Path). Note that you can work on a path without creating a path layer, as it will automatically be placed on a layer called Work Path. This is fine for putting in a quick path, but it is overwritten the next time you draw a fresh one. If you accidentally draw a path on the Work Path layer, you can drag it onto the Create New Path icon and it will be added to a path layer and be saved with the file.

Before you draw your path, I suggest you set the path options (usually found along the top options bar) to Paths, rather than Shape layers or Fill pixels. This means you are drawing just the path, without putting any pixels down. Also make sure the Add to Path Area option (located farther along the top toolbar) is set, so that you are drawing positive shapes as opposed to cutting out holes.

Drawing paths is fairly simple: just click and drag the mouse to place a point and give it a direction and weight. Trace around your shape, putting in only as many points as you need to achieve that shape. Don't worry if you're not exact, as you can go back later to tweak the positions. Clicking the final point on the first point seals the path shape; otherwise the path automatically seals by drawing a straight line from your start point to end points.

Now you can modify the shape using the Convert Point tool, located under the Pen tool you just used (click and hold the pen icon until the dropdown icons appear). You can either click and drag a section of the path (i.e., between two points) to change the shape or use the handles for a more controlled approach (as dragging the path only changes the weight of the curve).

The Handles are the lines coming off each point which control the tangency (direction) and weight (how much influence it has) of the path at that particular point. Clicking the path section with the Convert Point tool will bring up the handles, which you can click and drag into position. Holding Ctrl while doing this matches the tangency of the points' other handle so there won't be a kink in the path. Holding Ctrl also allows you to move the points (whereas just clicking resets their handles and you have to drag them out again).

Once your path is drawn, you can use the Path Selection tool (hot key A, also under the Pen tool icon) to select the path, and then Right Click for several options for using the path.

The main options I use are Create vector mask, Make selection, and Stroke path. Stroke path, as mentioned above, runs your Brush tool (or any other drawing tool you select) along the edges of the path on whichever layer is selected. Make selection simply copies the path shape into a selection, and Create vector mask links the path to the current layer you have selected, making any pixels on the layer that fall outside the path disappear. In fact, the pixels are still there, they are just hidden, so if you click on the vector mask icon (next to the regular layer icon in the layer palette) you can modify the path to get those hidden areas to show more, or less. Once your path is attached to a layer, it disappears from the Paths layer tab, so to use the same path in a stroke operation, you should select the path on the vector mask, and use Ctrl + C or Ctrl + V to copy and paste the path onto a new path layer.

The masking process works exactly the same with layer masks, except layer masks are controlled by pixels, not paths. This makes layer masks more flexible than vector masks because, although it's harder to alter their shape, you can have a graduated layer mask (whereas a vector mask is either on or off). Layer masks actually have 256 shades, as they are controlled by pixels on the mask being white, black, or gray (where white makes the layer fully opaque, black makes it fully transparent, and gray makes it semitransparent).

You can create a layer mask either by making a selection, then hitting the Add Layer Mask icon at the bottom of the layers palette, or by just clicking the same icon without anything selected (in which case your mask will be blank instead of loading the selection). You can then paint on, transform, or apply filters in the same way as a regular layer (just be sure to select the correct icon on the layer stack so you paint on the mask, not the layer itself!). You can also paint on just the layer mask (seeing the mask as black and white rather than the transparency it gives the layer) by selecting it in the Channels tab. This can be useful for fine-tuning and checking there aren't any unwanted artifacts on the mask. Note that you can use a path to make a selection for your layer mask, so you can have the best of both worlds!

Layer style

The Layer Style function is great for adding finishing touches to an image. The various styles I use a lot are Bevel and Emboss, Inner/Outer Glow, and Drop Shadow.

The layer styles work by recognizing the transparency of a layer, so your shape needs to be cut out properly (with or without a mask) for them to work. To bring up the layer styles box, you can either double click on the layer thumbnail on the layers palette, or select Layer > Layer Style and select the style there. Have a play with the styles and their various options; you can create some nice effects very quickly.

One of my favorite tricks is to fill a layer in the shape I want for a highlight, and then set the Fill of the layer to 0%. Fill is located just under Opacity, and affects the layer's pixels, but crucially not the layer style. Then I bring up the Layer Style box and select Bevel and Emboss. This makes the (now) invisible shape appear only in relief, giving a nice even directional highlight (and opposing shadow) to it, once you've tweaked the settings to suit your image. The layer style effects have many more uses though; in this image

(Figure 5.18) I have used a combination of bevel and emboss, gradient overlay, and satin effects on the same unshaded layer to achieve a polished metallic finish.

Backgrounds and compositing

If you have a suitable background for your rendering to sit on, it can really help explain the context of the vehicle, and the part it plays in that world. If you've used a similar rendering process to mine, compositing is really quite straightforward as you can easily adjust the colors and contrast of the base layers, and replace the studio-style reflections and shadows with new creations that are more fitting to

Figure 5.18

the scene. This is far preferable to re-rendering the entire vehicle!

There are a few key things to remember when looking for or creating a background for compositing images:

- **Angle.** If the perspectives don't line up, and you can't modify them convincingly, look for a new background image! It won't look right no matter how good your rendering is.
- **Cut out.** Soften the edges around your rendering slightly, especially toward the back (far away) edges of the vehicle, so it doesn't look too cut out. You can even partially erase the upper surfaces at the back so the background shows through, appearing as a hazy reflection. You can also add some noise or blur to your image to better match the scene.
- **Lighting.** Adjust the color balance of your rendering to suit the colors and light in the background image, and make sure your highlights and shading are consistent with those in the image.
- **Shadows.** Imagine how your vehicle will affect the scene, the shadows it will cast on the floor, and the glow of any light sources on your vehicle. Also remember your scene may have objects casting shadows on your vehicle.
- **Reflections.** Even some basic shapes or colors picked up from the scene will help integrate your concept into the environment. Also your vehicle might reflect in the scene (i.e., puddles in the foreground), which is a good opportunity to add realism and immersion.

In the example of the dark studio shot (Figure 5.19), I rendered only the new reflections, a grid for the tiled floor, and did a variation of the blurred floor reflection from the earlier rendering (this time with a fading blur and some waviness to show a slightly uneven, satin finish floor). The other base, shadow, and highlight layers were adjusted using Curves and the Hue/Saturation adjustments.

The other two images, while far more time consuming, demonstrate how flexible the original rendering is and go to show how far you can take your backgrounds to sell the visual (Figure 5.20 and Figure 5.21). It's also a lot of fun!

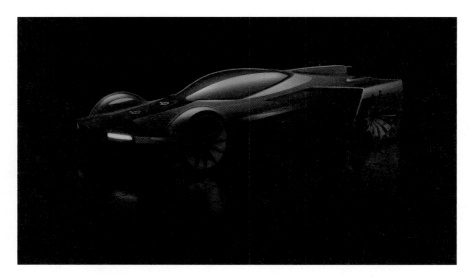

Figure 5.19

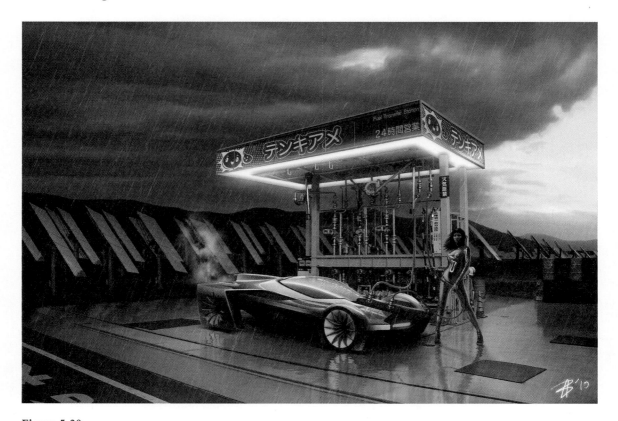

Figure 5.20

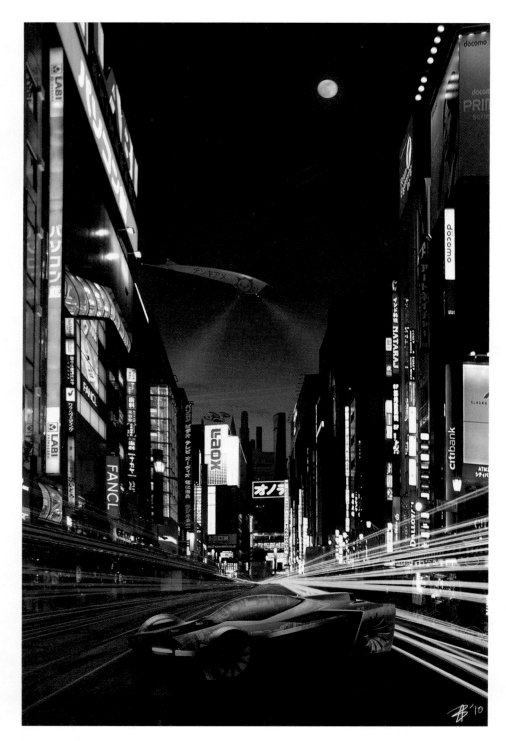

Figure 5.21

Part 5
Wireframe Modeling

Why Build a Wireframe Model?

Building a 3D wireframe model may seem like a lot of work compared to doing a traditional 2D ortho-graphic drawing (or blueprint), but in my opinion (and those of my clients!) its benefits are well worth the investment in time. Apart from the leg-up it gives you in creating an accurate underlay, it will give better results than 2D drawings for several more reasons. First, it allows the designer to see the vehicle in three dimensions and do the best possible job on the proportions and look of the vehicle.

Second, it provides a very useful starting point for whoever is responsible for the 3D modeling (even if that's you!). And third, it ensures the finished blueprint drawing is 100% accurate, since you are not drawing three or four curves to represent one line, but one curve viewed in several planes. So you can think of a wire-frame model as being four elevation drawings in one (side, plan, front, and rear).

Starting Point—Importing the Side View

Usually the first thing I do when starting a wireframe is to prepare my best side view sketch. This doesn't necessarily mean the best drawn sketch, but the one that is closest to your ideal proportions. Bear in mind

Figure 5.22

this is just for a reference, so you don't have to worry if it's still not quite as you want it or if the details aren't quite right.

You may find it helpful to remember these points when preparing your image:

Make sure the sketch is level. You can position a guide over the Photoshop image by dragging from the ruler bar with the Move tool (V). If the rulers aren't visible, press Ctrl + R to toggle them (Figure 5.22).

Make sure your vehicle sketch is facing to the left, as this orientation is the standard for automotive design. If it's not, flip it using Transform or Rotate Canvas. This isn't critical, but will make it easier to follow the rest of this guide!

Once you have straightened your image (if necessary), I like to knock the contrast right back so my curves will be easier to see when I put them in. Here I used Levels, dragging the bottom sliders toward the center, but you could use Brightness/Contrast or Curves to achieve the same result (Image > Adjustments > Levels or Ctrl + L) (Figure 5.23).

Figure 5.23

Next I crop the image right to the edges of the sketch. This makes scaling it in the 3D program much easier, since you can align the image to the baseline in 3D space.

Now that the image is ready, all that's left is to draw a box in your 3D package, to use as a scale and proportion guide (using the image's length and height, plus a given width), and finally, to import and place the image. The box part isn't really necessary, as you can always scale up/down your 3D model, but I prefer to start at the correct size in the first instance. As mentioned previously, if your vehicle is based on an existing car you can find out the measurements of that car and use those for your reference box.

In terms of placement of your reference box and side view image, I always position the side view on the XZ plane, meaning that the X axis represents the length of the car, the Z axis represents the height, and the Y axis represents the width of the vehicle. This is the standard automotive design XYZ orientation, but whereas most automotive modelers place the center of the front wheel at the 0,0 point, I usually place the center of the tire's contact point (i.e., the bottom edge of the wheel) here as I like to sometimes put in a ground plane (which is easier to do at the $Z = 0$ plane) (Figure 5.24).

Figure 5.24

Once your image/box references are in place, it's time to start creating the wireframe! Since there are many 3D packages capable of this process, I won't be making any reference to specific programs or functions in this section, and will only be using generic functions (e.g., drawing nurbs curves, snapping to objects, aligning tangents, and basic surface modeling).

Wheels, Centerline, Plan

As I mentioned in the *Creating Your Own Underlays* section, I always start by drawing in the side view, placing circles for wheels and putting in the main curves to denote the silhouette of the car (Figure 5.25 and

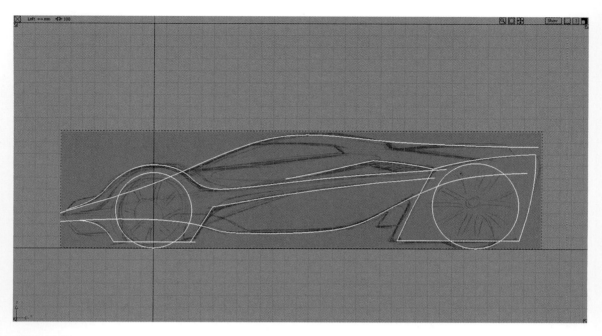

Figure 5.25

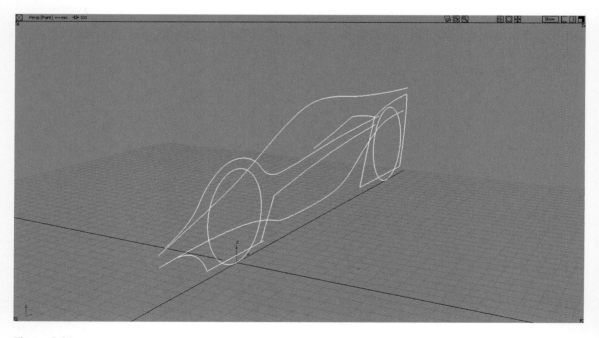

Figure 5.26

Figure 5.26). Make sure you do this on the XZ plane so you can mirror the model around the 0,0,0 point. You don't need to put every detail in yet just concentrate on making those key curves follow your reference sketch in as few CV or Edit points as possible (I always use nurbs curves for maximum control, set at 3-degree for simple curves or 5-degree for more complex or large blend curves). Using as few points as possible makes your curves smoother and also easier to edit since you will have to pull individual CVs to give it the plan shape. If you can't achieve the desired line shape with a simple curve (i.e., 3-deg with two spans), you should consider using more curves and aligning them so they flow in one line, as generally it's better to have many simple curves than a few complex ones.

CV points are Control Vertices, and are used to control the direction and weight of the curve, in a similar way to handles in Photoshop's path system. CV points often don't lie on the curve though. A blend curve is a curve that connects two other curves, in a seamless way. As a blend curve is often in an S-shape, it is more complex than a curve that only bends one way and therefore may need a higher degree or more points to get the shape you want. Aligning curves means matching either the position, tangent or curvature of one curve to another. For seamlessly joining wireframe curves, I tend to use just tangent align (as opposed to curvature) since I won't be building surfaces from the curves.

Next, I move the wheel curves (along with any other connected curves) out to their correct width position, and duplicate the wheel curves to show the thickness of them (Figure 5.27).

Figure 5.27

Now, keeping an eye on the reference box (if you made one) or the wheel curves as a guide for width, select the other curves you drew in the side view and move them outwards (in the Y axis). Remember, your vehicle centerlines should not be moved since they should already be in the right place (i.e., on the

XZ plane at Y = 0). Also, make sure you only move the curves in the Y direction, so if you return to your side view it should look as if nothing has moved.

Using the plan (top) view, move the CV or edit points (again, only in the Y direction) to give the curvature they need. You can add more points to the curves if you need more control to fit a shape, but this may affect your side view, so be careful and check the results (Figure 5.28).

Figure 5.28

Figure 5.29

Continue adding more curves for the larger features like the windows, strong feature lines, and intakes, etc. Remember to work in all three views (side, top, and front) when placing or shaping curves, as each curve will be stronger in one plane than another. By this, I mean (for example) that the front bumper of a car is almost always easier to draw in plan view since this is the view it has the most shape in. So draw it in plan, and then move it into position and tweak CVs in side or front view (Figure 5.29).

Viewing the Wireframe

Remember to regularly view the model in the perspective view since this is the most important view! Your gamer will never see a pure side view or front view, just as in the real world cars are only seen in a perspective view (Figure 5.30 and Figure 5.31). Vehicles often look a bit awkward in pure side view, as the overhangs (the car's body in front of the front wheels and behind the rear wheels) look longer than you expect them to, making the wheelbase (distance between the wheels) look too short. This demonstrates the good reason to build a 3D wireframe over a 2D elevation drawing.

Assuming you are working to scale, I would tend to set the focal length at around 35–50 mm in the perspective window as that gives a pretty standard angle of view and won't trick your eyes into making your

Figure 5.30

Figure 5.31

car look bigger or smaller than it is. Just to demonstrate, this image (Figure 5.32) shows the same wireframe at three different focal lengths: the top image is a wide angle equivalent, the middle one a more natural perspective, and the bottom one a telephoto equivalent.

Also, I recommend that whenever you check your model, you mirror across the other half or you won't get a good idea of the proportions. Some programs have an automatic symmetry function, which is pretty useful, but mirroring manually also has its benefits since you can work on the two sides independently, trying things out and comparing the difference.

Figure 5.32

Editing Scale and Proportions

Another benefit of building a 3D wireframe is the flexibility it gives you to develop and evolve your design. As an example, the image below shows the front end of my concept (Figure 5.33). At this stage I've decided that the nose is too low and needs to be raised to get the look I want, so I will need to pull the curves and CV points into a better shape.

First, I decide which curves will need to move or be altered, before duplicating them and setting them to a locked/template layer. This is useful to provide a before and after reference, but also is a safety net in case I make a mistake or change my mind after editing the curves. Make sure you duplicate not only the whole curves that need moving (shown in black), but the adjoining ones that connect them to the areas that don't need to be changed (shown in white).

Next, turn on CV points for the curves selected, and select all the points of the curves that need to move (black) and the end points of the adjoining curves (white). Move the whole curves into position, dragging the corresponding end points with them (Figure 5.34).

Finally, re-align the adjoining curves (either manually or with an automatic tool) and mirror them over (Figure 5.35). If you are happy with the results, you can delete the template curves; if not, then repeat the process until you are!

Figure 5.33

Figure 5.34

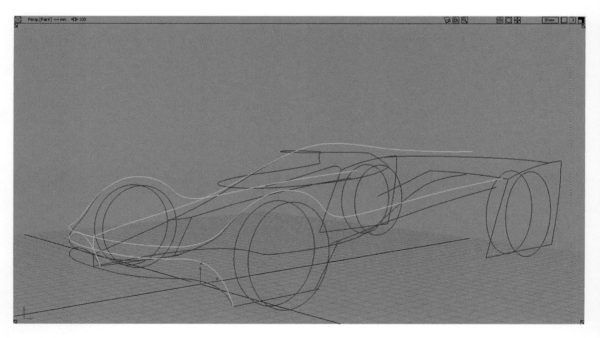

Figure 5.35

This method also works well with scaling curves—in the past I have scaled literally half a vehicle at a time to get the proportions right, but be careful when doing this, as you will need to consider how the wheel-arches and other round curves (e.g., headlights) may be affected. Also, I'd advise you to tackle any doubts or issues you have with your proportions as soon as possible. Pulling curves and points can be done at the end, but will obviously take longer to fix up when you have more adjoining curves to adjust.

Detailing

Now your wireframe model should really be taking shape! The more detail you add, the more solid and convincing it will look. The next few sections will show you how I use some tools and techniques to add details and really bring the wireframe model to life.

Contours

If your vehicle is quite simple in areas, it may be hard to show the volumes of the surfaces and describe what's happening, so you can add contours to your model. A contour, just like on a map, is an imaginary line that describes a section—the shape of a solid object if it was to be intersected by a plane (imagine chopping an object with a straight blow; the edges of the flat surface you make form the contour). So, just as contours on a map show the shape of a mountain at a specified height, you can draw a contour on your vehicle to show the shape of the surface at that point. If you've followed the first steps of this wireframe tutorial, you will have already drawn at least one contour, the centerline. I usually put contours in the YZ plane, running through the center of the wheels and perhaps one or two more in the middle of the vehicle. Sometimes I also add contours on detail areas if there aren't enough curves to describe what's happening with the surfaces.

To draw a contour on the YZ plane, pick your point on the X-axis (i.e., how far down the vehicle's length you want it), and draw a vertical line there. In this example, I'll use the center of the front wheel (Figure 5.36).

Use this vertical line as a reference, as in the side view your contour should only be visible as a vertical line. Draw curves between any feature lines you have, intersecting with the vertical line. In this case, I've started at the centerline with the hood line (Figure 5.37). In the front view, you can pull the CV points up or down to get the shape you need.

Next I've drawn the lines from the wheel-arch to the haunch (the line running over the top of the wheel-arch) (Figure 5.38) and in the front view I've drawn the inside line of the wheel-arch (Figure 5.39).

After those curves are in place, I've put in the blend curve between the two latest curves (Figure 5.40) and trimmed the curves back, before aligning the tangents to give a smooth continuous flow over the wheel-arch (Figure 5.41).

The last fillet goes into place (Figure 5.42), finishing off the contour (Figure 5.43). The finished contour really shows the shape well and can be very useful for building more curves (Figure 5.44).

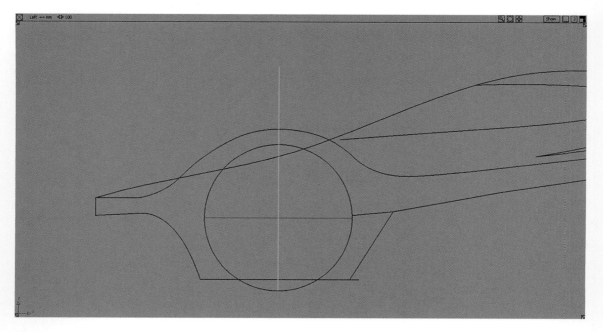

Figure 5.36

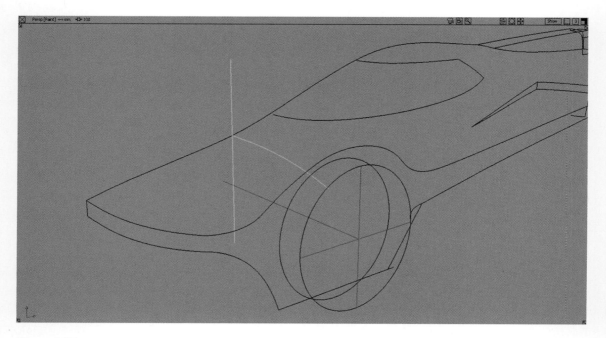

Figure 5.37

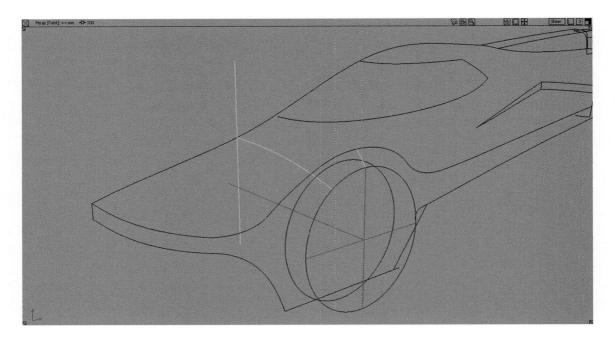

Figure 5.38

Figure 5.39

3D Automotive Modeling

Figure 5.40

Figure 5.41

Figure 5.42

Figure 5.43

Figure 5.44

Building fillets

You will probably need to build many fillets on your model. A fillet, otherwise known as a radius, is when you round off a sharp edge or corner. Technically, a fillet should have a constant curvature (i.e., when drawn from the side it should represent a section of an arc), but in automotive or product design, pure fillets aren't really used because they tend to look too controlled (and they break curvature continuity). Even the corners of Apple products such as the iPod and iPhone (the ultimate rounded rectangles) and are not pure arcs if you look hard enough! This is good news for us, as we can build these loose fillets much quicker by eye. In this example I will be filleting the tunnel feature at the rear of my concept (Figure 5.45).

As this fillet will run roughly along the X axis (front to back of the vehicle), switch to the rear view and draw a circle on one end of the edge to be filleted (Figure 5.46). This circle should intersect the curves at the point where you want your fillet to begin.

Duplicate the circle, moving the copy to the other end of the curve to be filleted (Figure 5.47).

Create a curve (in rear view again) from each point where the circles intersect their corresponding curves (Figure 5.48 and Figure 5.49) and then trim the curves back to the new intersection curves (Figure 5.50 and Figure 5.51). Don't delete the redundant edge curve (the one shown in white in Figure 5.52), as we'll use this later.

Align the intersection curves to the trimmed curves (Figure 5.52 and Figure 5.53) either manually by pulling points or by using an automatic align tool.

Figure 5.45

Figure 5.46

Figure 5.47

Figure 5.48

Figure 5.49

Figure 5.50

Figure 5.51

Figure 5.52

Figure 5.53

Finally, duplicate and move the redundant edge curve to the ends of the fillet curves (see Figure 5.54) to complete the fillet wireframe. You will probably need to scale/rotate the edge curves to get them to meet the ends of both fillets.

Figure 5.54

You can use this method for filleting anything from small detail edges to large feature lines, as it doesn't need the curves to be on the same plane for it to work (unlike automatic fillet tools which often only work properly in 2D).

Building basic surfaces

Although we are concentrating on a wireframe model here, sometimes it can be quicker to build a basic surface to work out what the curves need to do. This can be particularly useful when you have a lot of details or lines on a curved surface.

An example of this when designing a normal car is the door lines—making sure that the front and rear of the door shut-lines are on the same surface will make your wireframe more accurate—and also grille patterns or mesh, which would be a very frustrating job to model each curve manually! In this case, though, I will use a surface to help me place the complex hood details.

First, you will need to build the surface. You will probably be able to use lines you already have drawn, in this case I can use the centerline, the contour (I drew in the earlier Contours section) and the front bumper curve, so I can use a 2-rail surface tool without the need for any additional curves (Figure 5.55 and Figure 5.56). This only covers the section of the hood up to the front wheel centerline (where I built the contour), so I need to extend the surface or build another surface onto it (Figure 5.57 and Figure 5.58). Depending on your concept (and wireframe), you may need to make additional curves for the surfaces.

Figure 5.55

Figure 5.56

Figure 5.57

Figure 5.58

Next, draw your curves in the required view (which is the top view in this case), i.e., on a flat plane (Figure 5.59 and Figure 5.60).

Use a Project Curves tool to transfer the flat curves to your surface. See how they look in perspective view, and adjust/re-project the curves as necessary (Figure 5.61).

Figure 5.59

Figure 5.60

Figure 5.61

Duplicate the edges of the surface lines to turn them into curves (you may need to cut the surfaces out to do this in some 3D packages), and rebuild them if they are very heavy, meaning too many points (Figure 5.62 and Figure 5.63).

Figure 5.62

Figure 5.63

This technique is also great for doing wheels, giving you a lot of detail for a small amount of effort and time:

Start by drawing the section of the rim (i.e., the shape of the wheels' dish) in the front or top view, making sure it's placed in line with the wheels' axis (Figure 5.64).

Use a Surface Revolve tool (sometimes called *lathe*) to revolve the curve around the center point of the wheel (in the Y axis) (Figure 5.65).

Figure 5.64

Figure 5.65

In side view, draw one of the spokes and any other details (e.g., wheel nuts, holes, split-rim nuts, etc.) (Figure 5.66).

Project the curves onto the revolve surface, and then duplicate the projected curves as before (Figure 5.67).

Figure 5.66

Figure 5.67

Use a polar or circular array tool to copy the projected curves (of your single spoke) around the center of the wheel (Figure 5.68).

Repeat the process, building up detail as necessary (Figure 5.69).

Figure 5.68

Figure 5.69

Keep Going!

The methods described in this section are really the only processes you need to use to create an accurate and dynamic wireframe model. From this point, you just have to work in as much detail as you feel is necessary, one curve at a time, until your model is completed and ready for the final part of the concept design phase—drawing up the blueprints.

This is my finished wireframe model (Figure 5.70 and Figure 5.71). It's a bit tricky to see what's going on in there, but you can see the shapes a lot better when you rotate the model around.

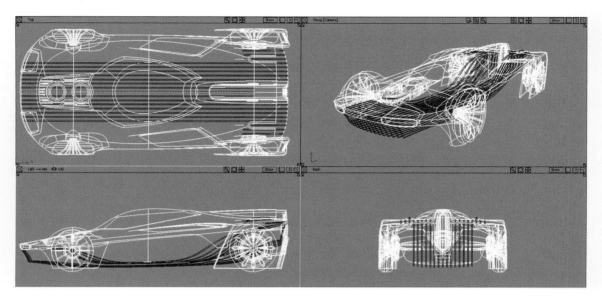

Figure 5.70

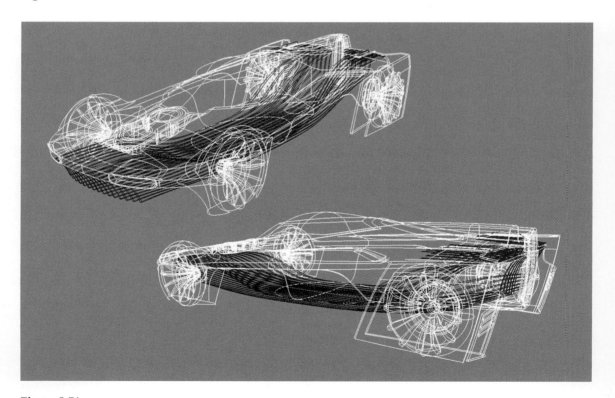

Figure 5.71

Part 6
Creating Blueprints

Flattening the Wireframe

The first step in creating your blueprint drawings is to make a duplicate of your file. In fact, you'll need several duplicates as you'll need to make one drawing for each view. I usually start with the side view, but it doesn't really matter which order you work in.

Begin by deleting any curves that are not visible from the particular view you're working on. For example, when making the plan (top) view, anything below the widest and longest part of the vehicle will not be visible, nor will the insides of the wheels (as the tires will block your view of them from the top).

You'll have to leave any partially hidden curves for later.

Try to avoid having duplicate curves in each view—for example, if your vehicle has any curves directly above another (in the plan view) or in front of another (in the front/rear view) you should delete all but one. This keeps your file less messy and makes the other stages easier.

You can save time by remembering that a wheel will have the same shape and profile in plan and front/rear views (provided it doesn't have any camber or toe-in angles). If your vehicle has open wheels (like an F1 car) you can copy the curve from one view to another.

Bear in mind that the silhouette of your front and rear views should be exactly the same, unless the vehicle is asymmetrical, in which case the silhouettes will be mirror images of each other. You can use this to your advantage as well, to save some time.

Once all the extraneous curves are deleted, you can flatten the remaining curves, either by projecting them onto a surface as described in the *Building Basic Surfaces* section or by selecting all the CV points of the curves and snapping them to the same X, Y, or Z value (depending on which view you are working on). Make sure you only move the points in the one axis though! And if your 3D package has a History function (where the program remembers alignments between certain curves), you may want to clear the history beforehand to avoid unwanted results.

Trimming Curves

Now that you're working on the flattened curves, you can trim away all the overlapping lines and generally tidy up the curves. At this stage, I set various curves to different layers, one layer for the outlines, one for the "break" lines (such as color splits, window edges, etc.), one layer for subtle surface creases (and extra-fine details such as meshes), and finally one layer for everything else. Although this isn't necessary, it allows you to give different line weights to the different grades of line, making the final image easier on the eye as the larger shapes are more visible and the smaller details are less overpowering.

When all your views are done, you can assemble the finished curves onto one plane (you will need to rotate them since each view will be on a separate plane). I tend to use the "third angle projection" layout (a pretty

standard layout), which basically means the front view is shown in front of the side view, the rear view is shown behind the side view, and the plan view is shown above the side view (with the side view facing to the left of the page). Make sure the front, side, and rear views are lined up with each other, and the front and plan views are lined up too!

Import/Export Options

Your import/export options will depend on the software you use. As I happen to use Rhinoceros 3D, this process is very easy, as Rhino can export to Adobe Illustrator's *.ai format. This even preserves the layers I set up in Rhino, so all I have to do is select the curves by layer and adjust the line weights, before saving the file as a Photoshop *.psd or *.jpg.

Other programs are not as flexible, so you may have to try different formats. If you are working in a program with a rendering function, you could even render the curves in an orthographic view or, at worst, screen-grab the views and assemble them in Photoshop.

If you are stuck with the screen-grab method, you can overlay the layers and use Filter > Other > Minimum to beef up the lines on each layer to achieve the differentiation in line weight.

Your finished blueprint image should look something like this (Figure 5.72).

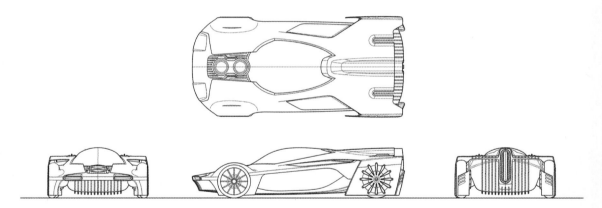

Figure 5.72

Sign off

Hopefully this guide has gone some way toward helping you realize your concept, from some vague ideas inside your head, to the finalized, concrete, orthographically defined vehicle. If not, I hope you at least enjoyed looking at the visuals. Now it's time to hand over your work to a modeler and then sit back, relax, and wait in anticipation for your creation to appear on the shelves!

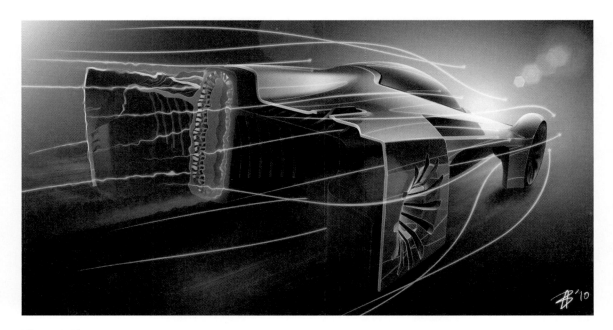

Figure 5.73

Good luck!

Chapter 6

Team Hizashi Racing Concept—From CAD to Complete

Johal Gow

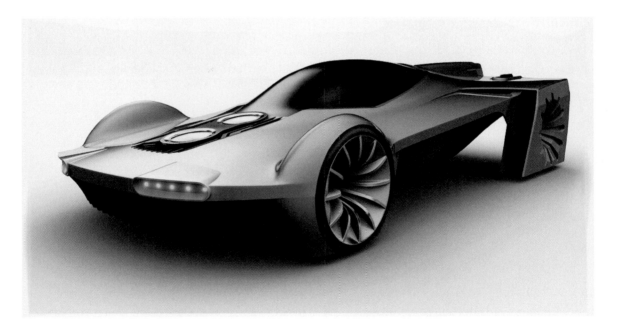

Figure 6.1

Introduction

Welcome to the 3D modeling section of the Team Hizashi Racing Concept.

This tutorial is intended to show you the modeling process of bringing Tim Brown's design from the concept stage to the in-game 3D model stage.

3D Automotive Modeling. DOI: 10.1016/B978-0-240-81428-5.00006-9

My aim for this tutorial is to reach out to a broad spectrum of artists, from those who have very little 3D experience to professional vehicle artists looking to see how other professionals work.

Although many people start with or use Autodesk's 3d Studio Max and Maya, Softimage XSI 7.5 is going to be the weapon of choice for this project. I prefer to use Softimage XSI for creation, before transferring the finished vehicle into the appropriate program for in-game setup. The reason for this is that Softimage XSI, in my opinion, offers the best range of selection options, mesh tools, smoothing/hard edge functions and program flow. I find it easiest to model in Softimage XSI and get the right result with the least headaches. When it comes to creation, ease of use is very important.

As this tutorial is intended to cater to artists of all different skill levels, the following section will explain every step in great detail during the early stages, before broadening out once everyone is up to speed.

In order to introduce first-time XSI users to the Softimage interface, I will explain all of the tools needed for general modeling while creating the front wheel of the concept. It's easiest to learn the tools necessary for a project by focusing on one area.

Modeling process vs. design process

Unlike the concept design section for this vehicle, the creation side is a lot more structured. Having the concept's design already decided for you sets you on a path for the creation of the model, but that doesn't mean you don't have plenty of design challenges along the way. During the process of bringing this futuristic vehicle from concept to game artwork, I will express my thought processes as to how the steps I'm taking might relate when making other car designs.

Preparing to Start

Know your specifications

Before starting the modeling process for the concept, it's very important to be aware of the specifications for your vehicle and develop a plan of attack. For this concept, I've chosen to use 45,000 polygons total, split 27,000 for the body and 4,500 for each wheel. These polygon counts are acceptable for high-end games on current generation platforms.

Understanding how many polygons you have available for each area is paramount. Take into consideration what each budget has to account for. If the body polygon budget has to include a low polygon engine bay and interior, for instance, be sure to set aside an appropriate number of polygons before starting the model so that you know what you have to work with.

When starting the modeling process, make sure that time is taken to create a body base that will allow all the necessary details to be added without going over the polygon limit. This can save you a lot of frustration later on.

For example, if you find yourself well over the polygon limit with an almost completed model, it may be that too many polygons have been used in the shape of the car before adding all the details. Once the details

have been modeled it can be very hard to subtract polygons from the shape of the vehicle without ruining the shading. This can largely increase the time it takes to complete your model and hamper your ability to make a deadline.

In all cases, the best method is to spend time making sure you're completely happy with the body shape and polygon count of the vehicle base before adding the details. It is always better to start adding details below the poly count and build up rather than go over the poly count and try to get back down. This applies to basically every form of model creation for games.

For the concept vehicle we will be making, the general car shape is fairly straight and flat, except for a few areas. This will allow polygons to be conserved on the less intricate areas and concentrated on the more detailed areas such as the wheel arches, canopy, and engine/exhaust details.

Reference material

The method in which you attack a model depends on many different aspects. Reference material, for one, can influence the method you take in creating the model. Reference can range from as little as a few pictures, to blueprints, to manufacturer CAD models. Some of these include full engine bays, interiors, and wheels, with even the smallest details provided. Receiving CAD models from manufacturers is becoming a lot more common, which is great from an accuracy standpoint, although it can be a detriment to those looking for a real modeling challenge.

When it comes to conceptual vehicles, drawn blueprints accompanied by rendered drawings from a few different angles are usually provided. In this case, we're lucky enough to have received a CAD for the concept.

One thing to consider with CAD models: if the car to be created has a complicated shape or lots of details, don't always assume that having this extra reference will save you time. A CAD will provide you with a perfect shape to follow, but it can be as much of a curse as it is a blessing. So while you save time on getting the right proportions, you can be slowed just as much by being too much of a perfectionist. Be aware of this when starting a vehicle using different types of references.

Tips

Save incrementally—for example, car_01, car_02, car_03, etc. While working on any sort of game artwork, it is very important to save in increments. This not only protects you from corrupt files, but is also useful if you need to retrieve part of your model from an older file. In recent iterations of 3d software, the backup and crash recovery systems have improved greatly, but it's best to leave nothing to chance. It only takes one corrupt file to happen close to a deadline for you to never forget to do it again. Save yourself the worry and start incrementally saving!

Cleanliness in modeling and shading

Anyone can jump onto a 3D program and, after some practice, produce a semi-decent-looking vehicle. The way to distinguish yourself from the others is in the care and attention to detail—the love you put into your work.

There are many things you can learn to help improve your modeling. One common problem often seen by beginners and professionals alike is that, while they can produce the shape required, they don't understand exactly how the mesh reacts to the placement of the polygons.

Making neat wireframes is not just for cosmetic reasons when it's shown in wireframe. A clean, nicely spaced wireframe helps greatly with reflections and shading (Normals). Don't confuse "nicely spaced" with "evenly spaced" either.

One thing that is seen very often, even from professionals, is perfectly spaced wireframe models without exception. While this may seem like the right way to go, it can often be to the detriment of details, the roundness of the model, and the shading produced. For example, it is senseless to use an equal amount of polygons (equal spacing of polygons) on a relatively flat door area when they can be put to better use on the rounder parts of the car. Of course, this is all relative to your poly count.

Bevels and cutting off shading

Understanding how to control and end the shading on a model is also very important. A good 3D artist should not only be able to create the correct shape of an object, but should also have a good understanding of how the normals react to the mesh they have created.

Cutting off shading is a concept that very few artists learn early on, and it's something that can vastly improve their work. As a rule, I always model with the 360 degrees of discontinuity, which means having total control over the visual outcome of the mesh is vital. Below are four examples to explain bevels and cutting off shading, which will help with the task ahead.

Figure 6.2

To illustrate this in a bit more detail, the examples show a simple 90-degree corner. Example 1 is the control mesh from which the other three examples are created. Each of the examples shows a different way of controlling shading around the corner. The outcome we are looking for is a nice bevel that flows around the corner, but doesn't shade along the entire top and side polygons.

1. Regular corner – Original mesh without shading control.
2. Normal bevelled edge – Simple bevelled edge that is commonly used.
3. Proper bevelled edge – Properly created bevel with controlled shading.
4. Fake bevel – Faked bevel using two control edges to cut off the shading and create the sensation of a real bevel.

Example 1 is the original corner without any shading control. This means that the normals will average between the entire two polygons, presenting with undesirable shading. This is generally what you will start with on a mesh before you decide to either bevel the area or use a hard edge.

Example 2 is a regular bevel that is an option in every 3D program. Regular bevels are where some in-game vehicle artists make mistakes. As you can see, even though a bevel has been created, the shading behaves almost exactly the same as in example 1. This is because the normals are still averaged in relatively the same way. Note: This only applies if a decent number of subdivisions cannot be used in the bevel, which is the case with most in-game polygon limits. Regular bevels will work great if the poly count allows for many subdivisions in the bevel or the mesh is being created in low detail to be subdivided later.

Example 3 is the same bevel as the second example, but with control edges to cut off the shading after the corner. As you can see, the two control edges do not add any extra shape to the corner but are there simply to cut off the shading. Now that the edges have control of the shading, the bevel flows around the corner, but the shading does not leak all the way onto the top and side polygons. This is the preferred method if the polygon limit allows.

Example 4 is what is called a fake bevel. A fake bevel starts off being the same as example 1 before having a control edge cut either side of the corner. This means that the normals will smooth around the corner, but cut off the shading before it leaks onto the rest of the top and side polygons. The big advantage a fake bevel offers is that it gives almost the same visual result as a real bevel but at a lower cost to the polygon count.

As you can see from the four examples, control edges are needed in low polygon situations to display the bevel correctly and cut off the shading from leaking onto the adjacent polygons. Controlling the shading in this manner is also useful on any area of the car where a curved mesh leads to a near flat surface. Just make sure to adjust the distance of your control edges based on how sharp the shading cut off needs to be.

Having perfect shading is particularly important when the mesh receives reflection and catches specular highlights. Intense highlights and reflection can magnify any mesh issues or bad shading, so it's best to create a great shading model and avoid the problem all together. This will often be the difference between a good model and a great one.

Throughout the tutorial I will show you where and how to use the fake bevels and control edges in order to create a mesh of the highest quality. Take note of this, as it will be very useful knowledge when creating any 3D asset.

Listening to others

This may seem a bit out of place under modeling tips, but it is very important.

Listening is a skill, but a skill that is often forgotten when there is a problem that you can't immediately solve. When constantly working on one project, sometimes you can be blind to the most obvious problems. It can be something as simple as not being able to make an object shade the way you want, a shader system that you don't understand, or the shape of the car you have made isn't quite right, but you can't figure out why.

No matter what the problem is, bouncing ideas off others can often lead to a quicker solution.

Always be open to seeking advice or different ideas from colleagues and others in your field, even if the person is less experienced than you. Don't be afraid to ask questions and take in every suggestion anyone offers you. While this does not always provide the solution, it does offer fresh thinking about the problem, which can lead to you discovering a solution.

This may seem obvious, but it is easy to forget.

Softimage tools/functions

Before we start the concept, it's good to know some of the tools we will be using to make the model and how to access them. In this section I'll offer a brief description of the tools' functions before offering a more in-depth explanation of how and where to use the tool in the section titled *Creation of a Wheel*. By the time you complete the wheel tutorial, you will be proficient enough in Softimage XSI to choose your own methods to tackle the tasks presented in the body creation. If you're familiar with Softimage XSI, you can skip to the next section and refer back when needed.

Widescreen monitor

In Softimage XSI, the camera view is set to a 4/3 ratio as standard. If a widescreen monitor is being used, this will take a lot of the viewing area.

To display the camera view in widescreen, select the camera icon from the top bar in the camera viewport and select properties (Figure 6.3). When the properties open, the Format is set to NTSC D1 4/3 720 × 486. Change this to HDTV 1080 16/9 1920 × 1080 for a full-screen camera (Figure 6.4).

Headlight

Headlight is a very useful viewport option that lights the scene evenly, creating the ideal viewport setup to work with. The big advantage is that it removes the need to adjust lighting to suit the area being worked on.

Figure 6.3

It's important to remember that when using Headlight, specular highlights will not show. Make sure to turn Headlight off from time to time to check the shading of your mesh against specular highlights.

To access: Turn Headlight on and off by selecting the viewport mode drop down list and selecting Headlight.

Figure 6.4

Figure 6.5

Explorer

The Explorer displays your scene in a hierarchical structure. This will allow access to all objects and properties as a list of nodes. This is where you can keep track of everything in your scene, name objects, and so on.

To access: Press the 8 key to open the Explorer window.

Figure 6.6

Geometry approximation

Geometry approximation specifies how the mesh should be displayed in the scene and at render time. You can control the smoothness of the mesh by setting the angles that differentiate between smooth shading and a hard edge.

To access: Open the Explorer window and expand the parameters of a mesh by clicking the + in front of the object name and double-click Geometry Approximation from the list.

Freezing the operator stack

Freezing the operator stack removes the current history of the object. As a result, the object will use less memory and allow the object to update faster. It's important to freeze the mesh regularly to avoid new tasks taking too long. While simply working on a mesh, changing values in the stack is not as necessary as with other tasks, so you can choose between manually freezing the stack and having Softimage automatically freeze the stack after every operation.

To access: To manually freeze the stack, select Freeze from the edit menu on the right-hand side. For immediate freezing, select Immed from the same area.

Figure 6.7

Figure 6.8

Freeze transformation

Freezing the transformations of an object resets its center to (0, 0, 0) in the scene without moving the actual object. In most games, transformation needs to be set to (0, 0, 0) before being exported to the game engine.

This should always be done once an object has been completed unless otherwise stated by a design document.

To access: Select the Transform tab from the right side menu and click on Freeze All Transformations.

Figure 6.9

Full-screen viewport

Changing from quad view to full screen is useful when you only need to focus on one viewport.

To access: Click the smaller to bigger screen icon in the top right corner of the appropriate viewport.

Display polygon count

It's a good idea to keep track of your polygon count at all times during the modeling process. There are two different ways to view your poly count.

To access:

1. Press Shift + Enter to open up the Info Selection screen. This will display a dialogue containing all of the information about the selected mesh (Figure 6.10).
2. Click the eye icon from the top of the appropriate viewport and select Visibility Options from the drop-down list (Figure 6.11). When the Camera Visibility box opens, select Stats from the tabs at the top. From the stats screen, select Show Selection Info (Figure 6.12). This will display the selected mesh info in the top left of the viewport.

Figure 6.10

Figure 6.11

159

Figure 6.12

Important shortcut keys

This table shows a few basic shortcut keys to help you get around in Softimage XSI.

Navigation	S + Mouse buttons/scroll (zoom/pan/rotate)
Edge Select Tool	E
Point Select Tool	T
Polygon Select Tool	Y
Raycast Edge Select Tool	I
Raycast Polygon Select Tool	U
Object Select Tool	Space
Grow Selection	Shift + N
Hide/Unhide Selection	H
Scaling Tool	X
Rotate Tool	C
Translate Tool	T
Move Point Tool	M (Also opens Tweak Component Tool menu)
Add Polygon Tool	N
Duplicate/Extrude	Ctrl + D
Frame Selection	F
Frame All	A
Reset Camera	R
Show/Hide Grid	G

Raycast selection tool

The Raycast Selection tool sends rays from under the mouse pointer into the scene. Any element that is hit by the rays will be selected. This is the best selection tool to select polygons with. I don't know what I would do without it!

To access:

Raycast Polygon Select tool – U.

Raycast Edge Select tool – I.

Select polygon island

Selecting a Polygon Island allows you to select an entire element of polygons that are connected. This can be used to select and hide whole segments of the mesh or CAD to allow you to work on smaller sections with ease.

To access: While in polygon select mode, select the drop-down list next to Polygon in the Select section on the right-hand side of the user interface. When the drop-down list appears, select Polygon Island. With this selected, enter the Raycast Polygon Select tool by pressing U. Now every raycast polygon selection will select the entire attached segment.

Figure 6.13

Sticky/supra mode

There are two ways to activate a tool in Softimage XSI, Sticky and Supra. This gives you the ability to have one tool activated (Sticky) while temporarily changing to another tool as long as you hold down the shortcut key (Supra).

To activate Sticky mode, press and release the shortcut key to keep the tool active.

To activate Supra (temporary) mode, hold down the shortcut key for the tool as long as you need to use it. Once the shortcut key is released, the last Sticky mode command is reactivated.

COG tool

The COG (Center of Geometry) tool should always be selected when you're modeling. It will set the pivot point of the transform gizmo at the center of what you have selected.

Figure 6.14

To access: Select COG from the transform menu on the right-hand side of the U.I.

Figure 6.15

Filter points

Filter Points welds vertices together on polygon meshes that are within a specified distance from one another.

To access: Select the vertices you wish to weld and open the Poly. Mesh drop-down tab on the right side of the menu under the Modify panel. Select Filter Points from the list that appears.

Extrude/duplicate edges or faces

To access: Select the polygons or edges that need to be extruded and press Ctrl + D and drag new polygon or edge the desired location.

Tweak component tool

The Tweak Component tool allows you to move, rotate, and scale points, polygons, and edges as well as offering a faster approach to welding a point to a target vertex. Throughout the tutorial we'll use it in two ways:

1. To transform a point by dragging it along one of the connecting edges. This allows you to neaten up points without affecting the shading.
2. To weld one vertex to another. This is quicker than doing it manually with the Filter Points tool.

To access: Enable the Tweak Component tool by pressing M on the keyboard. Take notice that a menu appears just above the timeline in the center of the screen.

Figure 6.16

Sliding points along edges: In order to set the axis of the manipulator along a chosen edge, middle click the edge with your mouse and then slide the vertex along that axis with the manipulator.

Welding points: With Tweak Component tool enabled, select the Weld Points button from the menu in the center of the screen, above the timeline (Figure 6.16). Now hold Alt and drag the point to be welded to the target point.

Snap

Target snapping allows you to snap a selection (points, polygons, edges, objects) to defined target types. For this task, snapping will be most useful for connecting extruded edge loops to already created polygons.

To access: Select the appropriate mode from the snap panel on the right-hand side of the U.I. (Figure 6.17). The most commonly used will be Snap to Points. Once you have chosen your mode, hold Alt and left-click to drag the pivot to the appropriate area. With the pivot point set, hold Ctrl and left-click down and drag the pivot to the desired area.

Figure 6.17

Clone

Creating a clone of an object allows you to keep a link between the original mesh and its clone. Any changes you make to the geometry on the original will be reflected on the clone. Clones are useful for many reasons that will benefit us throughout the creation of this concept, including creating rims (explained in the *Creation of a Wheel* section) and viewing the clone in a subdivided state while working on the original low polygon mesh.

To access: Select the mesh you want to clone. While holding the mouse pointer over the mesh, hold Alt and right-click. Select Clone from the menu that appears (Figure 6.18).

Figure 6.18

Mesh menu

Many of the tools that will be used to manipulate the mesh are located in what I will call the Mesh menu from here on. This is the most important and most used section of Softimage XSI when creating a model.

The tools included in the Mesh menu will change depending on the selection mode that is currently enabled. The two most commonly used will be in Edge Select mode and Polygon Select mode (Figure 6.19 and Figure 6.20, respectively). Explained below are the tools we will use from each of the menus throughout the vehicle creation process. These will be explained in greater detail in the "Creation of a Wheel" section.

To access: In either Edge Select mode or Polygon Select mode (depending on the tool to be used), move your mouse cursor over the selected mesh and hold the Alt button while right-clicking with your mouse.

Figure 6.19

Mesh menu—edge select mode

1. Select Edge Loop (no corners). This tool will select the entire line of connected edges when one of the edges along that line is selected. This is a huge time saver when trying to select rows of edges.

2. Select Edge Loop (around corners). This tool provides almost the same function as the one above. The only difference is that, if the edge runs to the boundary of an object, this mode will continue to select around the edges.

3. Select Parallel Edge Loop. This tool selects an edge loop along all the parallel polygons. This can be useful for selecting all the sides of a cylinder, for example.

4. Bevel Components. This tool is used to do exactly what the name suggests. This will create a bevel on the selected edge, providing options for how wide and how round the bevel should be.

5. Collapse Components. When collapsing polygons, edges, and vertices, the selected components are removed and remaining components are reconnected. Collapsing components will be used to cap off open areas with the least effort possible.

6. Disconnect Components. This is the opposite of welding. The selected edges will be disconnected from their neighbors and a new boundary will be created. This can also be used to create the same effect for hard edging when transferring a mesh to another program.

7. Subdivide Edges (evenly). You can subdivide edges with even spacing using this command. This will allow you to input the number of subdivisions to place along the selected edges.

8. Split Edges (with split control). This tool somewhat performs the same task as Subdivide Edges. However, Split Edges creates only one division between the edges, but allows the position of the edge to be controlled via a slider.

9. Mark Hard Edge/Vertex. This tool creates a crease in the corresponding surface. Hard edges can be used to create sharp edges on low polygon models, but are also useful in controlling the shape of a mesh being made with the subdivision method, as we will be using it to create the concepts body.

Mesh menu—polygon select mode

10. Slice Polygons Tool (Knife). This tool allows you to cut through all of the selected polygons in any direction.
11. Bevel Components. This will create a bevel on the selected polygons. Unlike bevelling an edge, this will affect the entire area around the selection.
12. Disconnect Components. This tool on a polygon level works just like on an edge level, except that an island of polygons will essentially be created.
13. Extract Polygons (Keep/Delete). This tool takes the selected polygons and creates a new object. Extract Polygons (Keep) will create the new object with the selected polygons intact while Extract Polygons (Delete) will create the new object and remove the selected polygons from the original object.

Preparing the reference scene

The reference for this concept vehicle was delivered in IGES format, which is predominantly used in CAD programs. For our purposes, it's best to be able to convert the CAD data into a mesh.

At first I tried to do this using XSI in order to supply the entire tutorial in one program. Unfortunately, Softimage XSI had some issues when importing the IGES data from the supplied files, so Maya will be used as a workaround to convert the data to mesh and export to XSI.

For those who don't have Maya, the CAD files are supplied as mesh in .obj format in the CAD folder that accompanies this chapter.

Figure 6.20

Now let's get this CAD into XSI!

Open Maya and, before we can import the file, we need to turn on the IGES import plug-in. To enable the plug-in, select Window from the top menu, Settings/Preferences, and open the Plug-in Manager. With the dialogue open, tick the boxes loaded and auto load next to iges.mll.

Now to import the CAD data. Select File from the top menu and choose Import from the drop-down list. When the import options pop up, select import and locate and double-click on the IGES file.

Now that the car is in the scene, we need to convert it from NURBS to mesh. Select all the components of the vehicle and from the top menu select Modify, Convert, and NURBS to Polygons.

With the CAD reference now in mesh form, we need to export it to XSI. Select File from the top menu and select the little box next to Export Selection (Figure 6.22). In the dialogue that pops up, change the file type to OJBExport and click Export Selection. Save the .obj file somewhere easy to locate and save the Maya scene just in case you need to come back to it.

3D Automotive Modeling

Figure 6.21

Figure 6.22

Hop over to Softimage XSI and when the program opens up, select File, Import, and Obj File. When the dialogue opens, all of the standard options are fine, so select OK and locate and import the file.

When the CAD imports, you'll notice that the vehicle is not the right way up. Select all parts of the vehicle mesh and rotate them 270 degrees on the X axis.

Figure 6.23

Now that we have everything we need in Softimage XSI, we need to make it easy to work with! Notice that currently the mesh is made up of hundreds of separate meshes. We're going to condense this to just a few. To start with, select all of the components of the front wheel by holding Ctrl and clicking the separate meshes. Now bring up the Mesh menu and select Merge. Make sure to turn the tolerance to 0 and click Delete under Input.

Note: I'll explain these options more thoroughly as we need them throughout the tutorial.

Figure 6.24

When the mesh is merged, open up explorer and name the new mesh accordingly. Now the front wheel should be one object that is easy to hide and unhide. Continue on and do the same for the body, rear wheel, and engine details.

Voilà, you now have a CAD that's ready to work from in XSI.

Learning the Basics of Softimage XSI—Creation of a Wheel

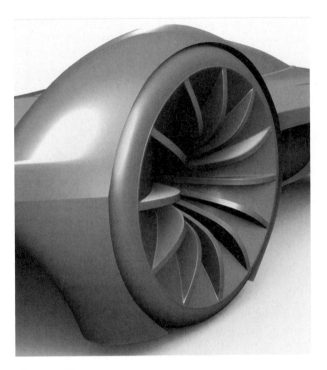

Figure 6.25

Front wheel—4,500 polygons

For a rim and tire with a polygon count around the 4,500 range, 50–60 sides should be enough. This offers a good compromise between roundness and the ability to add details and bevels. It is important to make sure that the cylinders' divisions can be equally divided by the number of spokes on the rim. The reason for this is that we only want to make as much of the rim as we absolutely have to. In this case, there are 12 spokes on the front wheel, so I will use 60 sides, which leaves us with 5 divisions from the center of one spoke, to the center of the next.

Often the easiest way to start making a wheel is to create a cylinder the size of the front face of the rim (as shown in Figure 6.26). On the left side of the U.I. select Get > Primitive > Cylinder and rotate it to face the correct direction with the transform panel on the right side of the U.I. Make sure to delete everything except the front face of the cylinder, as we will create the rest later on.

Figure 6.26

From this point, select all the edges that meet the center vertex on the rim face, and use Subdivide edges (evenly) from the Mesh menu. This will create all the divisions needed to create the face of the rim. Enter enough subdivisions to follow the shape of the rim face, ignoring the spokes. Eight should be enough for this area.

Align the inside set of edges with the center hole of the rim and select and delete the center vertex. The center is not closed off on the concept and therefore not needed. Select the remainder of the edges and scale and move them following the front face of the rim, using more edges in the middle area that turns sharply toward the inside of the rim. Also make sure to line up one division where the spokes start nearest the edge of the rim as we will use this to create the spokes later on (Figure 6.27).

Once the rim face is done, we need to make the tire. The best way to start the tire is to create both extremes before adding the roundness between. First, extrude (select Edge Loop and press Ctrl + D) the outer edge of the rim and place it at the center, highest point of the tire (Figure 6.28).

Now use the Subdivide Edges (evenly) function from the Mesh menu just like we did earlier to add enough edge loops to construct the tire's shape. Following the CAD, move and scale the edge loops into place (Figure 6.29).

Figure 6.27

Figure 6.28

Figure 6.29

Now that we have the base for our rim and tire, we need to show that they are separated by using a hard edge. To do this, select the edge where the tire meets rim and use the Mark Hard Edge/vertex tool from the Mesh menu. I will refer to this as *hard edging* from here on. As you can see in (Figure 6.30) the diagram represents the function being used on the left, and the result it has on the shaded version to the right.

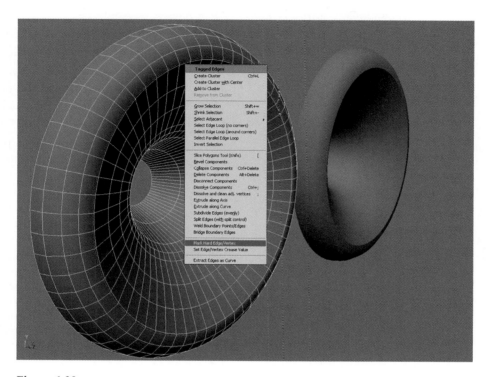

Figure 6.30

When you're happy with the shape of the tire, the rear half will need to be created. We will do this by essentially creating a clone and merging them together once in place.

Select all the polygons of the tire and use Extract Polygons (keep) from the Mesh menu. This will leave the original mesh intact while giving you a copy of the tire polygons as a new object. The new object will need to be mirrored to complete the rear half of the tire.

To determine what axis you will need to mirror the tire on, select the object and view which axis of the transform gizmo points toward the face of the rim. Now locate the scale section on the transform panel (Figure 6.31) and change the appropriate axis from 1 to −1. As you can see, this mirrors the object to the exact same distance from 0 transform (center of the scene) (Figure 6.32).

Now that we have both halves of our tire, we need to put them together. First, make sure that Snap To Points is selected on the Snap panel on the right side of the U.I. (Figure 6.33). Note that holding and letting go of Ctrl turns the snap function on and off.

Figure 6.31 **Figure 6.32**

Now select the mirrored tire and press V to enter transform mode. Hold Alt and Ctrl (Alt to move the pivot point, and Ctrl to snap it to a point) and move the pivot to one of the points along the center of the tire. While still holding Ctrl, drag the pivot point to the corresponding edge on the original mesh.

To join the two halves of the tire, select both meshes and select Merge from the Mesh menu. This will bring up a dialog with the merging options (Figure 6.34). As you can see, the panel is full of options. We don't need many of the options for our current purposes, but I'll explain the ones we may use later on.

Inputs: Hide/Unhide and Delete—These options control the outcome of the two (or more) original meshes that were selected to make the merged object. Hide/Unhide simply hides and unhides the input

Figure 6.33

Figure 6.34

meshes as its name suggests. Delete only leaves your newly created merged meshes and deletes input meshes.

Tolerance controls the parameter for determining the maximum distance that vertices will weld together.

Merge Materials, UVs, Vertex Colors, Weight Maps: This is a must click whenever you're past the initial modeling stages. This will copy over all of your assigned materials, UV coordinates, Vertex colors, and Weight maps from the original input meshes.

If you do not click this, all of that information will be lost.

For our current purposes the tolerance can be left as is, as it has already welded the vertices we need in the center of the tire. Also, we don't need the input meshes, so you can hit Delete under Inputs.

In order to create the spokes from the rim base, we need to create our working area. Start by raycast selecting all the polygons located between the center of the first spoke and the center of the second spoke. Right-click the selected polygons and use the Extract Polygons (keep) function.

Now, select and hide the old, full rim mesh and you should be left with 1/12 of the rim. We won't necessarily need the old mesh again, but it's good to keep it as a backup until the rim is finished (Figure 6.35).

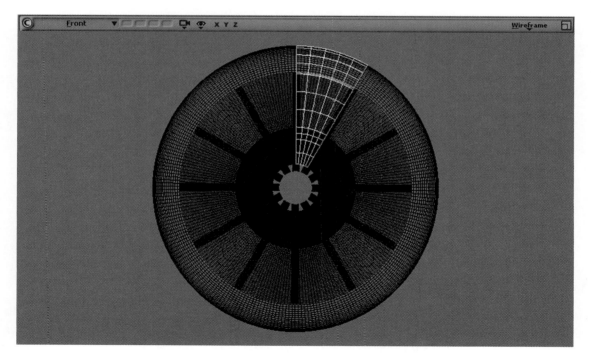

Figure 6.35

Only half of the current mesh is needed, so we can take this one step further and create a loop right down the center of the mesh and then delete one half. Use Select Parallel Edge Loop to pick the appropriate edges and Subdivide Edges (evenly) to create the new edge loop. Once the loop is created, delete the half that is not needed, leaving you with 1/24 of the original base (Figure 6.36, shown in steps from top to bottom).

Finally, we will use Clone to see the entire wheel taking shape while we model the one section.

To do this, select the mesh and select Clone from the mesh menu. Now duplicate the clone (Ctrl + D) and mirror it by scaling to − 1 in the appropriate axis. Once you've mirrored the duplicated clone, snap it into place on the original (Figure 6.37).

Figure 6.36 **Figure 6.37**

At this point, we have 1/12 of the rim again (with both clones selected). Now it can be duplicated and rotated into place. Before duplicating, make sure that both clones have their transformations frozen; otherwise all the pieces will take their own transforms into account when being duplicated. Quick math suggests that 360 degrees divided by 12 pieces is 30 degrees per piece.

Now select Edit from the top menu and go into Duplicate/Instantiate and choose Duplicate Multiple. In the Duplicate Multiple box that pops up, select the Transform tab under Duplicate Options and set your number of copies to 11 (as you already have your twelfth, the original clones), and your angle of rotation (30 degrees) in the appropriate axis (Figure 6.38).

Figure 6.38

This makes a very nice looking arrangement, but not exactly what we were after (Figure 6.39). Quickly grab all of the pieces and snap them in place. The initial clone is not needed as the original mesh (from which all the clones were created) will be our working area, so delete the clone to have your completed rim base (Figure 6.40). At last we can move onto the spokes on our way to completing the wheel!

Figure 6.39

Figure 6.40

First of all we need to create an edge loop where the spokes start. Select your original mesh (working area), enter Polygon Raycast Selection mode, and select the polygons where the spokes will intersect the rim base. Now use the Slice tool to cut in the edge loop where the spoke will meet the rest of the rim (Figure 6.41).

Figure 6.41

Figure 6.42

As you can see, near the inside of the rim we've got a few messy intersecting edges created from using slice to add the edge loop. You can tidy up these points by welding them to the closest vertex along the edge we just created. The best way to accomplish this is using the Tweak Component tool. Activate the Tweak Component tool by pressing m and select the weld points button from the options that appear in the middle of the screen, just above the timeline (Figure 6.42). To weld, hold Alt and drag the vertex that you want to be welded to the target vertex and it will merge them automatically.

Once you have tidied the area up, it's time to pull out the spokes. Before we can move the spokes into place, we need to break the connection between the original rim base and the spokes we're creating. Select the edges of the spoke that were just created, bring up the Mesh menu, and select Disconnect components (Figure 6.43).

Figure 6.43

Now that the spokes are free, you can move the spokes into place! Select the horizontal edges of the spokes and pull them out into place on the CAD (Figure 6.44).

Note: Example 1 reflects half of the edges positioned correctly with the next edge selected and ready to move, and two is the completed task. Remember to use divisions closer together on the rounder parts of the spoke.

The area between the spoke face and the rim base now needs to be filled in. To do this, select the Add Polygon tool from the Mesh menu. Now click an edge on the side of the spoke followed by the parallel edge on the rim base to create a polygon. Do this along the entire spoke to fill the gap and you should have what looks like a completed rim (Figure 6.45).

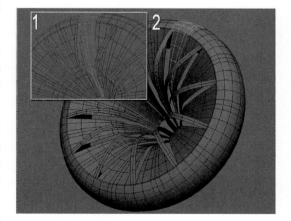

Figure 6.44

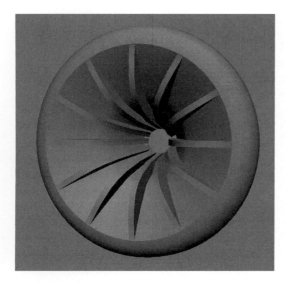

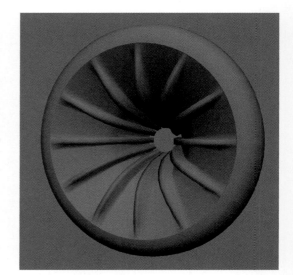

Figure 6.45　　　　　　　　　　　　　　**Figure 6.46**

One thing to note at this point is that while the rim looks correct now, it's possible that the in-game smoothing settings might allow for a greater angle to average the normals, resulting in something that resembles Figure 6.46.

This happens because all 3D applications have smoothing angles set—that is, the angle that one polygon can be from the next to average the normals between them. If the angle from one polygon to the next is greater than the allowed value, it will result in a hard edge. If not, it will average the normals between the polygons and smooth over them.

In most games, this is usually set on a mesh-by-mesh basis in the modeling package. However, it is better to make the mesh foolproof where smoothing is concerned and have absolute control over how the mesh will look in game. If this is done, then smoothing angles can always be set to maximum, and the chances of bad smoothing occurring are erased.

In Softimage XSI, the control for smoothing angles is called Geometry Approximation. You can access this by opening Explorer in XSI, expanding the tree of the mesh and double-clicking Geometry Approximation. When opening, a dialogue box pops up and displays an option asking if you would like to make a local copy of the settings. As we want this to apply to all objects in the scene, click No to make the settings global.

Now you are displayed with the Geometry Approximation settings (Figure 6.47). Under Discontinuity change the angle to 360 degrees. Why 360 degrees? Because we want it to smooth absolutely everything unless we tell it not to. Close the Geometry Approximation and the Explorer and view your mesh.

As you can see, your mesh is now covered in bad shading, as shown earlier in Figure 6.46. This is exactly what we want, as now we can take absolute control over how our mesh will present in-game.

Figure 6.47

In order to get the rim looking correct again, we need to control the smoothing using hard edges. From the mesh menu, use the Select Edge Loop tool on the side of the spoke and the area where the spoke connects to the rim base. Make sure to check that the edge loop has selected all the edges you want. If there is a triangle intersecting one of the selected edge loops, it will stop the selection process there. It is important to check for this every time you use the Select Edge Loop tool, as one missed hard edge can lead to undesirable shading. Finally hard edge the selected edges and you should be left with a properly shaded rim again (Figure 6.48).

Now we're getting somewhere!

As the base of the rim is finished, all that is needed are some details/bevels and creating the rear of the

Figure 6.48

rim, and then we can move on to the rest of the car. Since the back section of the rim is easier to do when we've got all 12 pieces of our rim merged into one object, let's start with the details.

One issue with a lot of concepts is that, in general, the design is all about looks and the manufacturer often doesn't need to incorporate workable solutions into the shape and design. This is why concept cars often show drastic change from the concept cars presented at shows to the production car on showroom floors. One example of this on the concept we are working on is that the edge of the rim flows directly into the tire. To make a more workable and believable solution, we will make a lip on the edge of the rim which the tire sits into just as it would on a real car. It may not seem like much, but it's all the little details that add up to something believable in the end!

Here we will use a fake bevel to achieve what we want. A fake bevel looks essentially like a regular bevel but achieves the same visual result at a lower poly count. The reason for this is that we want to create a lip,

Figure 6.49

but if we don't cut off the shading, it will bleed onto the rest of the rim and create an undesirable look. Let's start by selecting the edge that connects the rim and tire and use Bevel Components from the mesh menu. In the options make sure to set Center to 1 or −1, whichever makes the new edge completely in line with the edge of the rim and the first edge of the tire wall.

Choose a distance that you think is appropriate. In this case I've used 0.55 (Figure 6.49).

The outer edge of the two that were just modified will now be the new edge of the rim. Make sure to hard edge the new rim edge and remove the hard edge from the previous one. To remove the hard edge, select the edge you want to soften and use Mark Hard Edge/Vertex from the mesh menu as you would to create a hard edge. This time untick Hard Edge from the dialogue box that appears (Figure 6.50). Finally, to complete the lip, select the new rim edge (the line you have hard edged) and pull slightly toward the rear of the rim. Clean up any of the vertices you don't need using the Tweak Component tool and the model should closely resemble (Figure 6.51).

Before welding the entire wheel back together, we'll use a few more fake bevels to soften the edges of the spokes to attain a more realistic and solid feel to the wheel.

Select the edges on both the sides of the spoke and where the spoke connects to the main dish of the wheel with the Select Edge Loop tool and use Bevel Components to

Figure 6.50

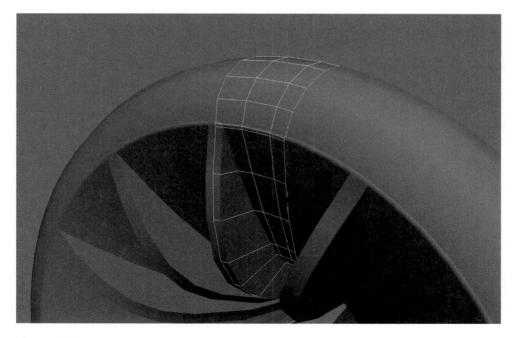

Figure 6.51

create your fake bevels as shown earlier. Make sure to do this twice this time, once to create the outside edges for the fake bevels and again for the inside edges of the bevels (Figure 6.52). Use appropriate distances to achieve the look you are after and make sure to clean up any unwanted vertices along the way.

Finally, remove (soften) all hard edges from the spokes of the rim and you should be left with some sweet-looking fake bevels (Figure 6.53). One big plus to mention about using fake bevels in areas like the spokes is that if you happen to exceed your poly count for a given area, it's very simple to delete them and make them hard edges again, given the fact that we haven't modified the original control edge.

I know it's been an arduous journey, but it's finally time to put the whole wheel together and finish this sucker off! Select all 24 of your rim sections and select Merge from the Mesh menu. This will join all the parts back together (Figure 6.54).

When the Merge Meshes dialogue pops up, it's good to make a habit of pressing Merge under Materials, UVs, VertexColors, Weightmaps. Although we don't have any Materials or UVs in need of transfer on this object, making a habit of pressing it will save you headaches down the line. It's not much fun when you have merged a mesh and continued working, only to find that you've lost all the UVs later on. I have repeated this because it's just that important.

As you remember earlier, we started with 1/12 of the entire rim before cutting that 1/12 in half to create our final working area. Now that we've welded the rim back together, we have no need for the row of edges that we created anymore. Use Select Edge Loop to select the edges and delete them (Figure 6.55. Note: Before and after shots are shown).

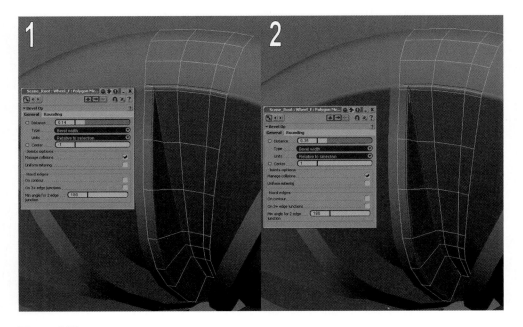

Figure 6.52

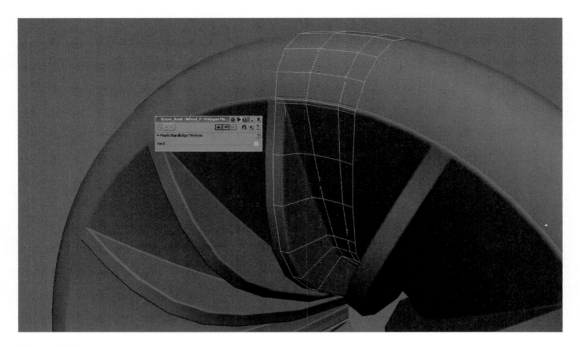

Figure 6.53

All that is now needed to complete the wheel is the rear of the rim. This section will rarely, if ever, be seen, so it can be made in very low detail in comparison to the front to keep the polygon count down. Select the tire edge and make it a hard edge. Once that is done, extrude (Ctrl + D) the edge a few times following the contour of the front side of the rim, placing the last edge just a bit larger and farther back from where the dish ends (Figure 6.56). Make sure to hard the last edge as we will need to control the shading when we cap that area.

To cap it off, select your last row of edges and duplicate them (Ctrl + D), and now select Collapse Components from the Mesh menu.

Make sure to freeze the mesh once done and then open Explorer to name your wheel. Also delete any old pieces of the rim that may have been saved as backups.

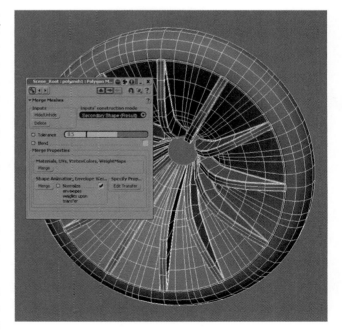

Figure 6.54

Figure 6.55

Figure 6.56

Figure 6.57

Now that the front wheel is complete, the rear wheel can be made using the tire of the front wheel as a base to save you time. The wheel is not nearly as visible as it's covered with a cover on the body of the vehicle and so is simple in comparison, meaning it can be made with a lot less detail.

And there we have it, our completed wheels!

In summary

This tutorial presents the most efficient method for creation of a rim and tire combination. Make sure to take note that, while I've shown you one method of attacking each step, the same results can be produced in many different ways, some of which you will have learned through other steps of the wheel creation. Take notice of these and learn which method works best for certain tasks.

For this wheel, a polygon count of 4,500 was used. This relatively high polygon count allowed full advantage to be taken of fake bevels and extra divisions around the wheel. When starting a wheel, keep in mind the poly count at all times and make sure to adjust the divisions around the wheel accordingly. Fake bevels work great in most low poly situations because they offer the same look as a real bevel (with properly controlled smoothing) at a lower polygon hit. Also if you run over the polygon limit, they can be removed without affecting the original edge, while a bevel is harder to correct where shading is concerned.

Now that we have a rim that's ready to be driven on, we need to create the car to take advantage of it. I've taken you through the rim creation on training wheels, so now it's time for you to handle it all on your own. I will guide you through the technique of creation the rest of the way and leave the method up to you.

Creation of the Body

Now that everyone is up to speed with the Softimage XSI User Interface, it's time to create a body for the concept vehicle.

If I'm worth my salt as a teacher, the *Creation of a Wheel* section should have supplied you with a good understanding of the tools and functions that will be needed during the modeling process of the body. Now it's time to rip off the training wheels and give you the reins. In this section I will present the necessary steps to create the body, but the method in which you tackle the small tasks is up to you.

It's time to get dirty and get this body under way.

The subdivision method

To create the body of the concept vehicle, we will be using a technique that I call "The Subdivision Method." Subdivision is the act of creating a low polygon mesh that will be used to control the creation of a higher polygon mesh. While there are many different techniques to successfully create a car, subdivision is normally the fastest and one of the cleanest ways to work. And as we all know, a boss will never be angry with an employee who finishes ahead of time!

As we are working on an in-game model, we will use subdivision to complete all the major details on a base mesh before cutting in the finer details after the subdivision phase has been completed. The reason for this is

that while using subdivision to create all the details can be ideal, it generally eats up too many polygons for game purposes. It's important to remember that even though the details aren't added originally, they still have to be accounted for when designing the wireframe of the mesh. This means that our aim is to produce a perfect shading base mesh that will allow the details to be added as painlessly as possible later on. Subdivision also makes it easy to have great spacing and flow on the wireframe, which is the basis for good shading.

To accommodate for bevelled edges and hard shut lines on the vehicle, we will create them with hard edges (and/or vertices) during the subdivision stage. This will tell the program to hold the edges in place instead of smoothing them when subdivision is applied. Proper bevels and fake bevels will be added as final touches after the subdivision phase been completed.

Planning—draw a wireframe

Drawing up a plan of attack, while not essential, is always a good idea. From the available reference I always pick different angles of the vehicle, whether it is pictures, blueprints, or screen-grabs of the CAD model, and create a few plan drawings for polygon placement on the body. You won't always follow your drawn wireframe to a tee, but doing this will give you a better understanding of the flow of the body work and the general shape of the vehicle.

Start by identifying the biggest and most detailed feature elements of the car and build the wireframe and polygon flow from them. As we're using the subdivision method to create the concept vehicle, make sure to be aware of the smaller details while you create the polygon layout, but don't let them fully dictate the shape of your mesh. It's most important to have a smooth flowing mesh that incorporates all the large areas seamlessly. Once all the feature elements have been laid out, draw all the connecting lines that will create a smooth flowing wireframe.

As you can see in Figure 6.58, I've chosen to use a top and side view for my plan drawings. It's best to print out the pictures and use a pencil to draw in the lines so that you can modify the polygon placement and erase any mistakes as you go along. Don't be pedantic when it comes to neatness on the wireframe plans, as they only serve as a tool to help you to get to know the car before you begin the modeling process.

Working with the CAD

Unless you have a supercomputer, working with a large CAD model such as the body of the vehicle can be very heavy in the viewport. Make sure to hide any of the CAD components, such as the wheels, when they are not needed. If the viewport is still slow to update when only the body CAD is visible, you can hide areas of the CAD on a polygon level to focus on the area that you're currently working on.

It can be very frustrating to try to create a model when you're constantly waiting on the program, so avoid the problem as much as possible.

Starting the body

Now that we have decided the technique and plan of attack that we'll use to create the body, we can finally start modeling.

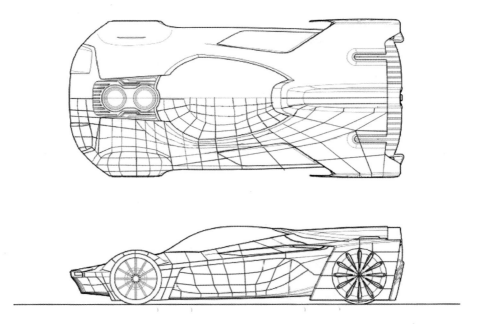

Figure 6.58

We're going to start on the hood of the vehicle and work our way along the body, using the *multiple extrusion method* to create our base to be subdivided. Make sure to use the drawn wireframe as a guideline to help along the way.

The reason for starting on the hood is that, when using blueprints as reference, the hood allows a big area of the car to come to fruition with the least amount of effort. The hood of a car is often a fairly straightforward shape and the extremities are often clearly visible in the three axes of the blueprints. Once the base shape of the hood is laid out, details, loops, and roundness can easily be added to start shaping the car. While this is not as important when using a CAD model as reference, it's a good idea to keep to a routine.

Start by placing a polygon between where the wheel arch starts to curve up and the engine bay. From here extrude the edges one at a time and move the vertices to create the entire area between the wheel arch and the engine bay, making sure to follow the flow of the panel that leads up to the windscreen/windshield area (Figure 6.59). Keeping the polygons evenly spaced is a good idea on rounder areas of the car. This will allow for even shading across the entire round surface.

Feel free to snap the vertices to the CAD, but keep in mind that all of these points will have to be modified later to make the mesh flow correctly over the surface of the CAD during the subdivision step. To check how your mesh is subdividing, you can press + on the num pad (to undo, press −) on your keyboard. Take note that the mesh will smooth between the vertices that you have laid out, and some will need to be moved in order to match the shape of the vehicle correctly while in subdivision mode (Figure 6.60).

Figure 6.59

Figure 6.60

Extrude the edges along the front and side windshield, connecting edges to the main feature points of the car first before adding edge loops to fill in the roundness (Figure 6.61).

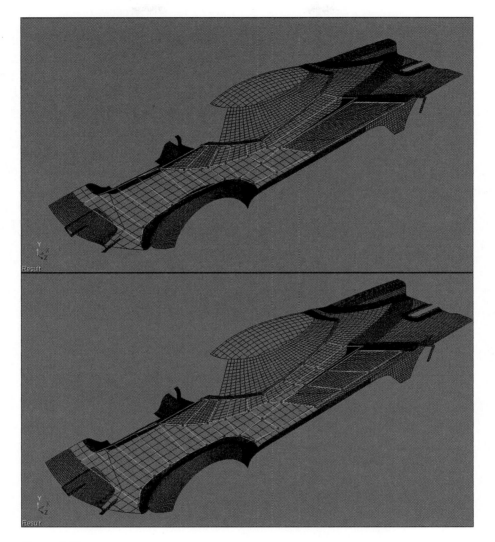

Figure 6.61

Now that you have an understanding of the approach we are taking to create the base mesh, continue extruding the edges around the entire top flat section of the vehicle to create a low poly base to work from (Figure 6.62). Avoid using triangles wherever possible as this will create a cleaner subdivided mesh. If a triangle must be used, the area can be cleaned up after subdivision, but it's best to use as few as possible. Ignore the front air intakes for the moment, as they will be cut in during the detail stage.

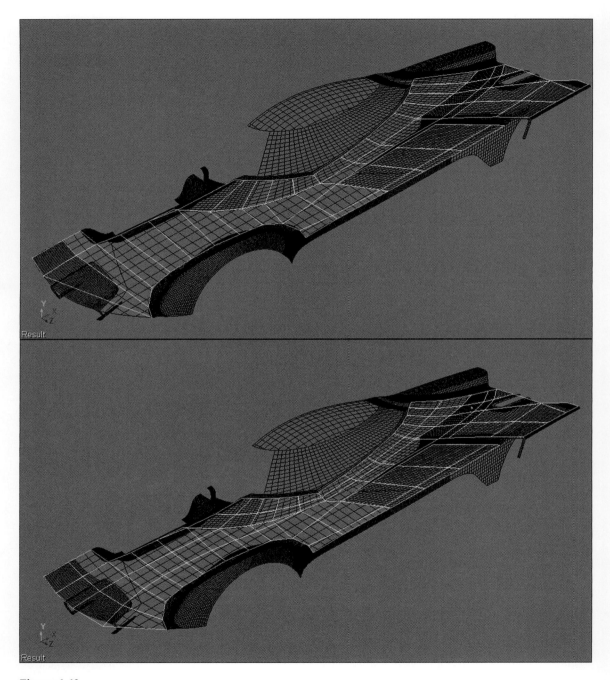

Figure 6.62

Once you've started to get the basic shape of the car, it's a good idea to clone your body mesh and mirror it, so you can see the entire car taking shape as it is being made.

At this stage, we need to define some edges that will stay sharp throughout the subdivision process. Make sure to hard edge the windowsill area, the large vent, and the edge that connects the top and side of the car where any sharp creases should be (Figure 6.63). Then follow the contours of the car to finish off the vent area and extrude the windowsills to meet the window glass (Figure 6.64).

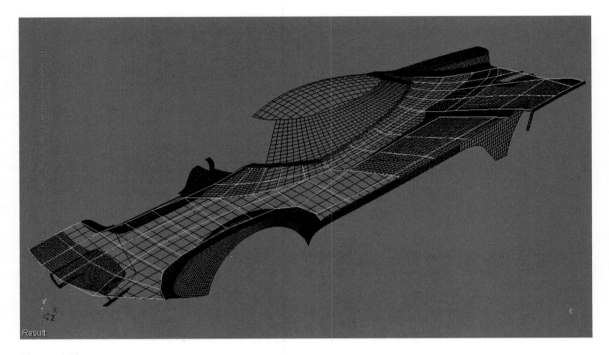

Figure 6.63

As you can see, I've hard edged the inside of the vent (Figure 6.65). While this isn't actually a crease on the vehicle, sometimes it's necessary to do this to get the mesh to smooth the way you want it to. This is going to hold the whole vent area in place during the subdivision process. Although this will create a small crease once subdivided, it's an area that can be easily corrected after the subdivision has been frozen into the mesh.

At this point, it's a good idea to have a look at your vehicle in subdivided mode. Notice that, even though the important shut lines have been hard edged, some of the initial edges (where the hard edge starts) have moved away from their original starting point. Some of these vertices will need to stay in place when the mesh is subdivided to hold the correct shape of the vehicle. Select any vertices that you want to stay in place and mark them as a hard vertex. It's important to keep this in mind at all times throughout creating the subdivision mesh (Figure 6.66).

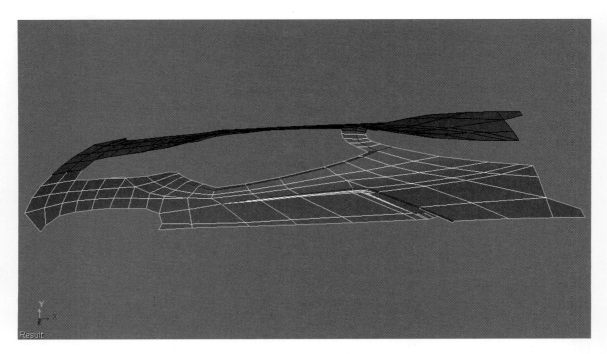

Figure 6.64

Figure 6.65

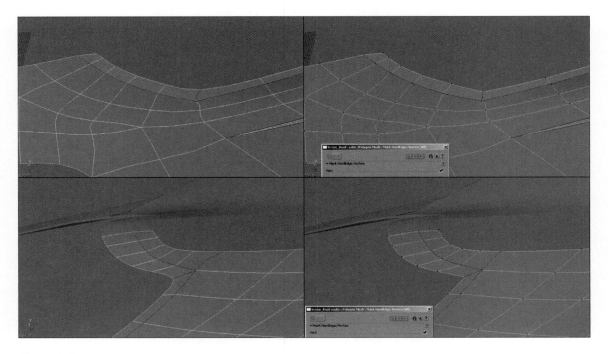

Figure 6.66

Now that the flat area of the vehicle is complete, continue on to creating the wheel arch and the area that houses the jet engine using the same techniques that have been used thus far. Remember to check your mesh in subdivision mode against the CAD along the way and adjust the vertices to suit (Figure 6.67).

Create the windshield and engine bay area and then we can move onto the rest of the car. The engine bay doesn't need a lot of shape or detail as it will covered by the engine, but it's best to use sufficient detail to get the correct shape now and remove what's not needed later (Figure 6.68).

The top of the vehicle should now be ready for subdivision, so we can move onto the side of the vehicle. Before the sides are started, we need to accommodate the rear wheel cover. This area has a lot of a detail and will be easiest to make using the same technique as we used on the front wheel.

We'll set up this area for the roundness of the cover now, but extract it to complete in full detail after the subdivision process. To accomplish this, we need to create a cylinder that has 24 sides and place it in the appropriate position on the mesh. This will result in a 48-side base to work from once Subdivision has been applied. Make sure to follow the panel changing angle near the top of the spokes and don't be afraid to slightly modify the design to allow for easier modeling (Figure 6.69).

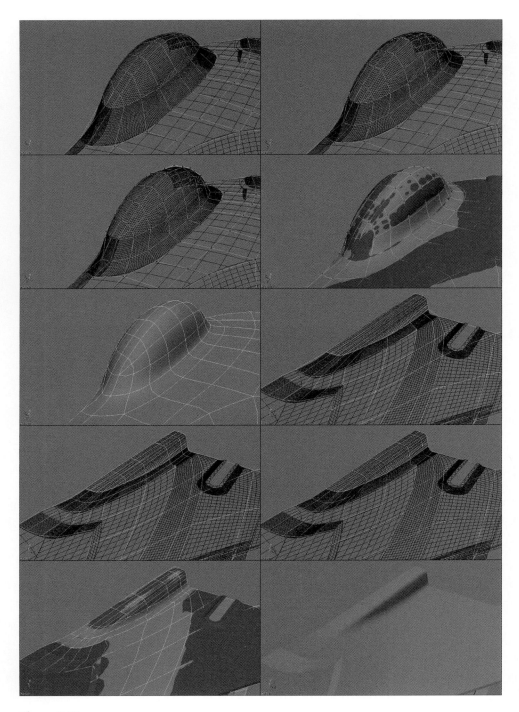

Figure 6.67

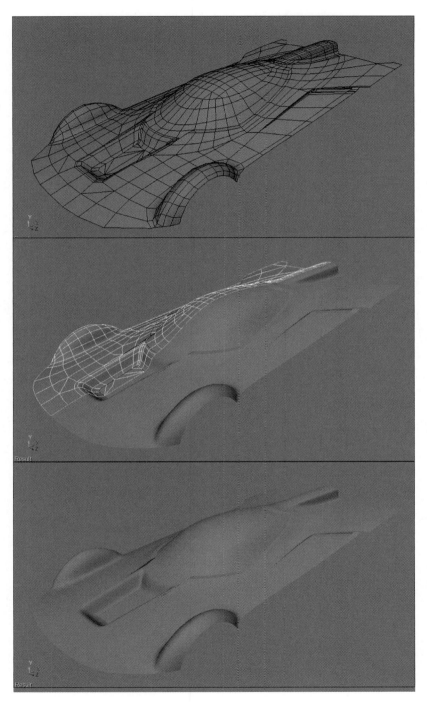

Figure 6.68

Figure 6.69

Edges can now be extruded onto the side of the vehicle to incorporate the cover. The edge between the top and side of the vehicle should be hard edged for now as we'll bevel it after the subdivision stage. For the wheel cover area to subdivide correctly, it's important to keep the entire cylinder intact, even though it dips below where the panel finishes nearest the ground. This can be cut off and closed up after the subdivision stage. Also make sure to hard edge around the cylinder as this will keep it in shape when subdivided. Triangles will need to be used to connect the rear wheel cover area cylinder. This will also be cleaned up after the subdivision process (Figure 6.70).

Figure 6.70

Now that the cover area is completed, the rest of the body is fairly straightforward. Continue creating the entire body in the same low polygon manner that has been used to this point. A series of screenshots will show the steps I've taken to reach the subdivision process.

While modeling the rest of the body, remember to:

• Hide different sections of the CAD along the way using to have a clear view of the area that is being worked on. The Polygon Island Select tool is good for selecting whole panels to hide/unhide.

- Check the mesh in Subdivision mode regularly. Note that some vertices on the center of the vehicle will move out of place when subdivided. Leave those for now as they will behave as normal once the two sides of the vehicle have been merged.
- Concentrate on making the main shape of the car for the subdivision step and ignore details that will be easier to create later on. These include the vents along the bottom of the car and the ball-shaped area that attaches to the panel on the underside of the front wheel arch.

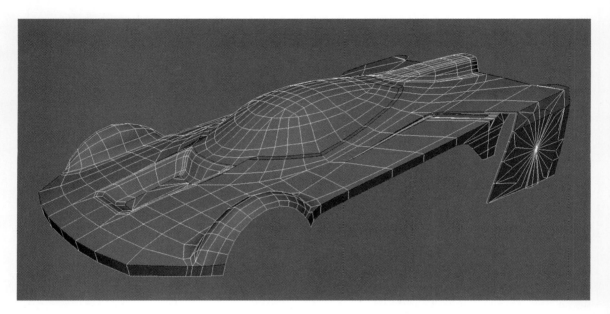

Figure 6.71

When you come to the underside of the vehicle, it won't often be seen and therefore doesn't need great detail. Enough polygons should be used to get the in-and-out shape, but try to use as few loops as possible to achieve this. Due to the shape, this area will likely be too many polygons when subdivided, but loops will be easy to remove.

The rear wheel cover area will need two more cylinders created with the same process that was used on the outside area. These can be made with 12 sides as these areas are not commonly as visible and won't need as much detail modeled in (Figure 6.74).

All open areas of the model will need to be closed off. Back faces aren't visible in-game and you will be able to see straight through the model. This can be done before or after the subdivision step to your discretion. If the area is not often visible, close it off with the least amount of polygons possible, but make sure that it holds up the integrity of the model visually (Figure 6.75).

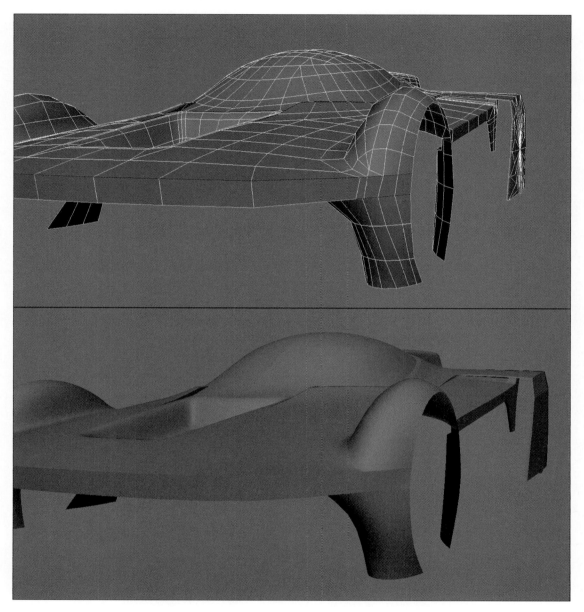

Figure 6.72

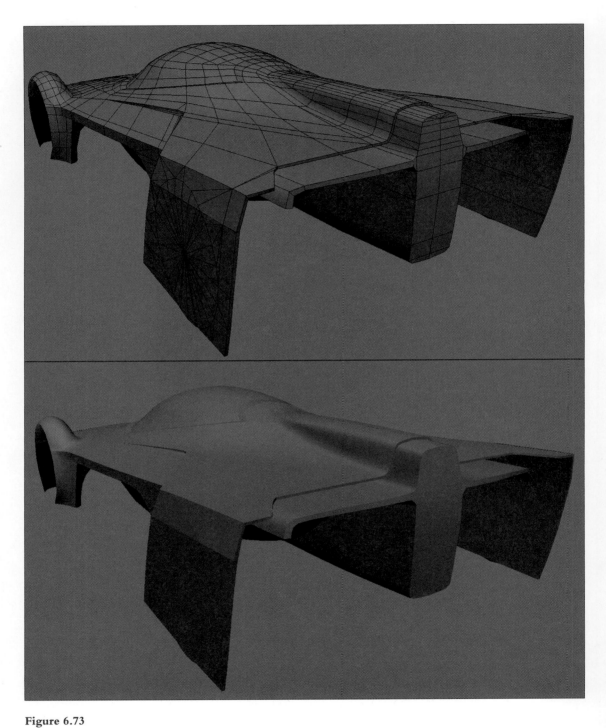

Figure 6.73

Figure 6.74

Figure 6.75

The interior area of the front wheel arch should be modeled to wrap around the tire before the subdivision step. The ball-shaped area that incorporates the deep dish of the rim will need to be modeled when there is more poly to work with after the subdivision step (Figure 6.76).

Once you're done with your low polygon mesh, it should look something like Figure 6.77.

At this stage, make sure your wireframe flows nicely and is as neat and well spaced as possible. This will help create a nice wireframe when the mesh is subdivided and will also be the last chance that you are able to correct any of these mistakes with ease.

Notice that I've changed my design slightly from the drawn wireframe. This was done to meet up with details on the vehicle and get a better flow throughout the model to produce better shading.

Now that our low polygon mesh is done, it's finally time for subdivision!

Select both the original mesh and the clone and merge the objects. It's a good idea at this point to make a copy of the mesh, as we'll need it to see where hard edges are needed after the subdivision process. Hide the copy for now so that it's not in the way.

Once the body is merged together as one whole object, select Poly Mesh under the Create tab on the left side of the user interface and choose Subdivision from the drop-down list. All the standard options in the pop-up are correct for our purposes, so select Delete under Inputs (as we already have a copy of our mesh) and you should be left with the subdivided mesh (Figure 6.78).

Figure 6.76

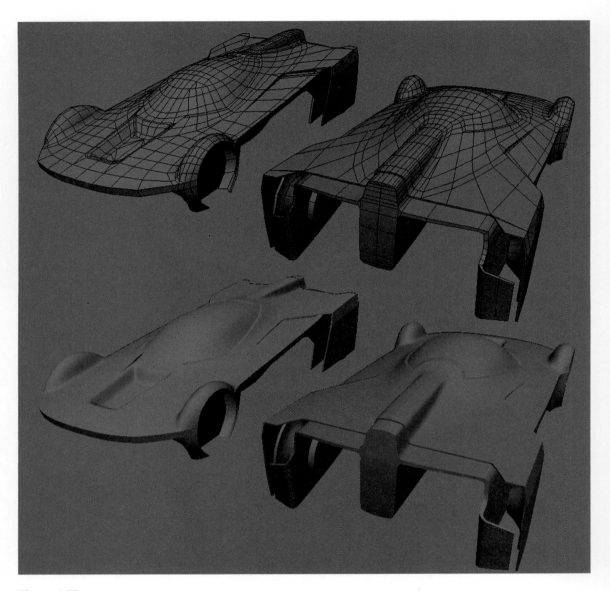

Figure 6.77

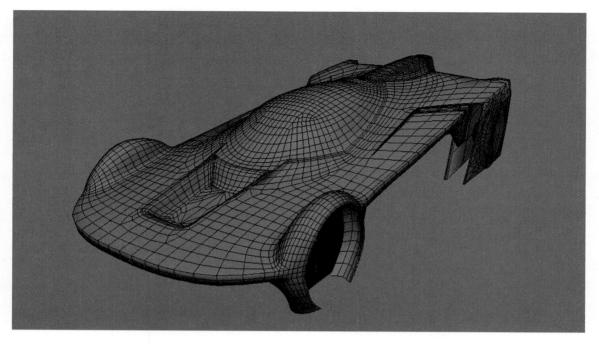

Figure 6.78

As usual, we only need to work on one side of the vehicle, so select one half of the vehicle (making sure to leave the centerline of the car intact) and delete it. Now clone the mesh and mirror it to the other side so that we can see the details taking shape on both sides of the car while working and we can move onto the next step.

Warning: You're about to enter a stage in the modeling process that I call the *controlled mess.*

Notice that while the mesh has a fairly nice poly flow, it's littered with bad shading and all of the hard edges are gone. This is where you will need the low polygon mesh that we hid earlier. Unhide it and use it as a guide to replace all of the hard edges on your subdivided mesh. This doesn't necessarily need to be done on edges that will be fake bevelled later on, but it's easier to work on the mesh while it's shading correctly. Just remember that the Select Edge Loop tool will be your best friend here (Figure 6.79).

Now that the shading is corrected, it's time to clean up the mesh from the subdivision process. Run over the model and tidy up any messy areas and correct the flow of the wireframe where needed. Slice Polygon tool can be useful for cutting straight lines from one vertex to another before deleting the old edges to clean up an area (Figure 6.80). Also look out for and delete any unnecessary edge loops that were created between two parallel hard edges during the subdivision. These will create no extra shape which makes them a waste of polygons. Areas where triangles were used on the low polygon mesh will also need to be tidied up as these produce very messy wireframes. Setting Immed mode will speed up this process immensely (Figure 6.81).

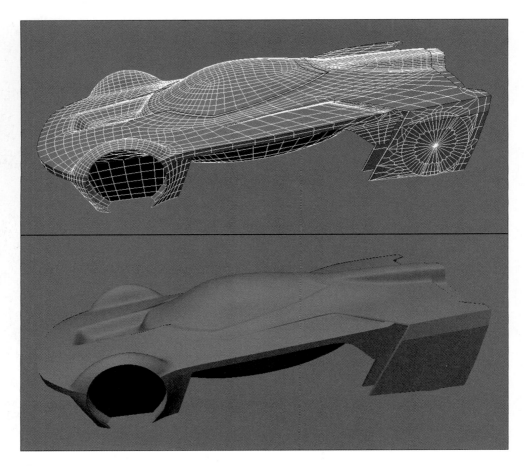

Figure 6.79

Figure 6.80

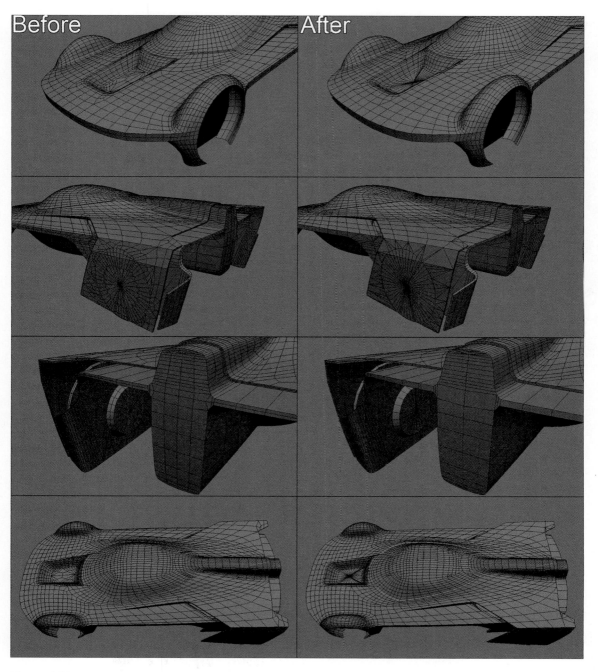

Figure 6.81

Figure 6.82

Congratulations, you've made it past the most tedious, mind-numbing part of the entire process. We can finally get into creating some details!

Select and Extract (keep) the rear rim cover area from both the subdivided mesh and the CAD. With both meshes extracted and selected, rotate them to be square with the scene. Make sure to write down the rotation values for X, Y, and Z as you will need them later on (Figure 6.82). At this point, make another copy of your extracted mesh and hide it for now. We'll use this as a guide to produce the angled part of the panel once the cover has been made.

Create the rim cover area using the same method as we used on the front rim (Figure 6.83). I suggest using the spokes at either three o'clock or nine o'clock as these are complete spokes that aren't affected by the angle change in the panel.

With the rim cover completed, a few modifications need to be made to suit the design. Firstly modify the bottom of the panel and the bottom spoke of the rim to match the shape of the CAD (Figure 6.84).

All that is left before we can merge the cover back into place is to modify the mesh to follow the angle change of the panel. Unhide the copy of the extracted mesh that was saved for reference earlier and use it as a guide to slice an edge through the finished rim cover area. Make sure to clean up any nasty areas that have been left behind and hard edge the new cut (Figure 6.85).

Now comes the hard part! Select all of the polygons above the edge at which the panel changes angle. With the polygons selected add a lattice by selecting Get > Primitive > Lattice from the left side of the user interface. Once the lattice appears, change X, Y, and Z to 1 subdivision and rotate the lattice to follow the line of the angle change (Figure 6.86).

In vertex selection mode, select the top four vertices of the lattice and translate them away from the face of the cover until the angle matches your original extracted mesh (Figure 6.87).

Now that the cover is completely finished, we need to move it back into place. With the cover selected, we need to enter in rotation values to match the rotation of the body. Here is where the twist comes. We want it to rotate in the opposite direction to which we rotated it originally. Take the numbers you jotted down before from the rotations X, Y, and Z and when you enter the numbers back into the rotation panel, each, one that was a minus now needs to be a plus, and each that was a plus needs to be a minus (in my case 0.9508 becomes −0.9508, −0.3425 becomes 0.3425 and −0.0057 becomes 0.0057). Once the cover is properly rotated, unhide the body mesh and use vertex snap to put it in place.

All that is left is to merge the two objects together. The rim cover area has a high degree of modeling difficulty, so if you find your cover not matching up exactly with the rest of the vehicle mesh, try to use a lattice on the cover to match the angle of the panel. This will help you to avoid shading issues as it will move all the vertices in line.

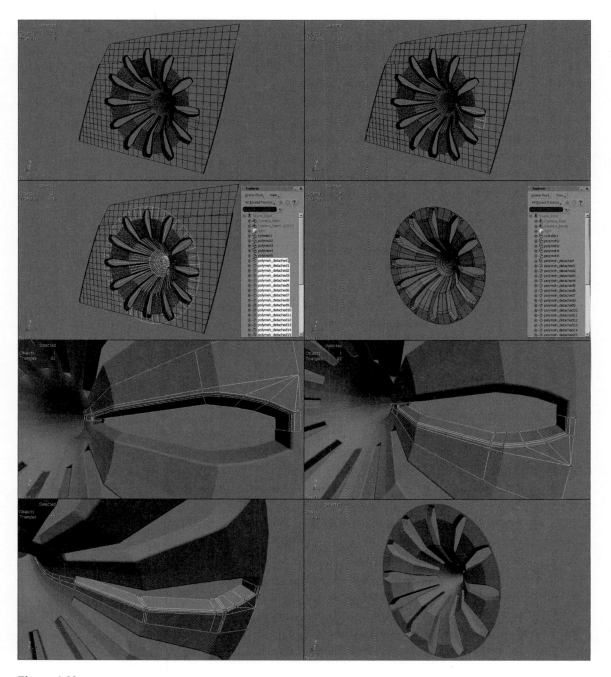

Figure 6.83

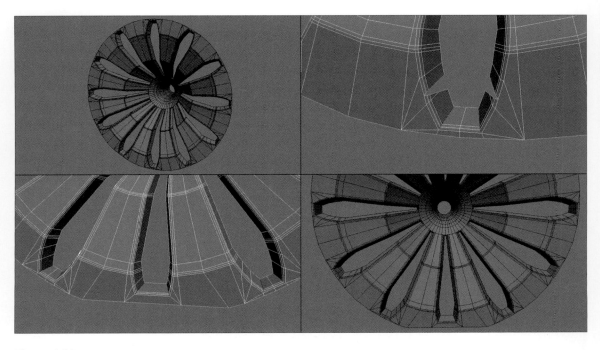

Figure 6.84

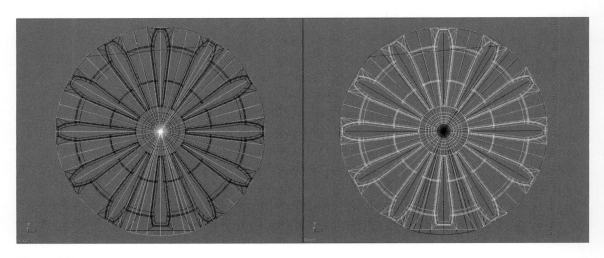

Figure 6.85

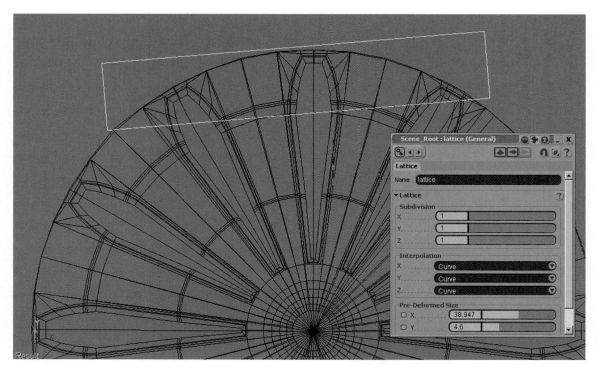

Figure 6.86

Figure 6.87

Once the panel is in place, select the two meshes and merge them. You should now be left with a mesh that resembles Figure 6.88.

With the hardest part complete, we need to move on and create the rest of the main body details. Remember, any time you cut in a new detail, the area will need to be cleaned up and close vertices merged in the interest of providing the best shading. A series of screenshots will display the steps I've taken in the creation of the details to help you along the way.

Figure 6.88

Figure 6.89

Figure 6.90

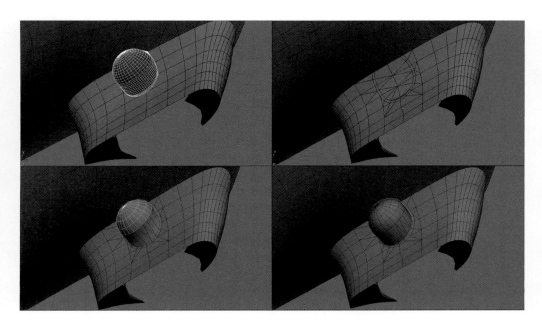

Figure 6.91

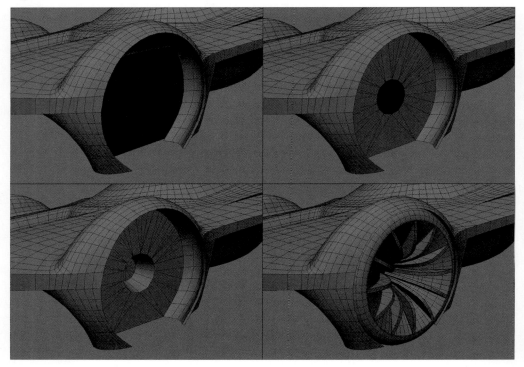

Figure 6.92

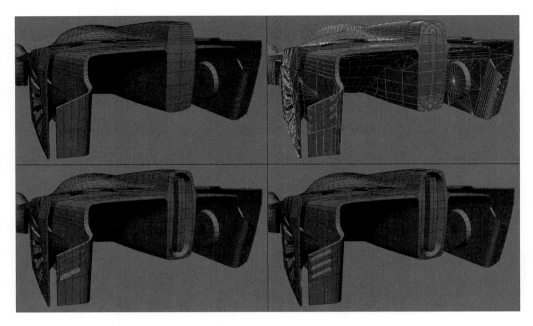

Figure 6.93

After all the main body details have been modeled, all the holes in the body need to be closed. These areas will rarely, if ever, be seen, so use as few polygons as possible to fill the gaps (Figure 6.94).

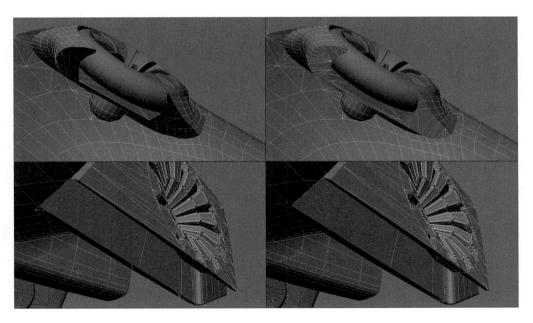

Figure 6.94

3D Automotive Modeling

With a solid model in place, it's time to create all of the details that aren't part of the main body. All of the remaining parts are simple in shape and can easily be modeled using slightly modified primitive objects. Since most of these details simply cut through the car, polygons that aren't visible can be deleted.

Figure 6.95

Figure 6.96

Figure 6.97

With all of the details added, you can push the poly count right up to the limit using fake bevels to offer a better feel of completeness to the model. When creating the fake bevels, make sure to concentrate on the rear first and foremost, as this is the angle that the vehicle will most often be seen from. It's also important to fake bevel any feature shut lines on the vehicle that face toward the sky. Light catches on edges that face upward and nice soft edges (fake bevel) will display nice highlights instead of breaking the illusion by illuminating ugly hard edges. It's not nearly as important for edges that are in shadow or face the ground as these don't catch the light and therefore won't light up the hard edged areas.

Before starting the fake bevels

Depending on the polygon limit for any vehicle, a decision should be made about where polygons should be used to offer the best visual gain. For instance, polygons saved from the general shape of the mesh might be put to better use on details. It's important to strike a nice balance between using enough polygons on the shape and roundness of the vehicle and being able to create high-quality details and bevels. This is up to the artist's discretion and a good artist will always find the right balance!

In the concept's current state, there are a lot of polygons that could be removed without adversely affecting the quality of the shading. However, In this case, the polygon limit is high enough that a nice flowing, evenly spaced wireframe can be produced, while leaving enough polygons to add many high-quality details and fake bevels.

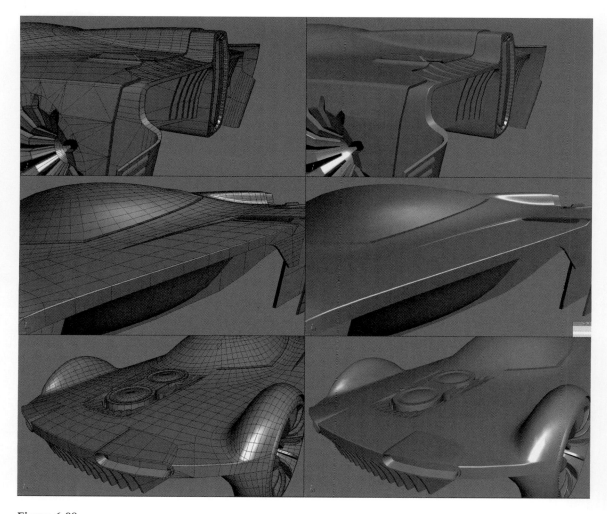

Figure 6.98

Once all the spare polygons are used up and you're happy with your details and fake bevels, merge both sides of the vehicle together. It's best to have separate pieces for the body and different areas of details and name them accordingly.

You should now have a completely finished vehicle mesh ready for in-game use!

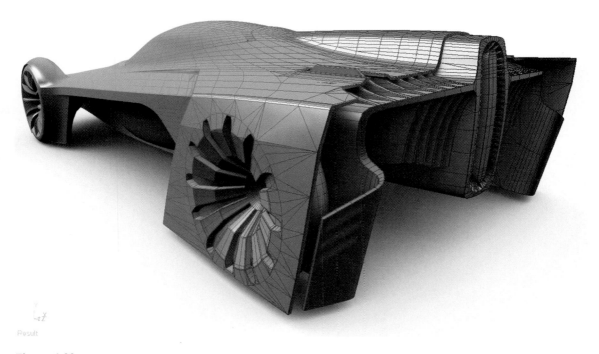

Result

Figure 6.99

Finally we've reached the end! I hope the tutorial was easy to read and understand, and you left having a better knowledge of vehicle modeling than when you started. My belief is that the best way to learn is to be presented with a very detailed technique to complete a task from which you can build your own styles and techniques. While this tutorial shows you one technique for vehicle creation, always keep in mind that practice makes perfect. The best way to improve your skills is to make vehicles of different types, shapes, and sizes and eventually the different techniques that need to be used in the modeling process of any vehicle will become automatic.

Good luck with future automotive modeling endeavors!

Chapter 7

Gallery

Andrew Gahan

In the following pages I'd like to present work from some of my friends. Some will be inspirational and some will be for reference. I'll include their contact details in the text too, so that if you have any questions or comments about the work you'll be able to contact them. They will of course be available for discussion too in the forum at www.3d-for-games.com/forum where they will happily discuss their techniques with you.

Figure 7.1 *Aston Martin DB4 Zagato, Johal Gou, Johal.gou@simbin.com.*

3D Automotive Modeling. DOI: 10.1016/B978-0-240-81428-5.00007-0

Figure 7.2 *Ferrari F430, Matt Battistone, mattbattistone@hotmail.co.uk HDRI and backplate by http://www.hdri-locations.com.*

Figure 7.3 *Lotus Elise S2, Eddy Brown, eddy@eddybrown.co.uk.*

Figure 7.4 *Honda, www.The3dStudio.com.*

Figure 7.5 *Chaos 126 from the game DIPRIP by Exor Studios, www.ExorStudios.com.*

Figure 7.6 *Aston Martin DB4 Zagato, Johal Gow, Johal.gow@simbin.com.*

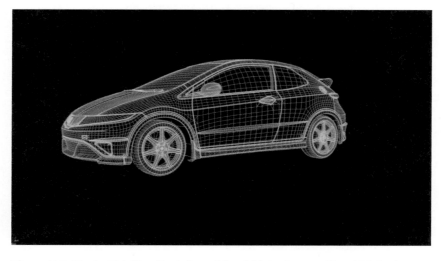

Figure 7.7 *Honda Civic Type R wireframe, Virtual Mechanix, www.Virtual-Mechanix.com.*

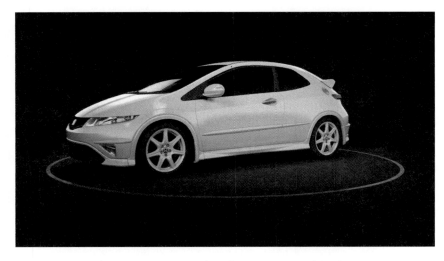

Figure 7.8 *Honda Civic Type R, Virtual Mechanix, www.Virtual-Mechanix.com.*

Figure 7.9 *Super Car, Alexej Peters, Alex.Peters@Rabcat.com.*

Figure 7.10 *Hizashi Team Racer, Tim Brown, tim@timdesign.co.uk.*

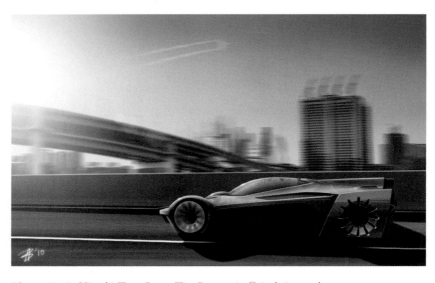

Figure 7.11 *Hizashi Team Racer, Tim Brown, tim@timdesign.co.uk.*

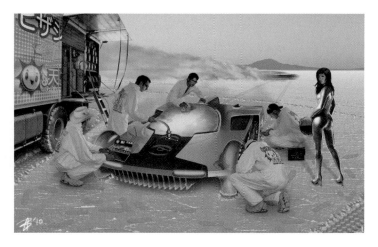

Figure 7.12 *Hizashi Team Racer, Tim Brown, tim@timdesign.co.uk.*

Figure 7.13 *VW concept, Robert Forrest, Robert.Forrest@network.rca.ac.uk.*

Figure 7.14 *Lexus concept, Robert Forrest, Robert.Forrest@network.rca.ac.uk.*

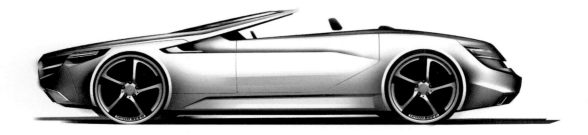

Figure 7.15 *Mercedes SL concept, Robert Forrest, Robert.Forrest@network.rca.ac.uk.*

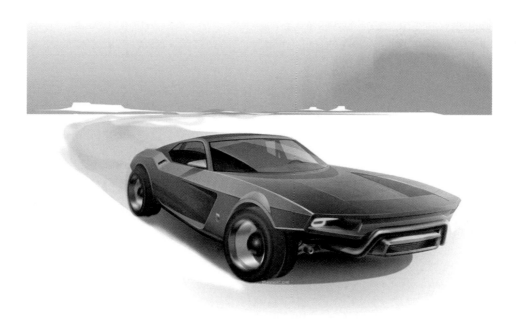

Figure 7.16 *Duster concept, Brook Banham, www.Middlecott.com.*

Figure 7.17 *Mobile Suit concept, Paul Cartwright, www.zero9studio.co.uk.*

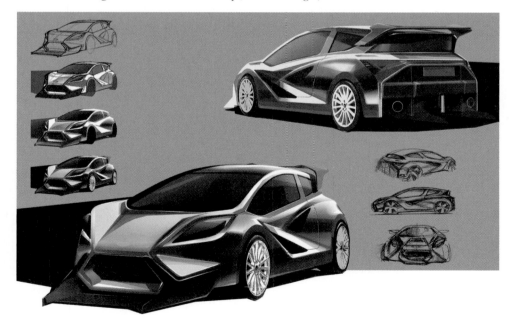

Figure 7.18 *Vortex concept, Robert Forrest, Robert.Forrest@network.rca.ac.uk.*

Figure 7.19 *Dodge Challenger, Johal Gow, Johal.gow@simbin.com.*

Chapter 8

A Photogrammetric Vehicle Pipeline

Words, rendering, and compositing by Tom Painter and
Modeling and texturing by I Putu Gede Aryantha
Big Man 3D

Figure 8.1

3D Automotive Modeling. DOI: 10.1016/B978-0-240-81428-5.00008-2

Introduction

In this chapter I give an overview of the photography-based pipeline we use at Big Man to attain the highest level of realism as fast and painlessly as possible. The inspiration for this chapter stems from the fact that, while there are a multitude of books out there about modeling or texturing, there are few guides to setting up a whole modeling and texturing pipeline.

I would need an entire book to detail every step of building this truck, so I'm not going to be holding your hand every step of the way. I need to warn you that this chapter isn't aimed at beginners. I'm going to assume you are comfortable with modeling and texturing at an intermediate level using Maya and Photoshop and are looking for that killer extra technique to boost the realism of your models.

Pipelines take a long time to evolve, and while aspects of them are carefully planned out, in the end it boils down to a lot of trial and error to get things running smoothly. As this is just a pipeline overview, it is way beyond the scope of this chapter to teach the detailed specifics of each stage. What we are showing you is our process but, ultimately, to some degree you will have to build your own pipeline. If you have any gaps in your knowledge you may need to refer to some of the learning resources I have listed at the end of this chapter to get your own pipeline working in a similar way.

You should also be familiar with the basics of MEL scripting. Although I have supplied all our custom MEL scripts for you to use to glue your pipeline together, you might need to adapt them to your specific needs. I certainly couldn't have put together this pipeline without the extreme customizability that MEL offers.

I hope this chapter can help show how to bridge the gaps between the various programs. I recommend that you have a quick flick through this whole chapter before you try to get your own photo-based modeling started. You might choose to follow my example and use my truck reference photos, or you might find it more interesting to take your own photos of a chosen vehicle and use this chapter as a rough guide as you work.

The scene files that I have supplied on the website www.3d-for-games.com are suitable for use with Maya 2009, ImageModeler 2009, and Photoshop CS4.

Photogrammetry

Using reference photography in some way or other to enhance the quality of 3D art assets is not a new idea. Gathering reference materials is often one of the first stages of any creative project, and often CG artists keep a library of images they refer to as they create their content. Sometimes CG artists will display concept artwork in orthographic (without perspective) viewports such as "front," "top," and "left," tracing the contours as they work, but this requires special artwork drawn without any perspective distortion, so it's not suitable for use with real-life photos (photos always have some amount of perspective distortion involved).

Taking this concept a stage further, it is possible to trace over photographic images by projecting them from cameras into the 3D scene. Using a mixture of experience, trial and error, and custom scripts, the

3D artist carefully sets the position, orientation, and focal length of each virtual camera to match each reference image. This practice is very tricky and can take years of practice to perfect. Recently, with the advancement of photogrammetry tools such as ImageModeler or Photomodeler, this technique has matured into a powerful, semi-automatic production method that, if done properly, ensures complete accuracy.

Figure 8.2

Photogrammetry is the mathematical process of determining geometric properties of objects from photographic images. Stereo photogrammetry estimates the 3D coordinates of points on an object by comparing common points on two or more photographic images.

Our pipeline relies on these photogrammetric techniques to drive the accuracy of the 3D modeling and texturing. We shoot detailed photographic references of our vehicle from different angles and match them to a 3D scene that contains one camera for each reference photo. These cameras are positioned exactly the same as they were during the shoot, so we can effectively use them to trace our vehicle's shape from the reference photo onto our 3D model. You might have a well-trained eye for proportions, a skill that can take years to hone, but nothing beats the camera for getting it just like it is—if they want photorealism then let's give it to them.

Figure 8.3

Shooting the Footage

As we are using a photo-based pipeline, the quality of the results is almost entirely dependent on the reference footage that we feed into our pipeline. Out-of-focus and low-res shots just won't help us attain those high-definition details that are expected of our work. A thorough knowledge of photography is critical to our work in CGI, so be sure that you know your camera inside out and you are well read on all the basic photography theory.

Here are some tips for shooting your chosen subjects:

1. The number one rule with your shots is to take as many shots from as many different angles as possible, not just the obvious front, back, side, etc. I find that it is usually the more obscure shots such as underneath and top views that add the extra details to your models, and they really help get another perspective on things when you're struggling to retain the exact volumes of complex shapes. The wider the range you shoot, the more data we have to work with down the line. Get more shots than you think you need; in the digital age it's better to have too much rather than too little ref. You can always delete the redundant footage when the project is complete. It is usually very difficult or impossible to repeat the same conditions for your shoot in the future, as often things get moved around or the lighting changes drastically from day to day.
2. A quality camera. Get yourself the best camera that you can get your hands on. It's not all about the megapixels though; while a higher MP count is usually better, factors such as the lens quality, manual controls, and features such as exposure bracketing shouldn't be overlooked.

3. Use a tripod, as this will allow you to take less blurry shots. You will be able to shoot longer exposures with a smaller aperture opening for the sharpest images with the widest depth of field.

4. Keep the same zoom/lens settings for the entire shoot. I've found through trial and error that nothing confuses photogrammetric programs more than a sequence where you have swapped lenses and adjusted key factors such as the field of view (FOV) halfway through. Also, try not to take portrait and landscape shots in the same sequence if possible as I've found this can cause camera matching errors too. Decide beforehand if landscape or portrait shots will work best for your needs.

5. In some situations it makes sense to shoot from afar. If you use a long zoom lens such as a 200 mm or greater telephoto lens, then perspective distortion will be drastically reduced. This will depend on the subject matter, but usually the reduced perspective distortion you get from these lenses gives you more orthographic-style shots, which is great for getting all parts of your subject matter at roughly the same size in the shot. Keep an eye on the depth of field though; this can be quite shallow with some zoom lenses.

6. Shoot exposure brackets. Most half-decent cameras allow you to simultaneously shoot a series of images with a range of different exposure values (EVs). This will allow you to recover missing details from certain areas of the shots that are underexposed in shadowed areas or recover detail from overexposed areas like the sky and lights. Certain programs such as DSLR remote pro allow you to control your DSLR camera from your computer (I recommend getting a very long USB extension wire) and take a larger series of up to 15 exposure bracketed shots.

7. Shoot in RAW format if your camera supports it. Like the exposure bracketing it will help you capture more light information in your images, which will pay dividends when you process your images later.

8. Try to shoot a Macbeth chart while on location (Figure 8.4). You can use these to set the white balance in your shots for accurate reproduction of real-world colors.

Figure 8.4

9. Although there are a number of expensive professional options, we have found that umbrellas and small, easy-to-pitch tents can help protect your equipment during bad weather. Putting your laptop in a tent makes it a lot easier to see what you are doing when shooting outdoors in bright sunshine.

10. Take assistants along with you if at all possible, as they can be helpful for all sorts of odd jobs while you have your hands full with the camera, such as helping to carry and set up the equipment, guarding your expensive equipment, keeping people and animals out of your shots, holding up umbrellas, and setting up tents.

11. Remember to charge your camera's batteries; pack a spare battery and the charger into your bag too.

12. Clean your lenses on your camera before you head out. I like to travel with a lens cleaning cloth, cleaning fluid, and a can of compressed air in case the camera gets soiled during the shoot.

13. I have found it useful to take along a 1 m ruler and shoot it alongside the subject vehicle. We can later use this information to get very accurate scale information.

14. Shoot on a cloudy day if possible; this reduces hard shadowing and overbright image areas. A fully overcast sky will give you subtle "ambient occlusion"—style shadows and minimal glare on reflective surfaces, which is much easier to work with during the texturing stage.

15. Be prepared. There's nothing worse than traveling a long way out to a shoot, only to return with inadequate reference material. Write out a quick plan of what you will be shooting before you head out, as this will force you to think in detail about the requirements of your shoot. What will you use your reference for? Are you modeling a low-poly game model that will need to be seen from all angles including the bottom? Or will you just be rendering one super-high-resolution shot from one fixed angle? How much detail you will need to capture, and which angles you will need are all things to think about back at base where you will be free from the myriad of distractions out in the field.

16. Remember that practice makes perfect. I've been through this whole pipeline a number of times now, and each time I usually pick up on at least one way to make things run a little smoother next time, so remember after you complete each shoot to ask yourself if anything might have made it easier. Keep a list of all the items you should take along to each shoot; take your list and a pen along to the shoot so you can add anything that would have been useful.

Figure 8.5

Photogrammetry

Our next step is to take our reference images, and for each one build a virtual camera in Maya that copies the position, orientation, aspect ratio, and focal length of the original camera used to shoot the reference. Here I am using ImageModeler 2009. At the time of writing, this product has been discontinued, but it is still bundled along with Maya if you ask for it. It is also possible to get very similar results with a number of other similar applications such as PhotoModeler or ImageModeler.

If we open up ImageModeler, it's straightforward to bring in our set of reference images into the program.

The images should load in so you can view each one by clicking on the image thumbnails at the bottom.

Now we need to start marking out points on our object. The best points are areas of high contrast, usually edges between different areas on our object that are easy to identify across the series of images. The more images that your chosen marker point appears in, the easier it will be for ImageModeler to "solve" your cameras. Try to avoid using blurry or hard to pinpoint features, as they will be prone to error and will affect the accuracy of the final result.

Figure 8.6

Figure 8.7

Figure 8.8

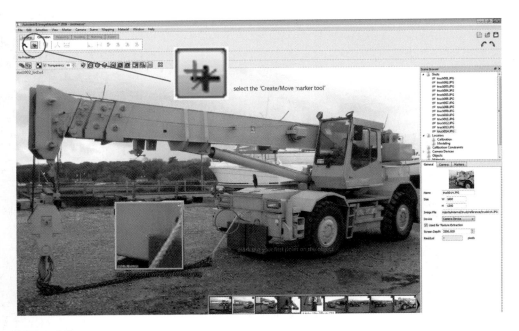

Figure 8.9

Let's start by marking our first point out, so select the Create/Move marker tool and click to mark out a locator position. The front corner of this flagstone makes an excellent point as it's easy to see in quite a few of our images. Mark this point out on as many images as possible.

Figure 8.10

Now let's mark out a second point across as many of the images as possible. Remember if you need to adjust a marker you can just click and hold on the point to see the zoomed placement window. Use the Scene Browser on the right-hand side to keep track of and select your locators as you work. If no locator is selected in the scene browser, then a new locator will be created as you click on the images (the crosshair will turn green if it is about to mark a new point). It is important to select the correct locator in the list if you are marking the same point out on a series of images.

Figure 8.11

Now continue to mark out features, trying to get each feature marked in as many different images as possible.

Figure 8.12

Figure 8.13

If you keep accurately marking out each locator, eventually you will reach a critical mass of locators, and ImageModeler will notify you that the scene has been solved. If you have done this correctly, then the icon for each locator and image will turn green. If the icons are gray, yellow, or orange, it means that you may need to mark more points or mark each point more accurately.

Once we have a solve, it is time to export our scene so we can open it in Maya. Choose File > Export Scene As from the menu bar; the default options should work pretty well. Type your File Name, choose the .ma file format, and press the OK button.

Figure 8.14

Importing into Maya

If we open up our exported ImageModeler scene in Maya, we should see a locator positioned correctly in space for each of the points we marked out in ImageModeler. Also present in the scene should be a number of cameras, each matching the position, focal length, and orientation of a particular reference image. One problem that you might have is that the locators and cameras might come through with tiny display icons. See the image below; the minucule dots you can see on the left are all the locators and cameras.

We could manually scale up each locator to fit our scene better, but that would take some time. It is much better in the long term if we write a little re-usable script we can use every time we have to fix an ImageModeler scene. The script below takes the selected objects and sets each member of the selection to a scale of "7" in X, Y, and Z. Just select all the locators you want to affect, open up the script editor, and type out and run the following script in the bottom window of the script editor.

```
string $loccSel[] =`ls -sl`;
for ($i in $loccSel)
{
  setAttr ($i + ".localScaleX") 7;
  setAttr ($i + ".localScaleY") 7;
  setAttr ($i + ".localScaleZ") 7;
}
```

Figure 8.15

Now we run the script using the script editor's Command > Execute option; you should see the size of all the locators change. If you want a different scale value, you just set a different number, replacing the three 7's in the script code above.

Figure 8.16

Now that all the locators are at a nice size, we have another similar script that will scale up all the camera icons together so they too can be more easily seen at a relevant scale.

```
string $loccSel[] =`ls -sl`;
for ($i in $loccSel)
{
  setAttr ($i + ".locatorScale") 15;
}
```

Figure 8.17

Now if we select all the scene's cameras and run this script, we get all the camera icons at a nicer size. Just like with the last script, if you would prefer a different camera size you just swap the number 15 for a different scale factor.

If we look through one of our cameras we can see all the locators similar to our view in ImageModeler, just without the actual reference photo. Now load each reference photo into the relevant camera, as an Image Plane.

Figure 8.18

If you select the camera that you are looking through, and open up its shape node, you can find a section called Film Back. As our reference photography is 1600 × 1200 px we need to set the camera aperture to a ratio that matches, so I use 1.6 and 1.2 in the two Camera Aperture text boxes, but your number may need to be different from this. Now go to the section called Environment and click Create to make a new Image Plane for this camera.

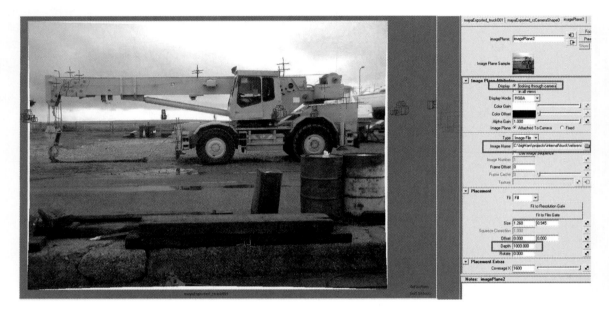

Figure 8.19

The Image Plane node should now appear in the attribute editor; make sure that the Display attribute is set to looking through camera; this makes sure that we only see this Image Plane when we look through this camera. Next we load in the image corresponding to this camera, into the Image Plane slot, so the image appears in the viewport.

Now we just need to adjust the Depth attribute, so that the image plane appears behind your locators, instead of in front of them. I find a value of 1000 does a pretty good job for me but your scenes might require a different number.

Now your viewport for this camera should look pretty similar to how it appeared in ImageModeler, with the locators marking out important points on the reference material. Do the same for each camera, loading in the corresponding reference image.

If you would like to compare your Maya scene to ours at this stage, check out the scene on the website: www.3d-for-games.com: Chapter 8/scenes/1_IM_ImportedIntoMayaAndFixed.mb.

Basic Modeling

Let's make a start on the modeling by just sketching out the basic forms of the mesh, starting with a cube for the main part of the truck and cylinders for the wheels. At this stage we are just trying to get everything at the correct scale, at the right positions in space, so they match up with all of the cameras. We are just looking for a rough approximation of the volumes of the truck.

The locators are a great help in the initial placement of the basic mesh. For quick accuracy, you might find it useful to snap the position of your vertices directly to the position of the locators by holding v while you drag the vertex near to the locator. After running through this pipeline for a couple of different projects, you will build an appreciation of where are the best places to place your markers (locators) in ImageModeler. Having a 3D point in space to match up with your mesh really takes out the trial and error of matching the model to every camera.

If you would like to compare your Maya scene to ours at this stage, check out the scene on the website www.3d-for-games.com: Chapter 8/scenes/ 2_modelingSTART.mb.

Remember to constantly change the camera you are using to check the positioning of the meshes. What looks correct in one view is often wrong in the others. It's better to fix big problems while the mesh is still simple.

When you are sure that the simple forms are accurately placed when viewed through each of the camera viewpoints, you can gradually build up the complexity of the mesh.

Figure 8.20

Figure 8.21

Figure 8.22

Speed Things Up with MEL

If we are going to make the best use of our reference photography, then we are going to want to change cameras very often, flick between the reference and the model, zoom in and out to focus on areas of detail, and be able to pan around while zoomed in to focus on different areas. Out of the box, Maya does not offer a nice streamlined way to do this, and you may find yourself frustrated as you spend more time clicking through menus and entering parameters into boxes than you do modeling and critiquing your model. The solution to these problems is to use MEL to streamline our workflow. This is where our custom pipeline really excels.

I do not claim to be an expert at MEL scripting, far from it. I am just an artist who over the years has modified other people's scripts until I felt confident to start writing my own. Gradually I have cobbled together enough knowledge to be able to hack together a number of robust, custom MEL commands to quickly perform all of the tasks mentioned above. To get a good idea of the power of these scripts, please watch the QuickTime video I have provided on the website www.3d-for-games.com: Chapter 8sc/movies/scriptsInAction.avi.

Here is a brief description of each .mel script included on the disk:

BM_cameraLast

This script will swap the camera that you are looking through for the last camera in your scene, a quick way to move between different Image Planes as you compare your reference to your model.

BM_cameraNext

Swaps the camera that you are looking through for the next camera in your scene, a quick way to move between different Image Planes as you compare your reference to your model.

BM_cameraPanDown

Makes the active camera appear to pan down, by changing its Image Plane's .offsetY value.

BM_cameraPanUp

Makes the active camera appear to pan up, by changing its Image Plane's .offsetY value.

BM_cameraPanLeft

Makes the active camera appear to pan left, by changing its Image Plane's .offsetX value.

BM_cameraPanRight

Makes the active camera appear to pan right, by changing its Image Plane's .offsetX value.

BM_cameraPolyToggle

This script toggles the polygon display on your active camera on and off. This is my favorite shortcut; it is very useful for rapidly checking your work against the reference.

BM_cameraZoomIn

This script makes the active camera appear to zoom in, by modifying its overscan attribute.

BM_cameraZoomOut

This script makes the active camera appear to zoom out, by modifying its overscan attribute.

BM_cameraIconScale

This is one of the two scripts that I detailed earlier in this chapter. Running this script will scale the display icons of the selected cameras in your scene; replace the number 15 with any value, depending on how big you would like your icons to be in the scene.

BM_locatorScale

This is one of the two scripts that I detailed earlier in this chapter. Running this script will scale the selected locators in your scene; replace the number 7 with any value, depending on how big you would like your locators in the scene.

Figure 8.23

To install these scripts, you need to copy these .mel script files from the disk included with this book onto your workstation. Copy and paste the scripts from the website www.3d-for-games.com: Chapter 8/scripts to the Maya scripts directory which on your machine should be something like C:/USERNAME/documents/Maya/scripts.

Figure 8.24

We can test if the scripts have been installed correctly by relaunching Maya, opening the vehicle scene with multiple cameras, and typing BM_cameraPolyToggle (the exact spelling and capitalization are critical) into the bottom window of the script editor. The polygons should hide/unhide each time you execute the command (using command > Execute).

Figure 8.25

Now let's set up our scripts so that they launch using hotkeys; we are not going to save much time at all if we have to type out the command into the script editor each time. If you have a numeric keyboard, I recommend using my settings as shown on the diagram above, but feel free to set these to any configuration that is easy to operate.

BM_cameraLast	7
BM_cameraNext	9
BM_cameraPanDown	alt + down arrow key
BM_cameraPanUp	alt + up arrow key
BM_cameraPanLeft	alt + left arrow key
BM_cameraPanRight	alt + right arrow key
BM_cameraPolyToggle	8
BM_cameraZoomIn	5
BM_cameraZoomOut	2

We don't use BM_cameraIconScale.mel and BM_locatorScale.mel very often, so it's probably not worth making hotkeys for these.

Figure 8.26

249

To set each hotkey, repeat this procedure:

1. Launch the hotkey editor using Window > Settings/Preferences/Hotkey Editor.
2. Select the User category.
3. Create a new hotkey.
4. Give the new hotkey a name, preferably the script name. without the "BM_" prefix.
5. Click the Edit button, then type the full name of the script into the Command text box, i.e., "BM_cameraIconScale."
6. Click the name of your newly created command in the Commands list at the top.
7. Type the key that you would like to launch this script in the Assign New Hotkey box.
8. Hit Assign.

Once we have filled up the list of hotkeys, the Hotkey editor should look something like this:

Figure 8.27

When we put these keyboard shortcuts to use, we should have an efficient and intuitive way to develop our photo-based models. It is a great example of how learning MEL scripting can save you serious amounts of time with the repetitive tasks like these camera manipulations.

Now comes the traditional modeling bit. We just keep modeling and checking our model against the reference until we are happy that we have accurately represented every detail. Once the object has UV coordinates (see next section), I like to bake the ambient occlusion onto the textures so it's much easier to see the details on the model as we finesse the fine details. I'm usually happy with about a 99% correct likeness. I find as we approach 100% accuracy we spend a lot of time tweaking micro details that don't really matter. Of course, use your own judgement as each project has different demands, but I'm confident that at this stage our model is 100% believable. No one is going to notice the difference from the reference model.

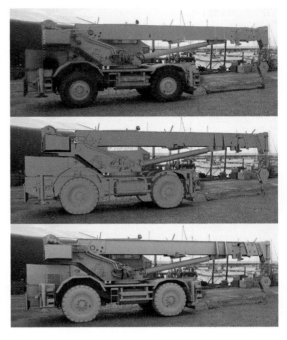

Figure 8.28

UV Groups

Now we need to UV unwrap our mesh so we can texture it. As we will be dealing with pretty high-resolution maps it's preferable to break the model up into groups. It will be much easier to work with this way. Each group will need a different UV set.

While I like to use UVlayout for the actual production of the UV coordinates (there are a number of excellent tutorials on the website: www.uvlayout.com), any major 3D app can manage this UV'ing job reasonably well. The more modern, stand-alone solutions such as Uvlayout, Roadkill, or Unwrella will do the job much faster and accurately though, with the major benefit of stopping you from going totally insane!

You can check out the final model file here on the website www.3d-for-games.com: Chapter 8/scenes/3_modelingFINAL.mb.

Now we need to decide the resolution of each map. I use my stock set of checkerboard textures to get the correct texel (the texture pixels once they are mapped onto the polygons) size. I've included Big Man's checkerboard textures on the book's website here www.3d-for-games.com: Chapter 8/checker boards.

Figure 8.29

I'll usually play with the texture size for one part of the object until I'm happy the resolution is adequate for the final renders. In this case I'm planning on rendering the asset in the mid-ground of a camera rendering HD footage (1920 × 1200 px) so after a few test renders I decided that 4k (4096 × 4096 px) is fine for the main body. Once we are happy with the texel size of this first object then it is just a case of setting the other textures to match its texel size as closely as possible. In the end I decided upon these texture sizes:

Main body > 4k map

Wheels > 2k map

Cabin > 2k map

Inner cabin > 2k map

Chains > 2k map

Crane arm > 4k map

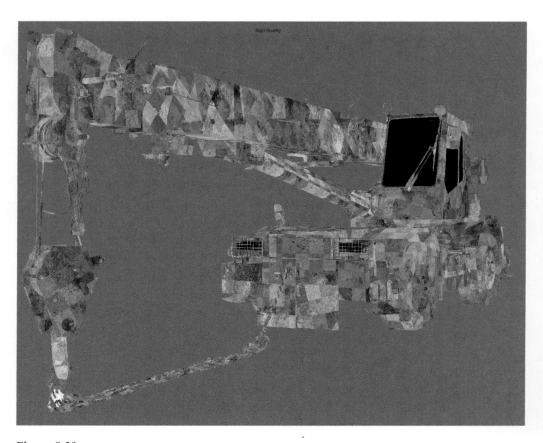

Figure 8.30

Projecting the Textures

If we have done our job right up until this point, we can also use our photographic images to help out with the texturing by directly projecting them onto our model.

If you have good, high-resolution and exposure-bracketed reference material shot on a professional camera, it is possible for an experienced Photoshop operator to remove the shadows and highlights from your reference and project them straight onto your object from the CG camera. The first step is to make a copy of your reference images; I like to store them in their own folder to keep them separate from the original images.

Figure 8.31

Now let's open one of our reference images in Photoshop and start removing all the shadows and specular highlights. I usually find the Image > adjustments > Shadows/Highlights tool is a great starting point for automatically removing shadows, but be careful not to damage your image by taking things too far, as we don't want to destroy any data.

Now let's take things a step further; for each area that we think looks a little bit shadowed we are going to brighten it up a little. I usually repeat the following actions for each major dark area until we have removed a lot of the big shadows.

1. Draw a selection around the dark area using the Lasso Selection tool.
2. Blur this selection using the Select > refine edge command.
3. Hide our selection using the Ctrl + h hotkey (this is so we can see what we are doing without the "marching ants" getting in the way).
4. Use the Image > adjustments > levels command to brighten the area up. After you raise the brightness, you might need to use an Image > adjustments > Hue/Saturation to re-saturate the colors a little if things get too garish.

Figure 8.32

We can also use the above technique to remove overbright areas. The important thing is drawing accurate masks that are sharp in the right places and gradually blurred in the right places too. It is an art you will pick up over time.

We should now have been able to remove all the larger shadows, and it is time to focus on the smaller ones; rather than trying to level them out using masks, I prefer a more brutal method of just painting over the smaller shadows with the healing brush and rubber stamp tools, as we could never hope to draw masks for all the little shadow areas.

Figure 8.33

Let's start off with the healing brush; select it from the toolbar. The basic idea is that we find interesting but rather blank areas that contain subtle details, such as the large flat areas of the body work, and we sample these by pressing alt + LMB. Now we can just paint out the small shadows and the healing brush does all the tricky work of making it all look seamless. If you run into problems it might be that you need to switch to the rubber stamp tool, which is like the healing brush but without the seamless, blending edges.

It's important to try to differentiate between dirty areas and occluded (soft shadowed) areas. Usually dirt occurs in those same places where the shadows hide, where the elements find it harder to wash away all inevitable stains and marks that buildup. Try to preserve as much of this grunge as possible.

In areas where your reference is under- or overexposed (shooting reference in HDR, using exposure bracketing will help provide details in these areas), often whole regions will just need to be annihilated and built up again from scratch. Here I might start by rubber stamping another part of the reference as a starting point; then often I will use iterations of the Paintbrush and Blur tools to build up progressively sharper details.

Eventually you will arrive at the point where you think you have painted out all the shadows and highlights. At this stage it pays to try copy and pasting the original, un-retouched image on a layer above your work in progress. If you toggle the visibility of this layer on and off quickly you can see how it compares to your retouched image. Comparing before and after like this will often help you to spot areas where, in an attempt to paint out the lighting, you have failed to retain the subtle color grades and details on the original object.

Here is the final retouched image for one of the images. I have paid much attention to getting the colors the same as the original image, which is quite tricky when we manipulate the image heavily to get rid of the shadows and highlights.

Figure 8.34

I have bled the color over each of the external edges of the truck so we don't get any nasty little outlines where the reference doesn't perfectly match the reference. It is important to focus only on the parts facing the camera; those parts that are facing away from the camera are very likely to be much clearer on other reference shots, so let's not worry too much about them. I've painted over these perpendicular-to-camera areas quickly and very roughly, using blocks of colors.

To set this image up ready for projection, select the relevant camera and open its Image Plane tab that we created earlier. Now we need to swap our old reference image for our newly touched up projection image by using the Image Name attribute.

OK, so let's project this image onto our wheels; select the wheels object and apply a new surface Shader shader. Open up the Surface shader dialog and load a new file into the out Color slot. Be sure to select As projection before you click the File button.

Figure 8.35

Figure 8.36

Figure 8.37

Find the attached projection node, and play with the settings:

1. Select Perspective for the Proj Type.
2. Load our retouched image into the Image slot.
3. In the Link to camera slot, choose the relevant Image Plane. In this case it's rzCamera Shape8, the Image Plane linked to our camera that we want to project from. Set the Match Camera Resolution for the Fit Type section.

Figure 8.38

Figure 8.39

Now we just need to bake the texture onto our mesh.

1. Open up the Hypershade window, and bring up the Convert to File Texture options.
2. Select the surface shader material.
3. Shift + select the wheel object.

In the convert to File Texture, make sure Anti-alias is ticked; set the X and Y resolution for your maps, choose the file type, and then hit Convert at the bottom.

Figure 8.40

After a short wait we get a new material applied to our wheel.

Figure 8.41

If you have a look at this texture applied to this new material, you can edit the texture to bring it up in a separate window.

Figure 8.42

Figure 8.43

If we repeat this process for each of our meshes, we get something that looks pretty good, from the current camera, but the illusion breaks down if we change the camera angle.

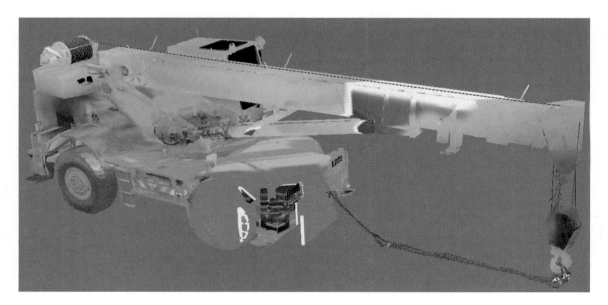

Figure 8.44

If we repeat this whole process of projecting each retouched reference image from each of the cameras, we end up with most of the texturing work done. Now it is just a matter of using Photoshop to combine the maps together; a 3D texturing program like cinema4D or Zbrush's Z appLink is very useful to fill in the inevitable gaps that all the cameras missed.

Unfortunately, the reference I shot (over two years ago when we first began to develop this pipeline) is too low-res to really look good when projected like this. I shot these images on a weekend using my low-resolution pocket camera, which lacks the resolution needed. This underscores just how important high-quality reference material is. These images were fine for photogrammetric modeling but lack the res for detailed texture projection. If the resolution of the reference is high enough for the purposes of the final output renders, then this camera projection method is second to none when looking to produce fast, accurate, and photorealistic textures.

Other Texturing Methods

If our reference images are not high-res or good quality enough for the projection method of texturing, then instead we have to use more traditional texturing methods. We can still use our BM_cameraPolyToggle script to quickly check the accuracy of our textures, however.

I don't want to stray too far away from the photometric focus of this chapter, but I'm going to include a few details of some texture layers we used in the creation of the final set of textures.

Figure 8.45

Ambient occlusion layer

The ubiquitous AO layer describes how occluded each part of our mesh is. As this map also describes how exposed an area of mesh is, we can use this as a mask when painting effects such as dirt (dirt tends to hide in occluded areas that don't get cleaned by weathering like the exposed areas do) or scratches (exposed areas get more scratched). Also, if you are not going to do a full ray-traced global illumination render, then the AO layer can be used in compositing as a nice cheap way to light your mesh.

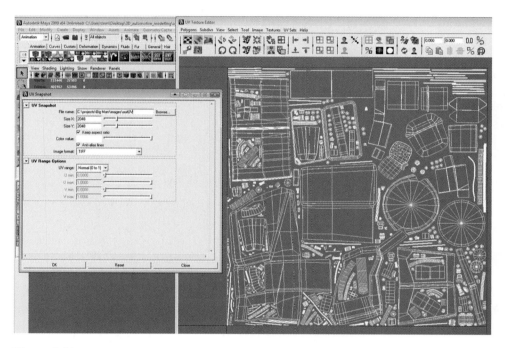

Figure 8.46

UV layer

Using the Polygons > UV snapshot dialog box in Maya's UV Editor Window, it is possible to bake out an image of your object's UVs. It is very useful to have these UVs as the very top layer in your Photoshop PSD, inverted and in multiply mode. You can then toggle the visibility of this layer when you want to check your painting in Photoshop.

Index layer

The index layer serves as a quick way for us to make and save certain selections that we might use again and again during texture production. In this case we have split up the metal, rubber, glass, and plastic surfaces using different colors on the index texture. Using Photoshop's magic wand tool we can quickly select areas.

Figure 8.47

Figure 8.48

Figure 8.49

This layer can be painted by hand, using the UV layer for reference. If the object is very complex, as in this case, it might be easier to apply different materials to parts of your 3D models and bake them to a texture using the convert to file texture in the Hypershade window.

Specular map

This describes how shiny each part of the truck is. The dirty areas are darker obviously, and the very shiny areas are almost white.

Displacement map

The displacement map adds the final small high-frequency organic details during render time. The displacement map example shown above is suitable for Renderman-compliant renderers, so the gray areas are not changed by the displacement map, but darker areas are pushed in, and

lighter areas pushed out. This is how we make the metal panels appear battered and beaten in the final renders.

We have included all the final textures on the website www.3d-for-games.com: Chapter 8/textures. We rendered and composited an animation to show off the results of this chapter, which you can find on the website www.3d-for-games.com: Chapter 8/movies/truckComp01.mov.

Conclusion

It took us quite a long time to develop this pipeline, so if you don't get everything working straight away, don't despair; keep thinking laterally and don't dwell on any one small problem for too long. If you hit a big snagging point, take a break away from your computer to where you can look at your problems in the context of the bigger picture of your pipeline. Remember that there is always more than one way to do any task in CG. It took a lot of web searching, asking questions on forums, reading through software manuals, and experimentation to get things running smoothly for us.

While I'm using the technique for a vehicle here, with a few adjustments it works just as well with other objects or even with characters (if you can get the subject to keep still!).

I hope you learn something from this chapter, and please don't hesitate to drop me a line at tom@big-man3d.com if you have any questions.

Figure 8.50

Recommended Reading

These books were all instrumental in my understanding of the more advanced concepts that underpin this chapter.

Mel Scripting for Maya Animators

Mark R. Wilkins, Chris Kazmier

ISBN-13: 978-0120887934

http://www.melscripting.com/

The classic text on Mel scripting for Maya is a great, easy-to-understand introduction to how Mel scripting can help you automate those boring, meticulous tasks.

Professional MEL Scripting for Production

Kevin Manners, Ed Caspersen

ISBN-13: 978-1598220667

Industry veteran Kevin Manners and friends guide you through how Mel is used in large studios to great effect. This is essential reading if you are interested in smoothing out your own pipelines and getting a grasp on more advanced techniques.

The HDRI Handbook: High Dynamic Range Imaging for Photographers and CG Artists

Christian Bloch

ISBN-13: 978-1933952055

This book explains HDR imaging within the context of the CG artist. It contains great instructions on how to shoot in HDR and how to process the results. HDRI is not only essential for quick, realistic lighting in your renders, but if you shoot your reference in HDR your textures need never suffer from under- or overexposed areas ever again.

Digital Texturing and Painting

Owen Demers

ISBN-13: 978-0735709188

This book is a good, timeless look at the core concepts and ideas behind good texturing practice. You won't get as many software-specific instructions as other books on the subject, but Owen will teach you how to think like a texture artist.

3ds Max Modeling for Games

Andrew Gahan

ISBN-13: 978-0240810614

Although specific to 3ds Max, this book offers a well-rounded look at the art of the professional game artist. My chapter on the creation of the character on the cover of the book reveals in detail my approach to texturing and serves as an excellent companion to my texturing overview in this chapter.

The Photoshop CS3/CS4 WOW book

Linnea Dayton, Cristen Gillespie

ISBN-13: 978-0321514950

I first picked up a Photoshop WOW book when Photoshop 6 was the latest version. What I loved about the book was its comprehensive and fun guide to all the major features in Photoshop in an easy-to-read format. If you feel that your knowledge of Photoshop work is lacking, you could do a whole lot worse than read this new edition of the book.

Recommended Websites

www.3d-for-games.com

The website and forum that supports all of Andrew Gahan's books and training videos.

www.uvlayout.com

A great website with loads of tutorials. A good resource if you want to learn the benefits of creating UVs in UVlayout.

www.creativecrash.com

Formally known as www.highend3d.com, this website offers, among many other things, the definitive collection of MEL scripts for download.

CG talk

http://forums.cgsociety.org/

This gigantic online community is a great place to discuss 3D and gauge other people's opinions about the latest developments in the industry. I find these forums are a good resource when you need help with a specific technical issue or you would like to get a fresh perspective on a problem you are having.

Chapter 9

Vortex Concept

Robert Forest

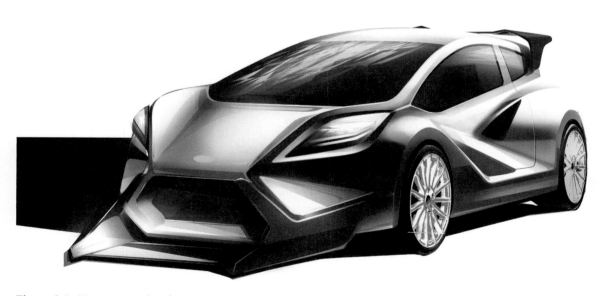

Figure 9.1 *Vortex concept, front ¾ view.*

3D Automotive Modeling. DOI: 10.1016/B978-0-240-81428-5.00009-4

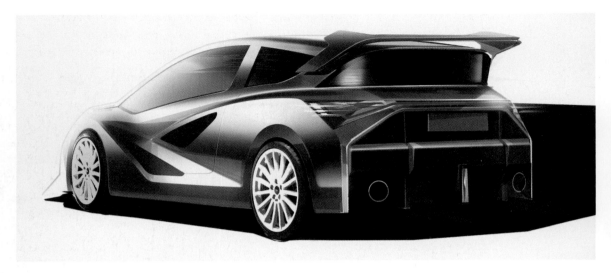

Figure 9.2 *Vortex concept, rear 3/4 view.*

Initial Idea

Tasked with creating a C-segment sports hatch in the spirit of the Ford Focus RS and Subaru Impreza, the project begins with a scribble. Many, in fact: I'm trying to find a strong theme that gives the car the same feel but with a different identity. Already in my head I have an idea for a rear-slanting rear screen and body-colored B-pillar for a unique window graphic. I also want to try something new with the body section: this is a dynamic car, so I want to reflect that with the haunch spiraling in with the front-fender flare.

As this is a virtual product, we can push things a bit, so the whole rear is a carbon-fiber diffuser, and the profile is spotted by twin air outlets that run through the door. Finally, I sank the headlamps for a more seductive and intent expression. Time to develop it up now.…

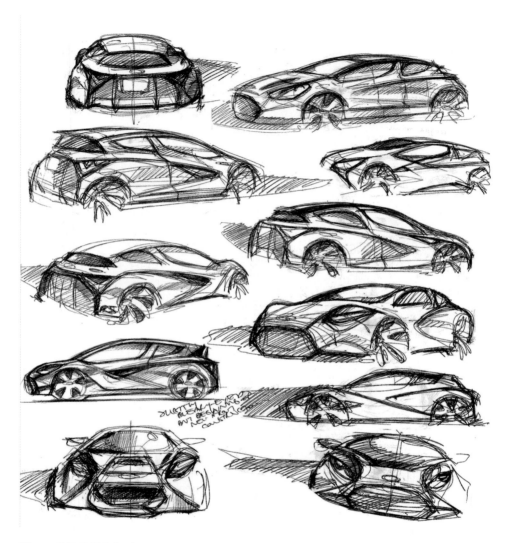

Figure 9.3 *Initial sketches.*

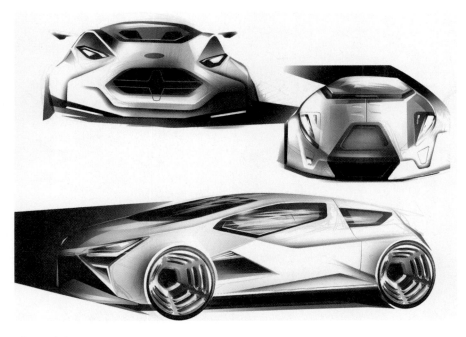

Figure 9.4a

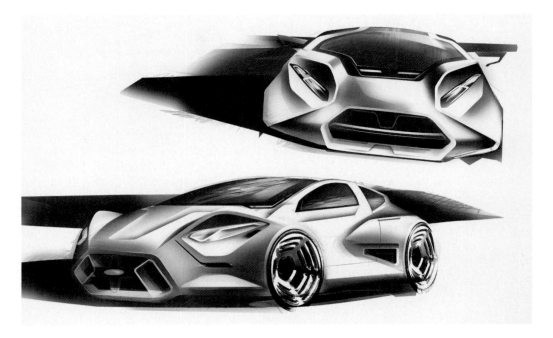

Figure 9.4b

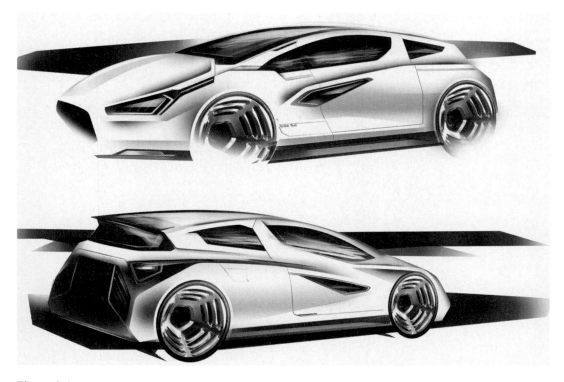

Figure 9.4c

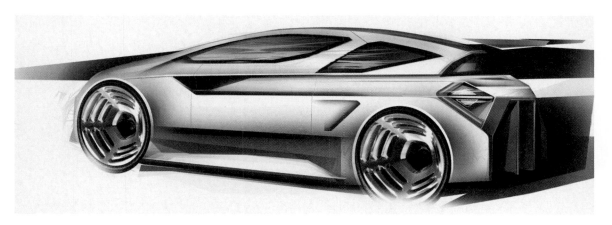

Figure 9.4d

Theme

Having explored different themes, one must be selected to develop into a more explanatory drawing. Variations to execute this abound, and each designer has a different technique. I am using the Lasso tool here with the Pen tool to tidy a few shapes such as the silhouette and glass.

The most important thing is to capture the intent, and here I emphasize the offset between rear wheel and cabin. I also used paths for the shutlines to better describe the surface. Once the model is finished, it will need to be rendered, for which I have provided sample images of different details to imitate. The face-lifted Audi Q7, Ford Focus RS, and the Aston Martin Rapide concepts provide the cues here.

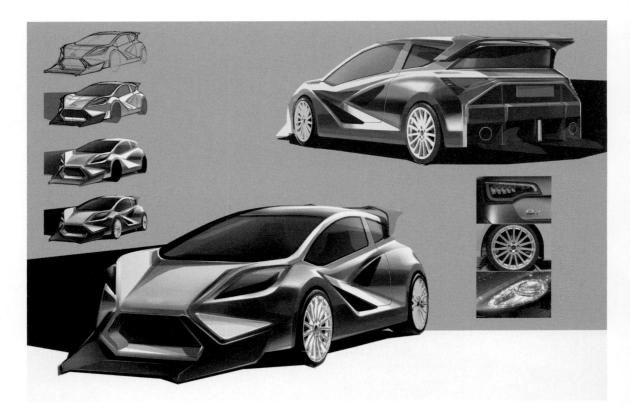

Figure 9.5 *Capture the theme.*

Ortho

This is quite an important stage. The designer in you might say "create!" but this is the time to communicate those ideas to modelers. Unless you plan to go into 3D yourself, blueprints need to be drawn up.

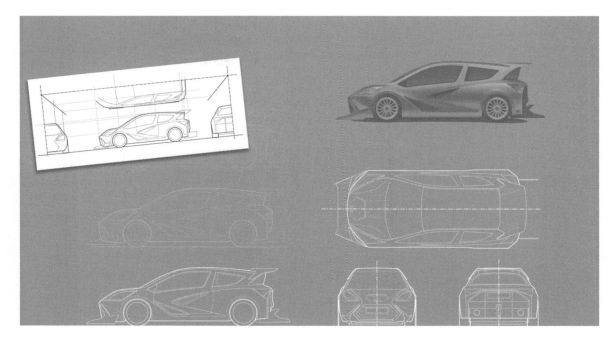

Figure 9.6 *Orthographic projections.*

The side view is Number One. You want to get this right. While sketching, keep flipping the paper to check the balance; don't be afraid to trace on the reverse. Once happy, scan it into Photoshop and use the Pen tool to draw the key lines.

You can use these later for the rendering. Copy these paths into Illustrator and trim where necessary; you may also wish to play with the line thickness—I use 2 pt for the outline and wheels and vary between 0.25 and 1 pt for the rest. Don't stop refining though: notice how the window base becomes aligned (left) and how the roof is flattened. I also tip the rear screen back and strengthen the jaw.

Next step is the plan view; you can work between this and the front view simultaneously. This is going to give the car its shape, so allow for the glass to tip in (tumblehome), and taper the cabin rearward. Because I want to emphasize the stance, the roof is about half the total body width, and don't forget to draw the rear spoiler and haunches in the front view.

Last, the rear view. To do this, simply copy the outline of the front over and fill in with a cool graphic. My intention here is to create a dominant diffuser within which the license plate and bumper are located. The important thing is that all views align and that there is sufficient wrap to avoid boxiness. It takes a while, but use guides to help you and do the front/rear/plan one side at a time before mirroring.

Final

This is it, the final side view. This is where you can really show the details and give an accurate impression of your vision. I took the profile from the blueprint and moved back into Photoshop and, using the path tool, traced it. Using a photograph for reference, I use the eye dropper tool to select the right tone for each area to describe the surfaces. This takes awhile, so I tend to break it up panel-by-panel, doing the glass and wheels first.

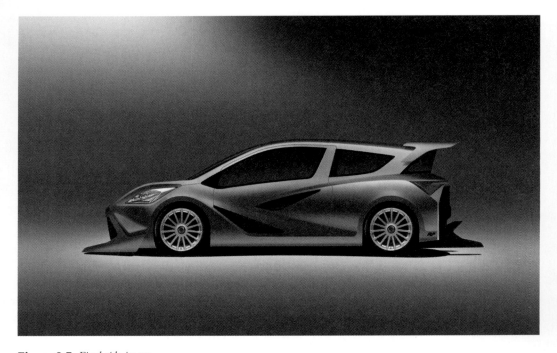

Figure 9.7 *Final side image.*

Once the basic form has been described, now comes the time to work on the details using the earlier images for reference. Don't be afraid to use black for the shadows, and try to avoid a pure white for the highlight—a lighter hue of the body color will look more realistic. I'll take mine in red.

Here's a step-by-step breakdown of how I built up the final side image.

Figure 9.8

Figure 9.9

Figure 9.10

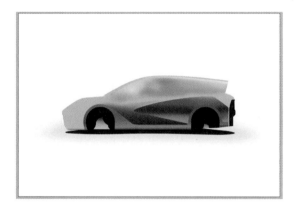

Figure 9.11

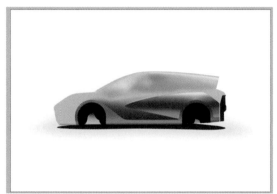

Figure 9.12

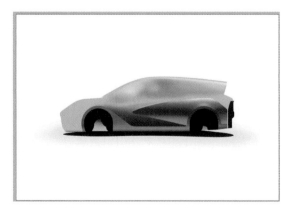

Figure 9.13

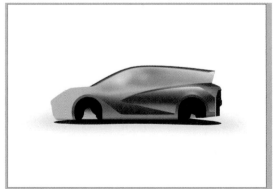

Figure 9.14

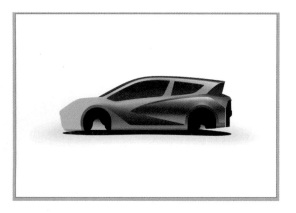

Figure 9.15

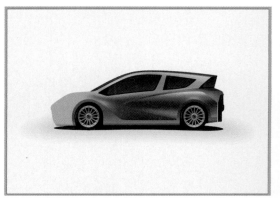

Figure 9.16

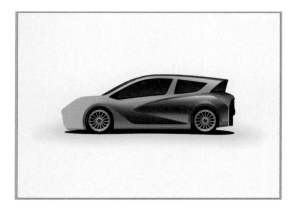

Figure 9.17

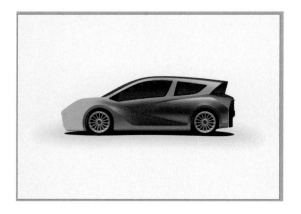

Figure 9.18

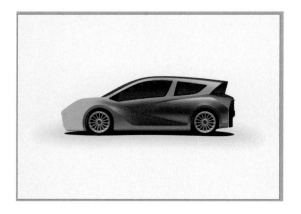

Figure 9.19

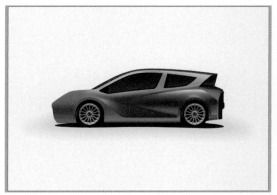

Figure 9.20

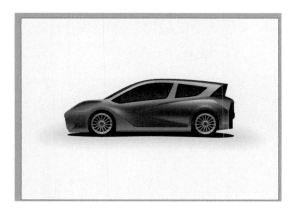

Figure 9.21

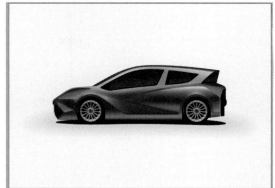

Figure 9.22

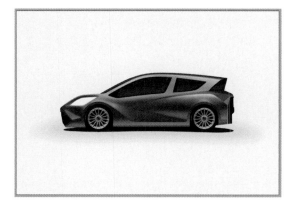

Figure 9.23

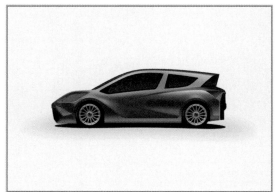

Figure 9.24

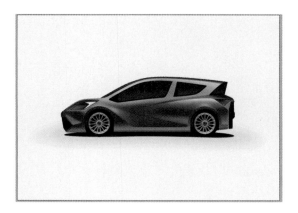

Figure 9.25

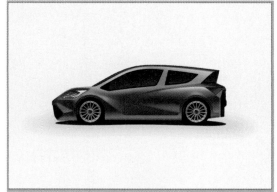

Figure 9.26

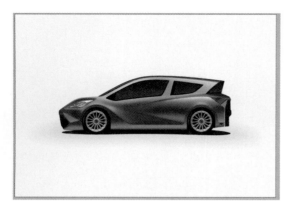

Figure 9.27

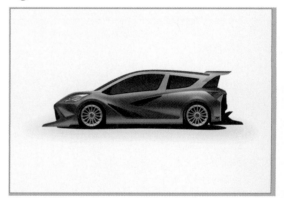

Figure 9.28

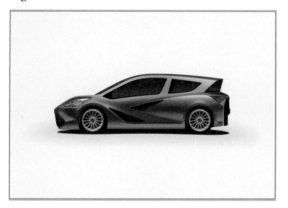

Figure 9.29

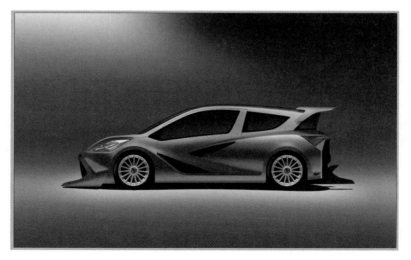

Figure 9.30

Figure 9.31

Chapter 10

Vortex Modeling in Maya

David Griffiths

When starting any new project, the first thing to do is to study the resource material as thoroughly as you can. I try to figure as much out about the shape in my head as possible, before I even touch a 3D package.

When studying your reference material, try to highlight any inconsistencies between the different images you have and collate a list of questions for the customer or Art Director. If you're doing the project for yourself, as in this case, then just decide which you prefer and ensure you follow the correct reference by making notes on it.

Step 1

In the case of the Vortex, the perspective drawings show a slightly more bulbous car than the blueprints depict, so I will defer to the perspective views as my guide. From my experience, unless otherwise stated, it's best to use the blueprints only as a rough guide to size. As you'll see through the course of building the model, the blueprints will be used less and less until you won't really need them at all.

The Vortex will be modeled with a similar polygon count to current generation games like MotorStorm. This means we will be building a technically detailed car with wishbones, suspension, a basic interior, and modeled lights.

The total polygon count for the model will be in the region of 40,000–50,500 polygons. We will be modeling using mostly quads while keeping the polygons evenly distributed for things like damage and vertex-based ambient occlusion, which is often used in game engines.

3D Automotive Modeling. DOI: 10.1016/B978-0-240-81428-5.00010-0

By using mostly quads, we can also tidy up the model with very little effort to make a full quad-based mesh for higher resolution versions of the car, should we need them for pre-rendered movies or marketing materials. To do this we would use subdivision modeling techniques.

Be aware that this car is quite tricky to build, as it has many faceted surfaces and complex shapes and cuts. Also be prepared to check over your model repeatedly over the course of the build. Don't be afraid to change anything on your model at any stage that isn't quite working, and keep a constant eye on your polygon count.

Step 2

Place the blueprint images in Maya using any method you are comfortable with. Maya has an image plane feature that you can use, but I still prefer to use image planes that I created myself within Maya (using a primitive plane) and keep them on a separate layer, enabling me to lock or turn the image plane on or off. For this build, I will model the car on a different plane from the image planes.

You may want to create NURBS curves to trace the blueprint images. This can help you to build up the form quickly and help you to visualize the shape better.

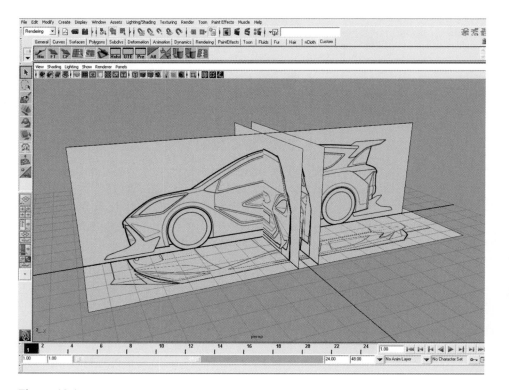

Figure 10.1

Step 3

When I start building a vehicle with wheels, I usually start off from the front wheel arch. I find that this works best for guiding the flow of polygons over the entire build. I will start by creating a Cylinder with 32 divisions.

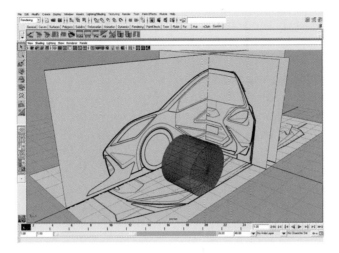

Figure 10.2

Step 4

Delete the rear and bottom portions of the Cylinder, leaving only the top cap, and extrude the outer edges as directed by the blueprints.

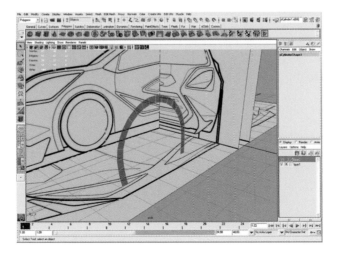

Figure 10.3

As you model you may want to start applying hard and soft edges. This is like smoothing groups in 3ds Max. To create hard and soft edges, select your model in Object mode, open Display/Polygons, and choose Soft/Hard Edges. Soft edges will be a dashed line, while the hard edges will be a solid line.

To create a hard or soft edge, select an edge and then hold down Shift + RMB to bring up the pop-up menu. Choose Soften or Harden edge and then choose again hard or soft edge. You should be able to use your own judgment to decide where the soft and hard edges should be.

Step 5

Further extrude the wheel arch edges out, as shown in Figure 10.4, along the side of the car. The technique of selecting edges, extruding them, and moving them to the shape of the car will be repeated a lot throughout the build.

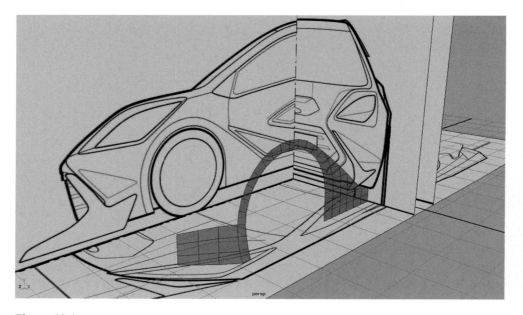

Figure 10.4

Step 6

Now we need to start to form the curvature of the wheel arch. Use the images as well as the blueprint to help you. You may notice that the blueprints don't quite line up perfectly in every view. This is quite common with many blueprints, as they are usually created by hand by the concept artist or from photographs. Very rarely do they ever match and if they do they are usually from CAD data.

Sometimes it is better to use one of the two views as your preferred guide. I generally use the side and the top views as my preferred modeling guides.

Remember, though, for this build they are only guides. Use your own judgment as the final word on what the car will finally look like.

Figure 10.5

Step 7

OK so now we have added a little more shape to the wheel arch and started to cater for the front head light. Keep extruding edges, manipulating vertices, and checking the model every few minutes from every angle. Slight adjustments to the vertices will be a continual process.

Figure 10.6

Step 8

Continue to extrude faces and adjust the vertices around the headlight, and start to build up the front of the car.

Figure 10.7

Step 9

Now that we have a little more geometry to look at, we can assess the shape a little bit more.

We need to finish off the front, bottom part of the bumper so we can visually understand the shape of the contoured detail directly underneath the headlight.

The rest of the bumper is obscured by the front wing and splitter, so a little bit of guesswork will be required here.

Figure 10.8

Step 10

Now we have the bottom of the bumper blocked out so, we can put the contour detail in.

The shape for the bottom isn't exactly correct at this point, but with the contour part filled in, we can see what we need to adjust to improve the shape.

You may notice that my contour section does not correspond exactly to the blueprints, especially from the side. I'm using a bit of artistic license here, as I believe that it would be very difficult to achieve the look of the concept images otherwise.

Figure 10.9

Remember, only use the blueprints as a guide and use your own judgment to make the final call on form.

Step 11

Now that the contoured detail has been fleshed out, we can start to work on the headlight shape. Don't focus too much on the fine details at this point, as we can get to them later.

You may notice that the headlight does not quite line up in all the views. Don't worry about this, and use your own judgment and the 3D concept sketches to line everything up how you want it.

We will be creating most of the smoothing on this model with bevelled edges.

Figure 10.10

Step 12

From the headlight we can now extrude multiple edges to create the bonnet/hood and the front of the car. We will have to add more subdivisions into the model where the front grille is, because of the very curved edges on the mouth of the grille.

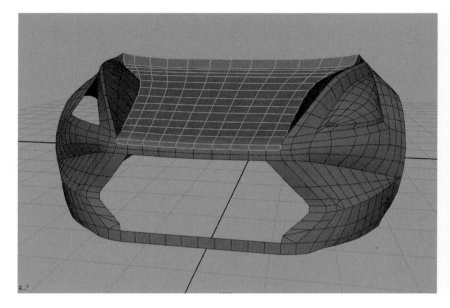

Figure 10.11

Step 13

The hood and front should now be filled in. If you look at the hood it is currently very flat. Perhaps this is a little too flat, so I can detach the hood and use a lattice to give it a little more shape.

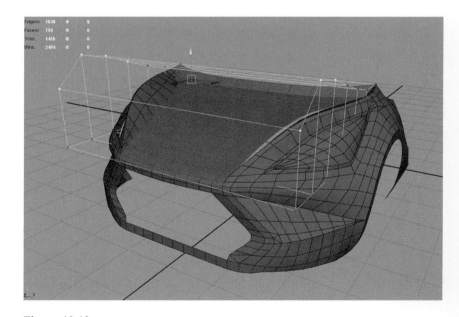

Figure 10.12

Step 14

After a few more minor adjustments to some of the vertices, you should have something that resembles Figure 10.13.

Figure 10.13

Step 15

Now it's time to fill in some of the polygons for the front grille. Extrude the outer edges of the grille opening and fill in the hole so it is totally closed off. You can do this very quickly by using Mesh > Fill Hole and then cutting across the new face to match up all the vertices horizontally and vertically with the split polygon tool.

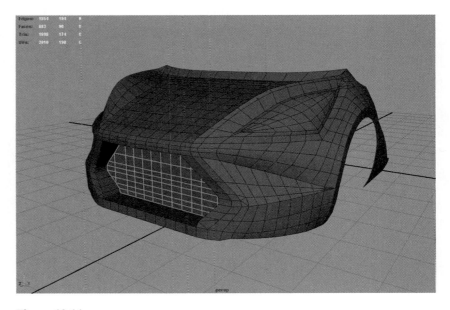

Figure 10.14

Step 16

As the front has been blocked out, we can carry on building the rest of the car. From here I have started to build in the sides of the car. This design is quite complicated and lots of care and adjustments of the model's surface will be necessary as you progress through it. I have started this by getting the edge of the door area ready.

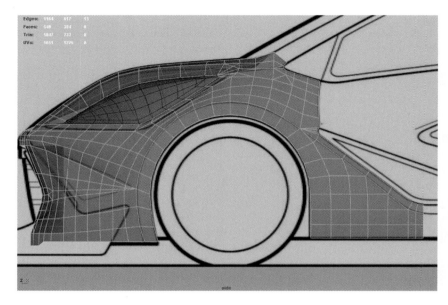

Figure 10.15

Step 17

Now it's time to fill out the rest of the door by extruding the rest of the open edges. Continue to try to use quads for most of the construction. Build the areas around the vents in the door while you are constructing the door. Make sure you keep checking the shape you are creating in all the viewports, and remember that the door is quite a complex, contoured shape. It's also a good idea to start building the A-pillar that also forms part of the door.

Figure 10.16

Step 18

By this stage most of the door should be complete. We now need to fill in the window area and finish off the rear of the front door, ready for the rear of the car to be built. To build the window you may want to create a plane with the correct subdivisions in the mesh and then manipulate the shape with a lattice. Don't worry if you can't get the exact shape, as you can modify this later. You can also use soft selection if you feel more comfortable with it.

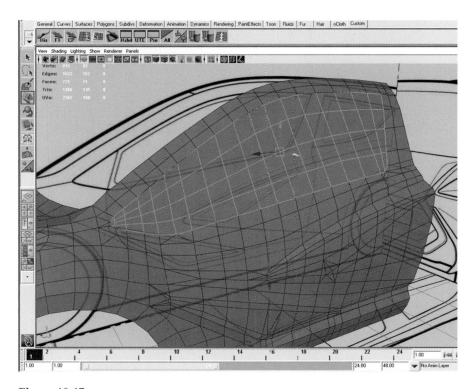

Figure 10.17

Step 19

Before we move on to the rear part of the car, we can build the area for the front windshield and the first part of the roof. As we build the windshield, make sure there is a lip that separates the hood with the windshield bottom. This will look more realistic in the final model as it will make the hood appear to be separate from the main body of the car. To create the windshield you can use the same method that you used for the side door window, or you can model it by hand.

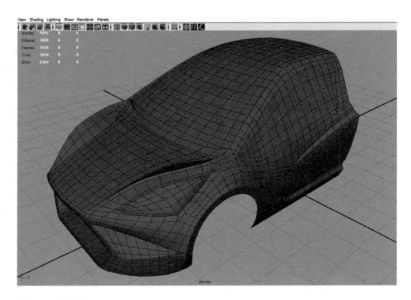

Figure 10.18

Step 20

Now we can look at the rear part again. Once again I am going to start building the back of the car using the rear wheel arch as the main control area. The rear wheel arch will be created using 32 subdivisions just like the front. You can create a new primitive cylinder or you could just copy the front arch. If you copy the front, remember that the curvature of this part

Figure 10.19

won't match the back, so you'll have to adjust it accordingly. Also remember to blend the wheel arch in with the side skirt.

Step 21

Now the rear wheel arch is in place and the side skirt has been blended in to the rest of the car, we can now join up the rest of the side with the rear wheel arch. You will probably need to add a few more subdivisions to the side so that the mesh flows continuously into the rear wheel arch. To better facilitate the shape of the side, I built a quick NURBS spline cage that I used as a guide to fix the curvature and to give a better surface. Use soft selection, lattice alter the vertices manually.

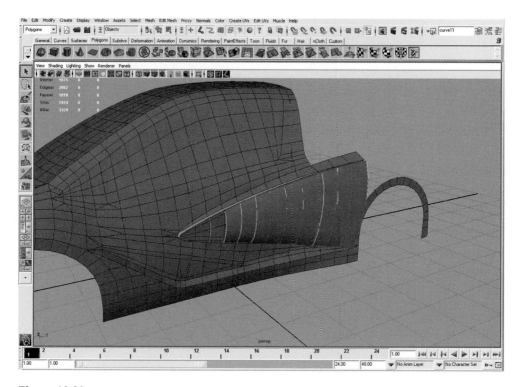

Figure 10.20

Step 22

Here is my finished version of the side that merges into the rear wheel arch. Don't worry if the surface isn't perfect; these blemishes will either be ironed out or less noticeable when you start to add detail like bevelled edges, the shut lines, and the door intakes to the mesh. You can always go over the mesh at this point and modify any vertices, edges, or faces you don't like.

Figure 10.21

Step 23

Now we can complete the rest of the side up to the rear light.

Figure 10.22

Step 24

Once we have most of the side modeling in, we can create the rear side window. This will be created in the same way as the front side window. Once the side window has been created you may need to adjust some of the vertices around the window to make sure the surface is smooth.

Figure 10.23

Step 25

We now carry on extruding faces around to start building the back. This will be a bit tricky because quite a bit of the back at the roof area is hidden by the rear wing. Look at the reference materials and try to judge, as best as you can, how you think it looks. Remember to build in the area for the rear light cluster.

We will build the rear window at the same time, as this will help us connect the back together. The rear diffuser will be built separately. Be aware that some of the previous mesh you have built around the rear wheel arch may have to be altered to curve around to the back.

I intend to make the back slightly more curved than it shows in the blueprints, because the back looks more curved in the concept sketches.

I have corrected the shoulder line at this stage on my model by pulling it in more than it was originally. You may want to do the same to your model if you built it in a similar way. This should give the model a more accurate appearance and make the shape of the back flow better.

I have also added a new subdivision in the shoulder area to give more resolution in the curve that flows all the way around the back.

Figure 10.24

Step 26

Now all that we need to do to complete the first pass of the body shell is the rear diffuser. Carry on extruding the faces around the back area, adjusting the vertices to fit the shape. At this point, you may also want to quickly look over your model to see if any minor adjustments need to be made. I have made a minor adjustment to the rear window and made it slightly more curved.

Figure 10.25

Step 27

You should now have the first pass body shell complete. We will now go through a second pass on the body shell, putting in more detail where it is needed. This will include rounding off and bevelling edges, making the details for the side intakes, shut lines, and body panel splits. We will add more detail around all the windows and just generally tidy up the model to make it look more realistic.

At this point, you should make any major adjustment to the overall shape if you are not happy with it. The reason for this is that it will be a lot easier to do now, before you start adding more detail. Obviously you can't foresee all possible problems, but anything that doesn't quite work should be addressed now.

Figure 10.26

For this detailing pass, I'll start again from the front and move toward the back of the car.

I will start by adding detail to the front grille area, bevelling the edges and modeling in the shut lines for the bumper and hood. When you start bevelling the edges you will get some stray edges and vertices that you will need to manually clean up. The settings I use for the bevel tool are width of 0.2–0.3 and segments of 2, but feel free to use your own settings. These settings will vary slightly with different parts of the model.

You may notice that Maya seems to alter the thickness, even though the settings haven't changed. Maya is using the mesh as the guide and if the original setting you enter does not match what you expect, undo the bevel and enter another thickness. You may even need to enter a value greater than 1 to get the bevel line to match up in some places.

If you have problems bevelling any areas in Maya, then try to break up the bevel process into smaller sections. Breaking it into smaller parts also helps you refine the mesh more precisely. When you come to bevelling the shut lines, remember to make the edges all hard edged. Overemphasize the shut lines a little too, to make them stand out. This will help to define the edges in a game engine environment. You will also need to sink the middle divided edge into the car slightly to simulate the recessed look to the panels.

Step 28

We continue with the beveling and shut line process to complete the front headlight area. Note that the shut line from the headlight continues until it reaches the door.

Figure 10.27

Step 29

Extend the shut line for the door shape and also the window. You will need to add part of the door corner that extends from the A-pillar section of the car all the way to the B-pillar.

Part of the door shut line isn't really clear, so for this I have made it cut part of the side skirt.

Figure 10.28

Step 30

Once the main shut lines have been constructed for the door and you are happy with the result, it is time to cut out the shape for the door window, using the blueprints as a guide.

Once the cutout has been made, make the recess for the window by extruding and scaling the inner portion of the glass smaller to make a lip.

Figure 10.29

Step 31

To complete the first pass on the door we need to add some detail to the intake vents. We will build shut lines into these areas too, but this time making them a little more subtle. We will also close off the holes to give the illusion that they lead somewhere.

I have made the vents how I believe they might work, which differs slightly from the concept. I've built them so that the front vent leads from the engine and front wheel arch to remove hot air, while the rear top vent sends cool air to the rear of the car for aerodynamics and for the rear brakes.

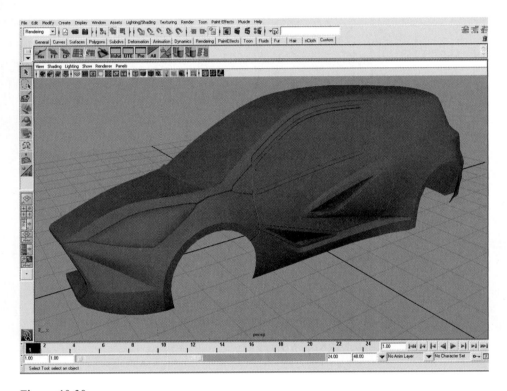

Figure 10.30

To make the vents, I refined the shape a little to give the model more rounded corners. I then detached the inner faces and used a lattice to manipulate the inner shape to fit. I then attached the shapes and filled in the holes.

Step 32

Once the vents have been completed, continue with the shut lines for the rear side window, and the side window. Create the window in the same way as you did the door window.

Figure 10.31

Step 33

Before we move onto the rest of the details for the rear, now would be a good time to build in more detail for the front windshield. This will be easy since most of it has already been done as we were creating the model, but it will need smoothing off in some areas. We will also need to build in the black area around the screen that hides the structural pillars of the car. I have created another simple material with its transparency set partially so that I can see the windows more clearly.

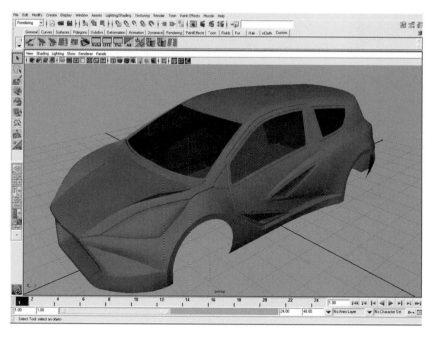

Figure 10.32

Step 34

We will now add more detail to the rear lights and the rear window.

The details for the rear lights will be completed using the same process used for the front headlight. The details we will be putting in the model at this point will only be for the clear glass that covers the rear light cluster. We will add the actual inner light cluster detail later on in the build.

At this point, I have also added some quick cylinders for the wheels to help visualize the final car.

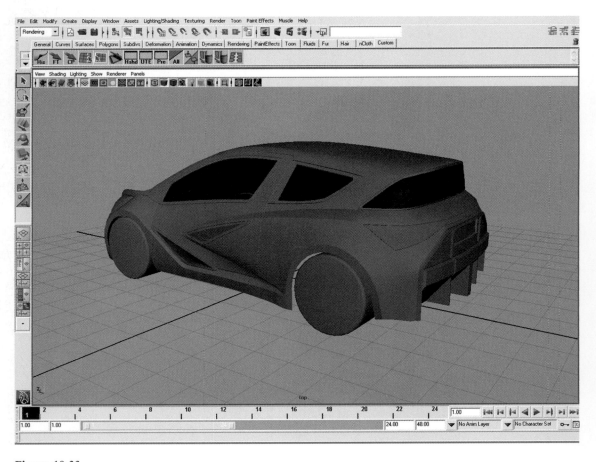

Figure 10.33

Step 35

Now we will add similar details to the rear diffuser, including some holes to house the exhausts. To add the holes I used the Boolean tool.

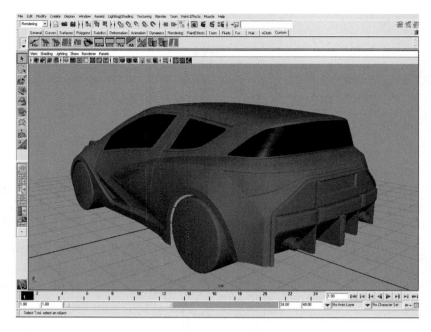

Figure 10.34

Step 36

On my model, I have added a shut line for the trunk, which doesn't appear on the concept. Decide how you would want the trunk to open and create one too. I have also made the headlight and rear light transparent, ready for making the light clusters.

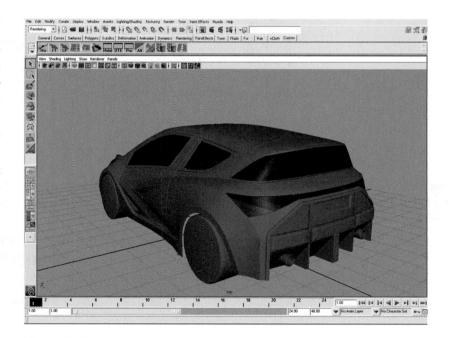

Figure 10.35

Step 37

Next we need to add two more shut lines either side of the roof.

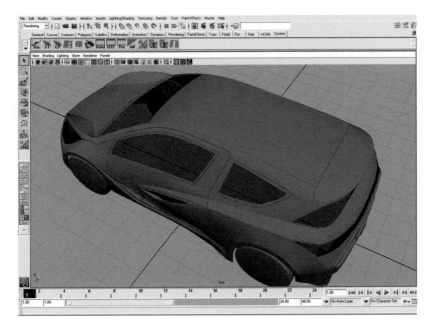

Figure 10.36

Step 38

Now we can move onto the headlight cluster. As the reference images are more conceptual than technical, there isn't a lot of detail for us to follow. If you are working on a similar build in the future, you can always ask the client or designer for a detailed close-up, or you can design the cluster yourself and send it off to the client for approval. On this occasion, the side view shows the most detail; however, feel free to use your imagination if you'd like to create something unique.

I am going to model the lights as they are shown in the design. I will create these by detaching the glass and extruding the edges around the light to get the basic structure. I will then use a set of three cylinders as a guide to make the headlight cluster. Next, I will fabricate and attach the outside structure, building from the outside to the inside.

The actual light cluster looks to be a teardrop, so the cylinder may be able to be manipulated into the required shape. You can always just keep these as guides, though, and create the cluster shape from scratch.

You may find it easier to Boolean the cylinder into the outer light shell to start the model off; this will take a lot of vertex, face, and polygon manipulation, though. This is the method I used to start the light cluster off.

Figure 10.37

Step 39

The front headlight cluster has now been completed. I stuck with the cylinder shape for my lights as it seemed to give the best result. I also added a little extruded cone, to act like bulbs sat in the reflector. This could be detailed further at this point, but remember to keep an eye on the polygon count. We can always add more detail in this area at the end of this round of detailing.

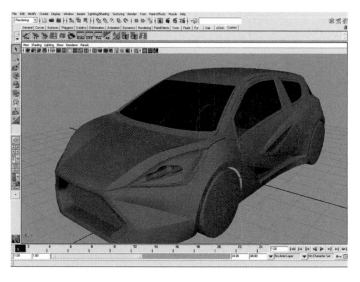

Figure 10.38

Step 40

Now we move to the rear light cluster. Again, we can be creative with the design here. The same techniques will be used here as we used on the front headlights. Note that there seems to be a small vent detail at each end on the outside of the rear lights. For this I used the Boolean tool to cut out some primitive cubes.

Figure 10.39

Step 41

Before we move onto modeling the wheels, I'm going to round off the shoulder line from the tip of the rear light down to the top vent situated in the door. This will help to soften it slightly.

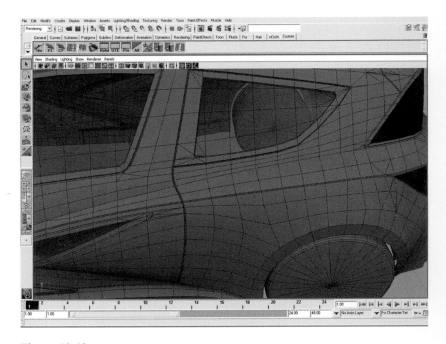

Figure 10.40

Step 42

Now we can move onto the wheels. You can use the placeholder wheels as a base model or feel free to model them from scratch.

We will keep the same subdivisions as the placeholders (32 segments), but we will add more subdivisions to the width of the tire and make them slightly more rounded.

I have put the wheels on another layer so we can turn them on and off independently from the car body.

Now we can divide the wheel thickness. I have used the Insert edge loop tool (multiple edge loops, with Use Equal Multiplier checked) and I manually scaled the edges. I then shaped the sides of the tire by scaling them slightly to get the slight curve. Feel free to use the side concept sketch as a guide for the wheel since it contains more visual information than the blueprints. I have used my eye as judgment for this, as it should be fairly easy to get the wheel looking correct.

Figure 10.41

Step 43

With the tire complete, we need to move onto the hub. Use the blueprints to judge the size of the rim for the hub, and then delete the center face, leaving the main radius of the tire. Once deleted, select the inner edges and extrude the faces. I have extruded the edges a little over halfway to the edge of the hub on the blueprints. The hub line on the blueprint may look a little too thick since these wheels are low profile, so adjust as you see fit.

Figure 10.42

Step 44

Now we can carry on creating the rest of the wheel hub. Select the edge on the outer side of the wheel and extrude the edges at different thicknesses, creating a convincing wheel rim. The back of the rim should be fairly simple and not as elaborate as the front, to keep the polygon count down.

Figure 10.43

Step 45

Once the rim has been modeled, we now move onto the spokes of the wheel. The best way to do this is start from the center, work out how many spokes are needed (in this case 15), and create a center cylinder with the correct number of divisions so you can extrude the parent spoke.

Figure 10.44

Step 46

Once we have the parent spoke, we can now add detail to it, like bevelling the edges and generally manipulating it so that it resembles the concept images.

Figure 10.45

Step 47

Once you're happy with the parent spoke, delete the rest of the cylinder and you can either use the duplicate special (rotate 24 degrees with 15 copies) or you can manually duplicate and rotate (with snap on and step size set to 24) to create the rest of the spokes. A tip to using the duplicate special is that you can create the spokes as instances so you can work on the parent spoke with the other spokes getting updated at the same time.

Figure 10.46

Step 48

The wheels are now looking good, but the spokes need a little more work. If you look at the ones in the concept sketch you will see that they join up higher in the spoke fingers. While we have the other spokes as a guide, we can model this detail in.

To create this, select the open edges at the back of the spoke and scale them out a little. You may have to manually adjust the vertices down in the spoke finger corners also. I then added another subdivision inside the spoke sides to allow a more curved look, especially in the center area. I also bevelled the center section of the spoke where it meets the center hub to round it off. Depending on how you created your spokes, you may have to do this too. Don't forget to close the back of the spoke up once you're finished. Do this on the parent spoke and then duplicate them again, or if you have instanced them, then they will update automatically.

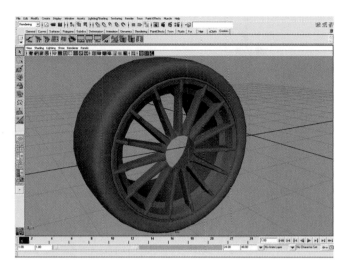

Figure 10.47

Step 49

The only part of the wheel left to model is the center of the hub and a racing wheel locking nut. If you've not seen them, a racing wheel locking nut is simply a six-sided cylinder with bevelled edges, with a depressed center section. Don't forget to fill in the back, once you've modeled this.

To finish off, I created a cylinder with 30 sides and combined it to the main spokes. I then filled in the holes. I added a bevelled edge to the tire rim on the inner depressed parts, as it looked a little too sharp. The spokes have now been combined to the wheel and I have copied the wheel to all the remaining wheel arches.

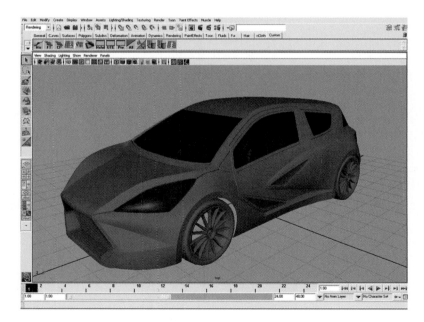

Figure 10.48

3D Automotive Modeling

Step 50

Now that the wheels are done, we will make a fairly low polygon brake disc and calliper to sit behind them. For my model of the brake disc and caliper I searched the Internet for some reference material, since no specific parts were detailed in the concept art. These shouldn't be highly detailed, as they will only be partially visible.

Figure 10.49

Step 51

Now that we have a brake disc in there, we need a brake caliper to fit onto it. Again, the Internet is a great source of reference details like this. If you search for "racing brake caliper" you should find all the reference material you need to model this part. The only thing you need to remember is to keep it fairly simple. Here I started with a rough shape of the caliper created from a primitive box.

Figure 10.50

Step 52

Add a little detail to the caliper to make it more refined. Once you are happy with the shape go ahead and bevel the caliper to finish it off. Then just copy the brake discs and calipers to each wheel.

Figure 10.51

Step 53

Since the wheels are now finished we need to create the inner wheel arches so that we can build a simple suspension model, wheel carrier, and arm later in the build. Having the wheel arch allows us to understand how much space we will have. The insides of the wheel arches are simple to make; just extrude the outer edges and cap the inside off. You may want to give the outer edge of the wheel arch a thickness so it looks like it is made from a solid material like aluminum or carbon fiber.

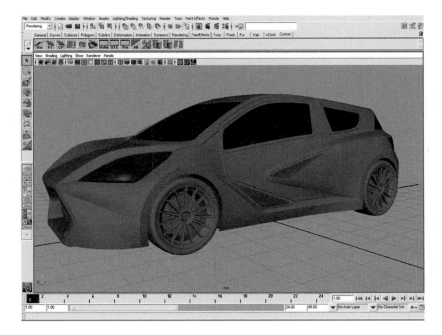

Figure 10.52

Step 54

With the wheel arches filled in, we now need to make a basic underside for the car. We don't have any specific concept requirements for this, so use the Internet to give you some understanding of what the underneath should look like.

If you look at what I have done with my model, you should see that it has just enough information in it to look convincing, should we ever get a glimpse of the vehicle in a game or reflected in the floor. This will look much better when we have put a texture on it and with shadows and details baked in.

I created the underside by extruding the surrounding outer faces and adding basic detail where I thought it was needed. The wishbone arms are combined with the underside, as they are not required to be separate on this model. I have also built a transmission tunnel for what would be a four-wheel-drive system.

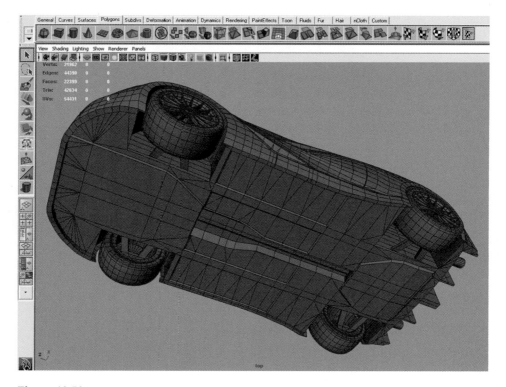

Figure 10.53

Step 55

Now that the detail underneath the car is complete, we need to build a suspension arm and wheel carrier, which we will attach to the brake disc and wishbone system. Again, these don't require huge amounts of

detail as they are rarely seen. The spring will be created using a cylinder that will have an alpha mapped spring texture to make it look more convincing.

The suspension I decided to create for this car is based on a Macpherson strut. This type of suspension can easily be found on the Internet. The strut arm is simply a cylinder of 20 sides, with the bottom face extruded multiple times to different sizes.

The wheel carrier is simply a box that again has had the front face extruded a few times and the vertices moved to shape the carrier. Finally, a 12-sided cylinder has been Booleaned, which guides the drive shaft.

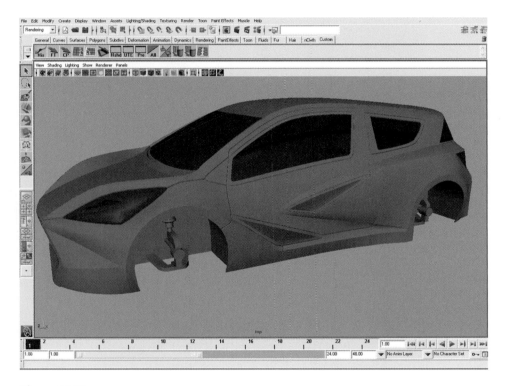

Figure 10.54

Step 56

Now the suspension is complete, and all that remains to be built is the interior.

The interior for this model will be very basic, as it is only required to deliver a silhouette of suggested detail, since the windows will be very black. The interior will also be assigned a black material for the final render, so we can keep it basic.

Most of the interior will only be created to fill holes that are currently present in the model. A set of chairs will be suggested by creating only the top parts that will just be visible through the dark glass. This is to convince the viewer that they are looking at a real car with a full interior.

To model this part of the model, you will once again have to use your imagination. Just remember to fill all the holes and maybe create a simple dashboard to improve the authenticity of the vehicle when viewed from the front.

To start the interior modeling, extrude the edges from all the windows and then begin to fill in the gaps.

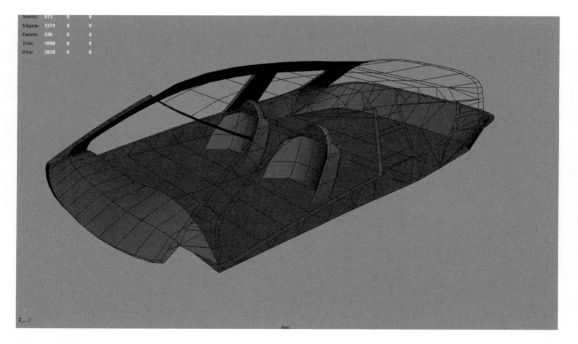

Figure 10.55

Step 57

The only remaining parts to model are the front and rear wings and the diffuser tail arms. You will probably need to reference the blueprints again at this stage. These can be quite tricky parts to get right.

To model these I used a NURBS spline as very rough guides. I started the shape from the side and used a primitive plane to create the shape. I set the divisions to suit the level of detail I wanted but, as you can see, the result is still quite rough.

Figure 10.56

Step 58

After working into the shape a little more to make it smoother and continuing the side into the floor, the front wing is now ready to be made a little thicker. Remember to keep checking the shape as you go.

Figure 10.57

Step 59

To give the front wing thickness, I duplicated the initial mesh, reversed the polygons, and then offset the duplicate. You will need to scale the duplicate faces, but you will have to do this in two stages. I did the side of the wing separate from the bottom of the wing so as to keep the scale relative to the original. Once I was happy with the result, I then combined both the top and the bottom surfaces and then created faces to fill the gaps between them. You can do this by creating faces manually or you can bridge the polygons.

Figure 10.58

Step 60

At this point I have also bevelled the edge of the front wing and softened the edge. Make sure you check over your mesh after the bevelled edge command has been applied to remove any unwanted polygons. I duplicated the original side of the wing and then combined and merged the vertices together to create the opposite half.

Figure 10.59

Step 61

Repeat the previous process for the front wing to create the rear wing. A loose NURBS spline outline is created to help me figure out the shape.

Figure 10.60

Step 62

After working into the shape a little more, I am now ready to give the rear wing some thickness.

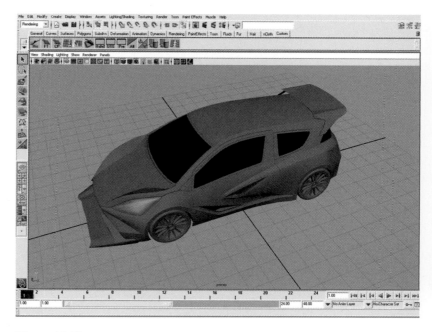

Figure 10.61

Step 63

Now that the rear wing has some thickness, I can bevel the edges as we did for the front wing.

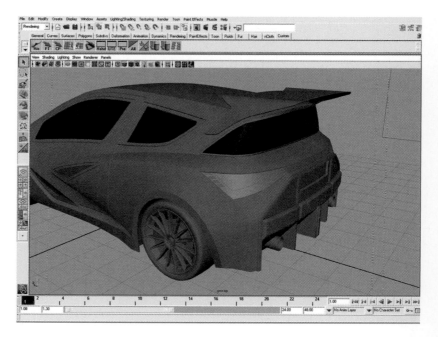

Figure 10.62

Step 64

The only remaining part of the model to complete is the rear diffuser arms. These are very simple to make. I initially started with a primitive plane and, using the blueprints, I created the shape. I then bridged the polygons to create the faces in-between. Again, I beveled the edges to soften the edge.

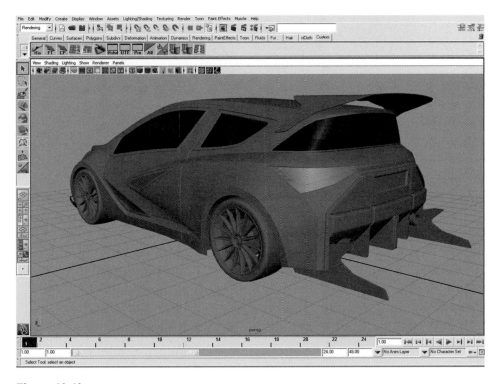

Figure 10.63

Step 65

The modeling is finally finished. Take a look over your model as a final pass to see if you can spot any problems. You might decide to add some more detail at this point or smooth off parts you are not quite happy about.

Also, now we have finished the modeling, I have taken the opportunity to clean up the objects, getting rid of the construction history, deleting unwanted groups, and just generally tidying up the model to get it ready for shaders and texturing.

Check things like the outliner to help you clean up parts of your model.

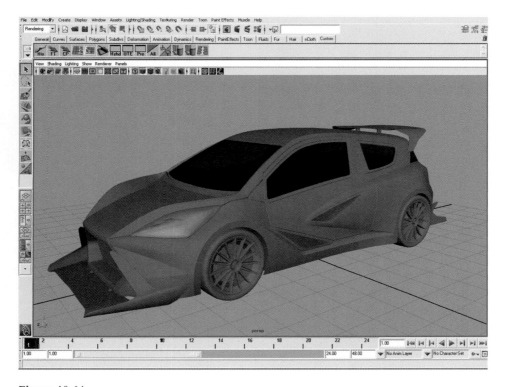

Figure 10.64

Even though I have started breaking up the model ready for texturing, we will no doubt have to break it up further, but for now, this will do.

Vortex Texturing

Step 1

To further help us with texturing and applying basic shaders to the model, I have separated some more parts of the car, like the inside of wheel arches and the underside of the car.

For this model we will use a combination of shaders and a few textures. In many game engines you would use proprietary shaders but we will use Maya's own and a few from Mental Ray. This set of lessons isn't really here to show you how to set up the shader to make the car look ultra-realistic, as that would be a little too much for this tutorial. It will, however, get you a good render.

The real lesson will be in how to lay out your UVs for the over body of the car. Back in the day, you would have to texture everything with a texture page. These days, with many next-gen titles, the shaders do much

of the hard work for you. Things like generic plastics and metals can be made as shaders. For these types of parts you may be able to use Maya's automatic unwrap.

The main focus for this tutorial is the main body of the car. The reason for this is to show how to map a livery to it. We'll also focus some attention on the tires so we can have a normal map tire tread applied. We'll also take a look at the suspension, the underside of the car, and the front and rear lights.

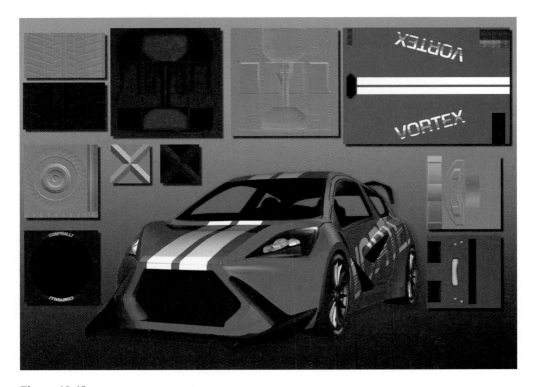

Figure 10.65

Step 2

Here I have applied a basic phong shader set to black to represent the black parts that are on the car. This separates the things like the window edges, the side intakes, the rear diffuser and headlights, rear lights, and the front and rear wings. The shader may well be changed in the future, but having it on here makes it very easy to select those parts if the phong shader needs to be changed for the final render. The exhaust also has a shader applied, as do the front reflectors in the head lights—these are all phong shaders.

I have played around with the colors a little as well as the reflectivity, making some less or more reflective. I have also created a matte black lambert shader for things like holes. I will apply this shader to parts like the exhaust holes and the side intake holes so they look like holes when rendered.

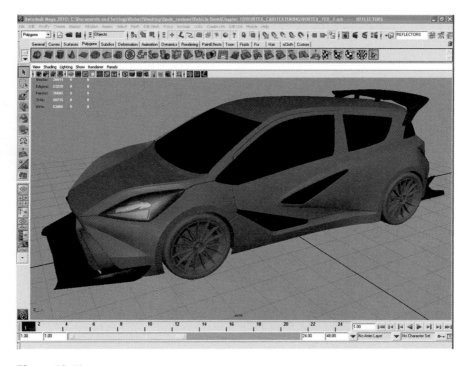

Figure 10.66

Figure 10.67

I have also added three spot-lights, set up in a basic three-way lighting technique, which gives a good simple light solution.

Figure 10.68

Step 3

At this point I have added a Mental Ray mi_car_paint_-phen1_x_passes shader. This shader can be found in the hypershade window. Pick Created Mental Ray nodes and under the Material tab you will find it. This is a really good but quick shader for you to make the color for your car. By playing around with the base color, specular parameters, and flake parameters, you can get a really nice shader, quickly. This color won't be used in the final version, as we will be using a texture map created in Photoshop, but it will help you to check the surface of the car for any defects or odd-look-ing shadows.

Figure 10.69

Once I had created the shader for the body of the car, I duplicated it twice, one for the wheel alloys and another for the wheel locking nuts. I then changed the colors to white and blue, respectively. I have also altered some of the parameters for each.

The wheel alloys had to be altered the most, as I don't want them to appear metallic with the flake paint. I also had to alter the ambient light to bring out more of the detail in the spokes when rendered.

Unwrapping the body is also started at this point. You could use Auto unwrap to help you, or any form of pelt mapping that automates the process if you have one, but to be honest it is very quick to do it manually once you know what you are doing.

I have applied a planar map to the whole car from the left side. Once applied, I opened the Attribute editor to set the mapping to be 1 to 1. I plan on separating the mapping into parts split by natural edges and shut lines. By that, I mean any natural edges on the model, especially a shut line between a hood or a bumper, will be treated as separate objects. It will become clearer as we go along, but at this stage I have mapped the front of the car by selecting the polygons I want to map and then, again using the planar mapping technique, split the UVs where the shut lines appear between the front of the car and the hood.

A tip when coming to unwrap the body is to use a texture with a grid-like pattern, which will help you line up the mesh and keep the car UVs in ratio to each other. In fact, you can use this method for any model you make.

Step 4

Here the body of the car has been cut in half with one side deleted. I have continued to unwrap the body of the car. Working with planar mapping techniques and with the same philosophy using shut lines and natural edges, this is the outcome of the unwrapping.

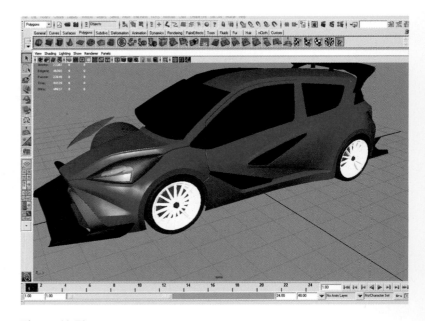

Figure 10.70

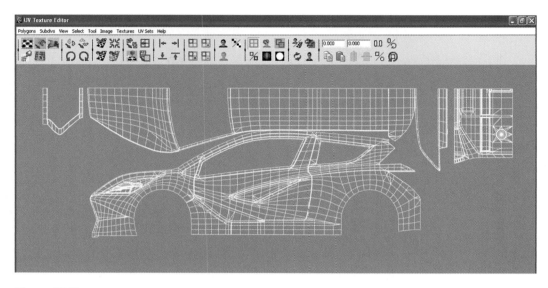

Figure 10.71

Step 5

The car body has been mirrored, and most of the body has been unwrapped. The whole process should only take a couple of hours.

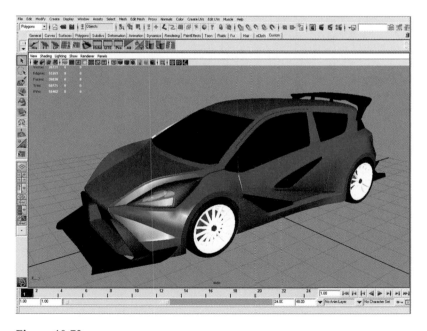

Figure 10.72

Step 6

The rear lights and the front indicators have been made as separate objects. I have created two new shaders with one a dark red color and the other a yellowish orange.

To map these, I have planar mapped them individually at an angle (using the texture gizmo). This will make mapping the light easier, plus it will stop the texture for the lights looking stretched. I have also applied the matte black hole shader to the interior of the wheel arches.

I was going to texture these with a map, but to be honest, in a render you won't really see anything, plus we have the suspension to help to detail those areas. The rear diffuser light has also been given its own shader.

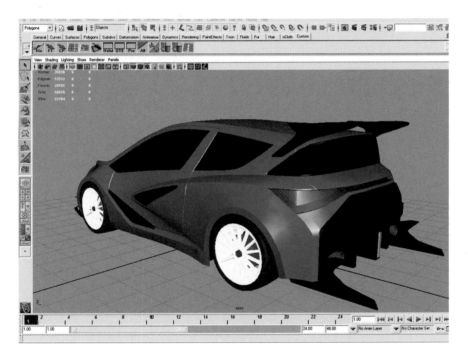

Figure 10.73

Step 7

At this stage I have applied a planar map to the whole of the underside of the car. I have also started to apply auto unwraps to things like the inside of the wheel arches, the windows and glass, and the front and rear wings.

I will be doing auto unwraps to everything that does not require specific mapping. Unless you want the front and rear wings to be made from carbon, for example, or if they need to have logos added to them,

then unwrapping them manually may be time consuming for the little gains you'd get in quality. It is best that you spend your time unwrapping things manually that really need them.

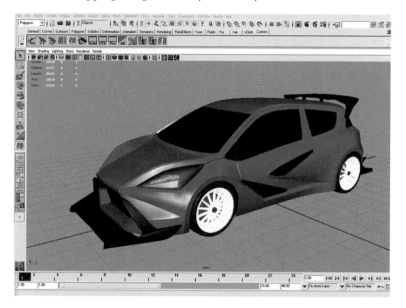

Figure 10.74

Step 8

Now that the majority of the car has been split into shaders and the unwrapping has been applied to the body, we need to create some normal maps for specific parts of the car like the tire treads, the underside of the car, and the suspension.

Normal maps, if you don't already know, store complex geometry data in the map and when applied to low-poly geometry can make it look a lot more detailed than it actually is. To create our normal maps we will use Maya's Transfer maps function. This can be used to get details from a high-poly mesh to a low-poly mesh. We will create a higher poly mesh in Maya and then transfer the normal map information to a standard primitive plane. This will become clear as we go through the process.

The higher resolution meshes we are going to make don't have to be pretty and neat. In fact, to make some of these maps it is good just to have geometry intersecting other geometry. When it is rendered as a normal map, nobody will ever be able to tell the original mesh was untidy.

Here, I start to add polygon detail to a duplicate mesh of the underside of the car. Only the underside of the car is in this file. I have flipped the mesh upside down so the bottom of the car is facing up.

You should be able to see what I have done to the mesh to increase the resolution.

I have added details like chassis holes and bolt heads. I have recessed some more of the faces, to generally make it a little more complex. Don't spend too much time on this part unless you plan on being able to see the underside of your car a lot.

Figure 10.75

Step 9

Once you have made the high-resolution parts, create a primitive plane just slightly bigger than the original mesh.

Figure 10.76

Open up the Transfer maps, which is in the Rendering tab under Lighting/Shading in the menu. Add your plane as the target mesh and then add the source mesh. Make sure the envelope is 100%. You can turn on the envelope and display it if you like. Below that, you want to create a normal map and an ambient map (to help with the shadows). In the normal map and the ambient map settings, choose where you want to save the map.

For the normal map, pick tangent space. You could pick more rays than the default if you like, but beware—large normal maps can take a long time to render.

In the Maya common output tab, create the size of the map you want. We will make this 1024 × 1024. I have chosen medium sample quality. Then just bake and close the window.

You should now have two maps: one normal map and one ambient map.

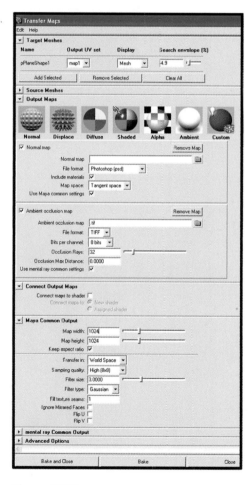

Figure 10.77

You will need to take the maps into Photoshop where you can now add a base color.

I have added a base color with a dirty texture overlay to make it look a little more realistic once mapped onto the car. From this dirty overlay you could create a grayscale specular map too. I have also manually added more shadows to help the overall appearance of the texture. You could create a specular map from your dirt map to help with specular highlights.

Figure 10.78 *Ambient occlusion, normal map, diffuse map, and specular map.*

Step 10

I have created a Blinn texture and named it underneath. I have turned down the reflection properties so it is matte in appearance. I have added the texture we created in Photoshop for the underneath to the base color. I have also added the specular map.

I have put the normal map into the bump slot and made sure that the bump map is using the tangent space normal and not the bump map. This can be found when you first open the texture into the bump map slot (found under the Bump tab).

Figure 10.79

All the shaders that use normal maps will be created this way.

Step 11

We now need to create a texture map for the tire treads. This will be a normal map for the tread and a separate map for the sidewall part of the tire. To create the tread we will use the same method as we did for the underside of the car.

If you look at the separate tread file, I have modeled a tread-like pattern intersecting the plane. The tread pattern is just something I thought looked good, made using reference images I found on the Internet for inspiration.

Figure 10.80

Once you have rendered the normal map and the ambient map using transfer maps, you will need to resize the tread texture and make it tileable.

Step 12

Using Photoshop, I have made the texture for the tread tileable and resized the file to 512 × 256. You will also need to make the base color in Photoshop. I have chosen a dark gray color with added noise. You could add dirt and other extra details like wear and tear in the rubber at this point.

Figure 10.81 *Normal map and the diffuse map for the tire tread.*

While in Photoshop, you will need to create the sidewall texture for the tire. The reason for having a sidewall texture is so we can have a branded logo on the side of the tire to give it a more authentic look. Again, choose the color of the wheel from the tire tread, add a little bit of noise, and create a logo for your sidewall. I chose a simple font and called my brand of tire Compralli (short for competition rally). You could also add a normal map for this part of the tire, which can help with the realism. The size of this map should be no larger than 512 × 512.

The tire has been cylindrically mapped (for the outer tire and inner hub) while the side walls of the tire and the hub, including the spokes, have been planar mapped. The spokes could have been unfolded, but unless you need that level of control it probably isn't worth spending your time on.

Remember to reverse the inner side of the sidewall so the writing is the correct way around.

Figure 10.82 *Tire sidewall diffuse texture and UV layout.*

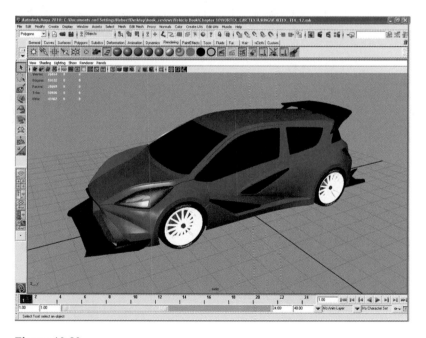

Figure 10.83

The shader I have used for the tire and sidewall is a Blinn. I have put the normal map into the bump slot and made sure that the bump map is using the tangent space normal and not the bump map.

Step 13

What we need to do now is to increase the resolution of the running gear slightly. This includes the brake disc, brake caliper, and shock absorbers. Don't go too far with this task as you won't see much of the work you put into this area unless you were to make a feature of it in a render, or the wheels are required to come off the car for some reason.

To achieve this increase in resolution, I have bevelled edges, inserted edges, and extruded faces, just simple techniques. For the drive shafts, I would leave them as they are and probably use a steel or metal-looking shader, unless you wanted it to look dirtier or rustier, which would require a texture map.

Once we have completed the higher resolution models, we need to create normal maps for the parts. For this we will use transfer maps again, but this time we will use Maya to map the objects for us. All we have to do is unwrap the parts and place them on the layout sheet as we see fit.

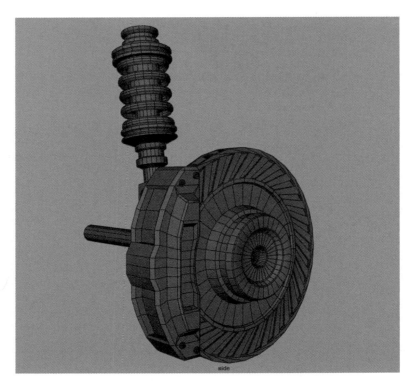

Figure 10.84

Step 14

Once you have unwrapped the low-poly versions of the running gear, combine the separate parts of high-resolution geometry together.

Next, name all the parts properly so they are easy to pick in the transfer maps box. I use High and Low suffixes to help distinguish the high from the low models.

Use the transfer maps as we have done for some of the previous models, but this time we will let Maya apply the shaders and the maps created.

A word of warning though—Maya sometime gets very confused with normal map creation. It sometimes has trouble with the envelopes on your model and faces that intersect the base mesh, causing render problems. If Maya does not give you the results you want, then the best thing is to do the normal maps manually from Maya. To do this, render the object onto a flat plane like we did for the tire and underside maps. You will need to do this for all the sides, but it works almost every time.

I have created the normal maps for the brake disc and caliper this way. You will have to manually configure the object with the normal map using Photoshop and apply the shader in Maya.

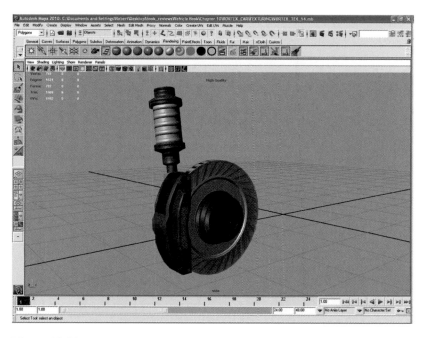

Figure 10.85

All the running gear will need only one normal map and ambient map created, while the spring will also require an alpha map. To view your normal maps, you can use the high-quality rendering in the viewport. If your normal maps appear the wrong way around, then the easy way to fix them is to invert the problematic faces in the UV editor.

Once you have created all the new maps and shaders, name them correctly for each part. You will also need to add a base color map in Photoshop to give each part a color and texture. You could add extra maps like a specular map at this point too, if desired.

At this stage, check all the maps you've just created. Make sure that the ambient occlusion maps are free from any defects caused by Maya. If you find any, the best way to clean them up is in Photoshop.

All the running gear maps only need to be 128 × 128 for the spring and the suspension arm or 256 × 256 for the brake disc and calipers, but if you want to get slightly better looking renders, create them at a higher resolution, 512 × 512 or higher if you wish.

Step 15

Clean up the file and delete all unused nodes and geometry (the high-resolution models). Tweak your UVs and try to get the running gear as clean as possible for it to be merged with the original car scene.

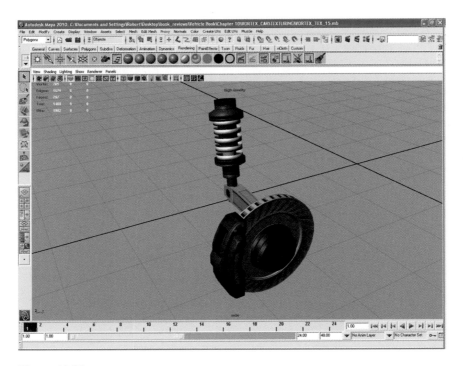

Figure 10.86

Step 16

With the car almost finished, it's now time to sort out the mapping for the body work of the car. You should have the whole body unwrapped. Place the entire unwrapped body in the UV square in the UV editor. We now need to create a snapshot of the UVs so we can work on a simple map in Photoshop.

With scaling the body to fit in the square, the ratio will now be incorrect. A simple way to get around this is to take a screen shot of the UV editor window, crop the image so only the UV space is in the image, and manually scale the image back to the correct proportions. This should be easy to judge by eye by using the wheel arches as a guide (make them look round again). When you are happy, check the dimensions in Photoshop, and then you can use these in the UV snapshot editor to get any size want.

The things added to this map are the main body, rear brake lights, indicators, and inside of the front grille. We will create a new map for the actual grille for more realism.

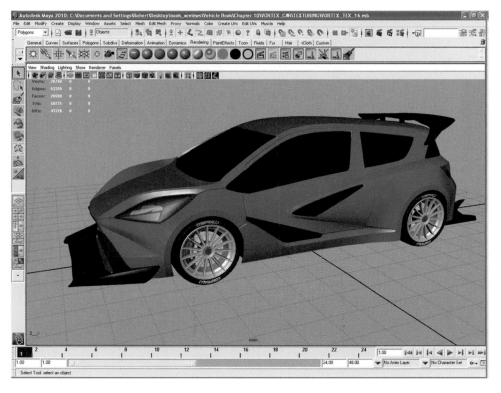

Figure 10.87

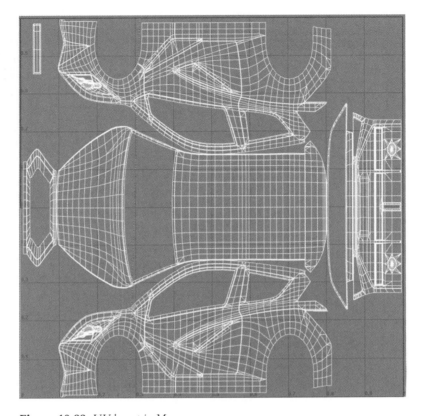

Figure 10.88 *UV layout in Maya.*

Step 17

Once you have the snapshot, open it in Photoshop and create a texture for your car. For this example I have created a simple livery, as you can see from the image.

On the livery you will need to create the light textures and an indicator light. You will also need to create a front grille on the texture page.

Once the livery has been created, you could either create shadows on the map to help with the shape of the car or let the rendering take care of the shadows completely. You could also use Maya to render shadows into a map for you.

You will have to create different shaders for the lights and the grille as you probably won't want these on the same shader as the main body shader or livery.

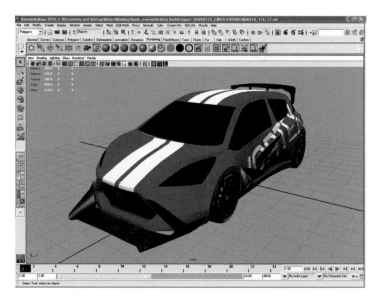

Figure 10.89

Figure 10.90 *UV layout in Photoshcp and texture map.*

Step 18

The car livery should now be finished. The only part remaining is a texture for the front grille. I have created a simple grille model. Only a small portion has been created because, once we have a normal map from the file, we can tile the texture. The normal map was created the same way as all the other normal maps.

Figure 10.91 *The diffuse map and the normal map for the grille.*

Step 19

The model is now complete.

Experiment with your shaders, cameras, lights, and Mental Ray settings to get different results from your rendered images. Experiment with HDR lighting to get even more realistic results. I have added a couple more lights to help with lighting the car and to help to accentuate details. These are a lot less intense than the main lights.

Congratulations for getting this far, and I hope you enjoyed the tutorial.

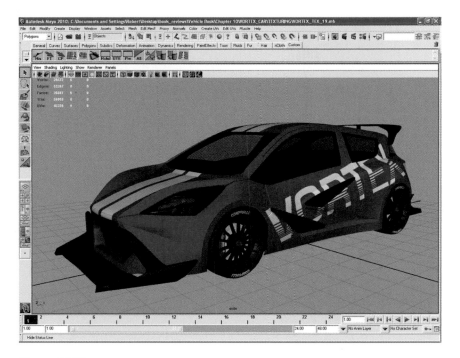

Figure 10.92

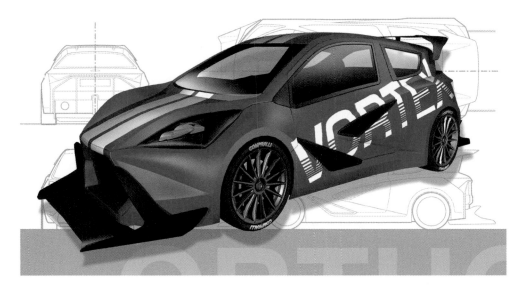

Figure 10.93

Chapter 11

Mobile Suit Concept

Paul Cartwright
Zero9 Studios

Figure 11.1 *The final Mobile Suit concept.*

3D Automotive Modeling. DOI: 10.1016/B978-0-240-81428-5.00011-2

Welcome to my Mobile Suit concept tutorial. I was approached by Andy Gahan to create a Mobile Suit concept and with little more than a basic outline brief I set to work. I'd like to take you through my creation process of this concept from start to finish, hopefully to give you an insight into how I work and also to provide the building blocks for you to create and improve your own work.

As this was a very open brief, I decided to kick things off by using Alchemy.

Alchemy is essentially a shape generator that has loads of options for creating random shapes. I find it very useful in the early stages of coming up with a concept. Alchemy is unpredictable and can really work wonders for your inspiration.

It's free to download at http://al.chemy.org/.

Shape Generation

The first thing I want to do is decide on the general shape of my mobile suit concept using silhouettes. Alchemy's shape generators used with its Mirror effect are perfect for this purpose.

I spend about an hour tinkering with the different shape settings and I don't worry about any fine details. At this stage I'm just trying to find a rough base upon which to build my design.

I keep my silhouette shapes varied; some turn out looking bulky and heavily armored, others are thin and insect-like, and some take on a more humanoid shape. Some are curvy, others sharp, etc.

Figure 11.2

Choosing My Direction

Once I've created a dozen or so rough silhouettes, I take them all into Photoshop and put them side by side to compare. Seeing them all together like this makes it easy to decide what works and what doesn't.

I get rid of the overly bulky shapes as well as the spikier-looking ones—as they look too similar to Transformers—and decide to refine the design of the rounder and more humanoid shapes.

Figure 11.3

Refining the Shape

Now that I've narrowed it down, I can use parts of the various remaining silhouettes to create a more refined design. I create a new document in Photoshop and drag the remaining silhouettes onto it. I place them around the edge of the document, leaving a space in the center where I can develop my final silhouette.

Using the Lasso tool I select parts from the various silhouettes and copy them to a new layer. Along with the Lasso I use the Transform tool a lot at this stage, constantly rotating and resizing the parts until I'm happy with the shape and proportions.

Figure 11.4

Adding Form

As soon as I get my overall shape done, I copy the refined silhouette into a new document so I can get down to designing it in more detail.

On a new layer using both a Soft and a Hard Round brush, I paint in some basic value to add form to the silhouette. I define the suit's head and the larger areas of armor, using just gray tones at this stage as it's easier to make quick alterations than if I was using color.

Figure 11.5

Control Pod

One of the things I particularly liked about this silhouette from the start was the circular area in the center. It's an ideal placement for the suit's control pod.

I decide I want the driver to look as if they are inside the suit's belly, so a glass sphere seems a good way to go. I zoom in now to add more detail. I make a circular selection on a new layer over the belly area and use a Soft Round brush to quickly paint some light and shade. Then I add a couple of highlights with a hard brush and add a layer mask to hide areas that are obscured.

Before adding more detail, I darken the background to a mid-gray. Painting on bright white can result in values being too dark and vice versa if on black.

Figure 11.6

Armored Panels

I create a new layer and start to refine the design of the suit's armor. I use a Hard Round brush for shaping the angles and a Soft Round brush for blending areas. I change the chest plates to be more rounded and work on sharpening up the edges of each panel to make them look solid.

For a lot of these panels I use the Lasso tool to select an area first and then paint inside it. This guarantees a nice crisp edge.

To save time at this stage I only work on one side of the suit at a time. I then duplicate my layer and flip it horizontally onto the other side.

Figure 11.7

Blending

When I'm happy with the overall look of the armor, I flatten my layers and open the image in Corel Painter. Painter has some great blending brushes for tidying up my rougher brush strokes and shaping edges. I grab the Just Add Water blender and zoom in closer and then quickly paint over any messy parts.

Figure 11.8

Contrast

Back in Photoshop I create a new layer and set it to Overlay. Then with a slightly textured brush I paint over the lighter parts of the suit to balance out the contrast.

Figure 11.9

Suit Development

While painting in the armor I noticed that the blocks either side of the sphere look like they could be shock absorbers that support the suit's chest and larger arms. This led me to see the bulky upper section as a separate attachment—used for heavier lifting or battle—which could be detached from the control hub entirely.

I enlarge my canvas vertically and use the Lasso to break the suit apart and move the heavy armor upward. Then I sketch in an alternative head onto the lower section. I also sketch in a human figure standing next to the suit to give an idea of the scale.

Figure 11.10

Putting It in Perspective

With my overall concept established, I can now use my front view of the suit as a guide to draw it in perspective.

I create a new document in Photoshop and, using guides and the Line tool, I draw a simple three-point perspective grid. I then paste in a copy of the suit and use Free Transform to match it to my grid. Now I can use it as a guide to line up the different parts of the suit to my new sketch relatively accurately.

I roughly sketch the suit from this new viewpoint, focusing more on getting the perspective correct rather than finer details. Drawing the suit from this angle will give the viewer a better idea of the concept as a whole by adding more depth.

I make sure I keep a copy of my rough sketch, as I'll use it later.

Figure 11.11

Tidying the Sketch

When I'm happy with the proportions of my rough sketch I lower the opacity and, on a new layer, use a thin brush to sketch in the details.

Figure 11.12

Blocking In

At this stage I also add some smaller details: some lights either side of the sphere, an infrared sensor to the bulky shoulder, and a ladder for access to the control hub.

I then gray my background and, on a new layer, block in underneath my line sketch with a solid darker gray. I click Preserve Transparency in the layers palette so I can paint quickly over the solid gray without worrying about straying outside my silhouette. I approach this blocking in stage very basically, just coloring in the separate parts in varying shades of gray to create a solid base.

Figure 11.13

Cheat Shading

To get some shadow around the edges of the suit really quickly, I take the rough sketch layer I put aside previously and put it on top of my flat gray layer. Then I remove all the white from this layer—I use a freeware plug-in filter from www.bergdesign.com for this called "Peel Off White" but the channels palette can be used just as easily—and then I use a Gaussian Blur filter to soften the sketch to the point where the lines are no longer visible. This is a bit of a cheat but saves time shading edges!

Figure 11.14

Light Source

With a Soft Round brush I now define where I want my main light source. To do this I create a new layer and, just using black and white, spray a loose gradient from top left to bottom right. I add areas of shadow and light to the more rounded armored panels, still keeping my strokes loose.

I keep my shading to gray tones and make sure I don't paint in pure black or white. Too much contrast can produce dark shadows that will obscure the details of the concept. I also paint some variations in tone over the background, just so it's not completely flat.

Figure 11.15

Sharper Shadows

Picking up a Hard edged brush I focus on painting in sharper shadows and areas where light would not reach.

Figure 11.16

Simple Background

I spend ten minutes painting some more detail into the background. Nothing fancy, as it's just to place the concept in an environment to make it a bit more interesting to look at.

Figure 11.17

Value Adjustments

I'm pretty happy with my gray values now but before adding color I increase my document size for a higher resolution.

I then merge all my gray layers together and blur a copy of my line sketch, which I also merge with the gray. Then I tweak the image slightly with a Curve adjustment layer to balance everything up.

Figure 11.18

Color Base

To quickly add a color wash over my concept I create a new layer and set it to Color mode. Using a soft brush I spray over the image in colors that are not too saturated. I adjust Color Balance until I'm happy with the overall palette. I settle on a lighter tone for the armored plates with a green-tinted control pod. This color scheme is definitely subject to change in the steps that follow, but using a Color layer as a base is a quick and easy way to kick off the process.

Figure 11.19

Sharpening Edges

On a new layer I use the Lasso tool to select areas of armor that could do with crisper edges and then paint inside my selection with a stone-textured brush. I alternate between Lasso and Brush tools and gradually refine the armor. I use the Color Picker to quickly select different tones from my canvas by holding Alt while in Brush mode.

Figure 11.20

Painting Freehand

With the armor plates now more defined, I paint in more detail without the aid of any selection tools using two different brushes. For shading I use the stone-textured one and for edges and finer details I use a small flat brush with Pen Tilt enabled.

As I paint freehand I add in things like extra panel seams, rivets, and vents to add more visual interest.

Figure 11.21

Hidden Mechanics

I notice that the suit's frame is looking a little bit light for how bulky and heavy the armor looks, so I create a layer underneath what I have painted so far and block in a heavier frame. I also paint some suggested detail in the darker areas between the armored plates. As these areas are mostly hidden beneath the armor and in shadow, I don't spend too much time on technical detail. Suggested detail such as cables and hard-edged metal with a few highlights picked out here and there will get the message across.

Figure 11.22

Control Pod

I draw a selection around the control pod and spray a smooth spherical gradient in green tones. Then to add some specular highlights I use Photoshop's Dodge tool on areas where the light hits the glass. When I'm happy with the pod's color I use a brush with a grungy texture to add dirt and scratches.

Figure 11.23

Adding the Lights

I now turn my attention to adding light generated by the suit—the suit's eye, headlamps, shoulder sensor, and various other LEDs. After adding the main color of the light, I pick up the Dodge tool again to boost the intensity of the center of each light source.

Figure 11.24

Light Reflection

The lights I just added would cast a colored glow onto the surrounding areas. To quickly achieve this effect I use a soft-edged brush on a new layer to spray color loosely around the illuminated areas and then use the Eraser tool to remove color where the light would not reach.

Figure 11.25

Scuffed Armor

A heavy suit like this would be used for work or battle that would see it take damage to its armor, so I decide to weather the surface of the panels. This is really quick to do by painting over the armor on a new layer with rough textured brushes and then tidying up with the Eraser.

Figure 11.26

Graphics

I had originally planned to use a camouflage print on the suit but it occurred to me that there would not be much point in it. With the suit being so big and having a number of glowing lights, not to mention the bright green control pod, camouflage wouldn't be much use.

So instead I decide to go with emblem placement and colored panels. I also add a serial number onto the arm.

I draw these elements on separate layers and then use the Transform tool to place them correctly. Layer modes Multiply and Overlay are useful here to blend the logos nicely onto the suit, and using a layer mask with a rough textured brush is ideal for adding wear and tear.

Figure 11.27

Adding FX

I use a cloud-shaped brush to add some steam coming from somewhere inside the mechanics of the suit. On an overlay layer I quickly paint pools of light onto the ground and sky to emphasize the surroundings. Then I use a grainy brush to add some dust here and there and add some rim light to the edge of the suit to make the silhouette stand out more.

Figure 11.28

Final Touches

With my suit concept pretty much complete, I zoom in and clean up any parts that look particularly rough. I add a vague silhouette inside the control pod to hint at a driver and then flatten all my layers and use the Curve adjustment to make all the values bolder.

Then I use the Sharpen filter, add a small amount of noise, and call it a day.

Figure 11.29

Thank you for reading this tutorial. I hope you liked it and I hope that you can use some or all of these techniques in your next piece of work.

Chapter 12

Modeling the Mobile Suit

Andrew Gahan

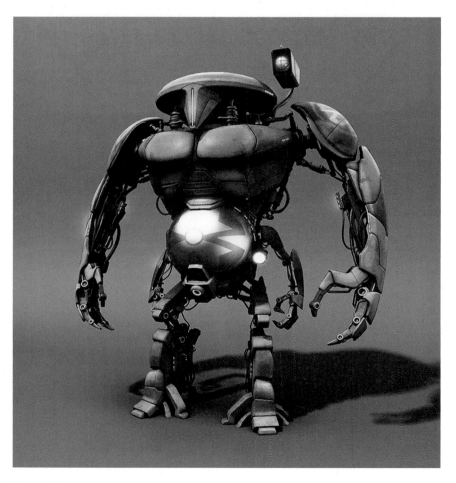

Figure 12.1

3D Automotive Modeling. DOI: 10.1016/B978-0-240-81428-5.00012-4

Step 1

First of all we will prepare our scene. To do this we need to make two planes, one for the front view and the second one for the side view, so we can assign our concept images to them to use as a guide.

Figure 12.2

Step 2

Now that we have our scene prepared, we can start to block out our model. We will start to do this quite loosely, to give us a better understanding of the overall shape.

Figure 12.3

Step 3

As we continue with blocking out the main forms of the mesh, you should notice that I am keeping everything quite simple and I'm predominantly using primitives like spheres and boxes.

Figure 12.4

Step 4

Continue to do this until you have the lower part of the Mobile Suit blocked out. We should now have a much better idea of the main proportions of the model.

Figure 12.5

Step 5

Now we can start to add a bit more detail to the head and the torso. At the moment we are just using a simple cutting tool in Editable Poly mode along with the Connect tool in Edge mode for making cuts between multiple edges. At this stage, take care not to add too many details as we are still only blocking out the main form of the mesh.

Approach this type of modeling as you would a sketch. Keep the forms big at the beginning and resist the temptation of getting into the detail until you have blocked out the whole shape in full and you are happy with the complete block out.

Any main detailing will probably be wasted work until you're sure that you are happy with the model. Refer to the reference every couple of seconds, and have it printed out and pinned up next to your screen or on your second screen.

Figure 12.6

Step 6

Now that I am happy with the overall shape, we can start to sculpt a bit more detail into the upper arms. We are using the same technique as before, just moving vertices along and cutting in edges when there aren't enough vertices to move around to get the rough shape.

Figure 12.7

Step 7

Continue to work detail into the lower torso and the cockpit bubble. Stick with the simple tools for now in Editable Poly. Cut to add edges where necessary and Extrude edges to make the thick walls around the cockpit bubble.

Figure 12.8

Step 8

For the protective cover over the cockpit bubble, use a sphere to get a nice round shape with clean geometry. This clean geometry will help us a lot when we move into the higher poly stage. Again, we are still using the basic Cut tool in Editable Poly mode, along with Edge extrude for making the thicker outer parts.

Figure 12.9

Step 9

Next we are going to connect the protective cover of the cockpit with the cockpit frame. For this, we will use the Bridge tool in Editable poly.

Figure 12.10

Step 10

Now it's time to add some details into the lower arms. To do this we will divide the box edges a couple of times with the Connect tool in Editable Poly mode and move the vertices around to fit the shape on the concept. For the back of the armor, just use Bridge to fill the space.

Figure 12.11

Step 11

Next we will start to shape the upper part of the lower arm. Continue with cutting in faces and moving the vertices around to match the concept. At this point, we can also move the blocked out hand into place and adjust it if necessary.

Figure 12.12

Step 12

Now that we have a fairly good-looking arm, let's do some work on the legs. To start off with, we need to cut in some extra polygons, and then for the toes we will use the Extrude polygon tool combined with moving the vertices around to achieve the right shape. Once we've completed the work on the toes, we've finished the second block out stage.

Figure 12.13

Step 13

OK, now that we have our model block out complete, it's time to bring the armor up toward the final level of details. We'll make a start of this at the top of our model.

To get started we need to add extra polygons on the edges around the top where we need to create the extra detail. To do this we will continue to use simple Cut tools and we will move a lot of vertices around to get the forms we require.

It's very important at this stage to *see* the details on the concept when you look at them and that you build what is there, rather than what you *think* is there. I know that this may sound a bit odd, but it's quite easy

to get carried away with a model and forget to really look at the concept. Remember to ask yourself questions as you go, such as, "How long is this part compared to this one?" "How does this connect to the model?" "What angle does this need to come out at?" and so on—I think you get the idea.

To help with this we will need to start to look at a higher resolution version of our model, so we will need to set up a Subdivision Surface, which can be found just below Edit Geometry in Editable Poly. Use NURMS Subdivision (by checking the check box) and under Display set the Iterations to 2.

We will use this tool a lot to get an accurate idea of how the final model will look. If you want to edit your model, though, I recommend turning this off due to performance issues.

Figure 12.14

Step 14

We are now going to add some extra details and refine the shape of the chest armor. We will be using exactly the same workflow as before, adding extra polygons using Cut, and then moving the vertices around to match our model to the concept art. The only difference now is that we will be turning on the Use NURMS Subdivision from time to time to see how our higher-res version is being affected by our changes.

Figure 12.15

Step 15

To make the cooling rib on the back of the chest armor, we will use the Extrude tool. To do this, we need to prepare the polygons where we want to make ribs, so select them and use Extrude. For my model I set the value to − 0.35 and pressed Apply. I then changed the value to + 0.35 and applied again. Use NURMS Subdivision to see how it looks. We will have some extra polygons at the edge where we will need to connect the mirrored part of the mesh, so we will need to remove them.

Figure 12.16

Step 16

For adding small details we can use a slightly different technique. Select the edges where we want to make a lip, and then apply a Chamfer and set the value to 0.1. Then clean up the areas where the chamfer has created unwanted geometry. Then select the edges in the middle of the ones we created with the Chamfer, and use Connect from Edit Edges, and a new edge will be created. Finally, just select it and move it inside the armor slightly. Check with Use NURMS Subdivision to see the result.

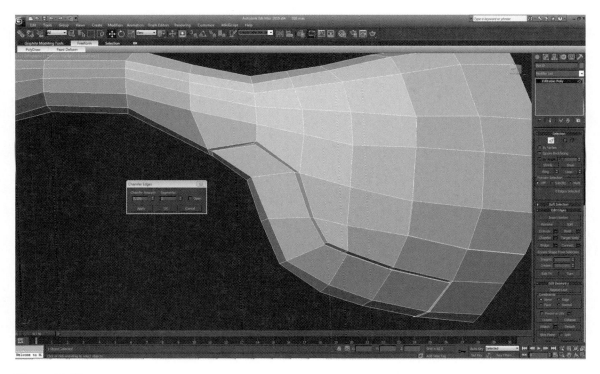

Figure 12.17

Step 17

Next, we will cut out all the details that we want to make up the armor. Remember that this is still not the final stage of modeling, so for performance reasons, try to keep the mesh under a reasonable number of polygons.

If you find that some of the parts of the armor don't look good in places where they join together, you can separate them, as I have done on the part under his chest.

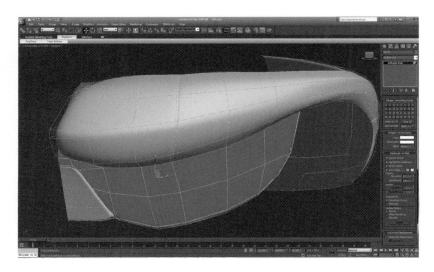

Figure 12.18

Step 18

Once you are happy with the look of the chest armor, we will move on to the shoulder part. We will start off with creating half of the shoulder, as this will help us to get a nice symmetrical shape. We will use the Cut tool along with moving vertices around to get a shape resembling the concept art.

Figure 12.19

Step 19

Now we need to put in any detailing that needs to be visible on the shoulder armor. Once again, we are only using the Cut tool and Chamfer on the edges to give us the nice edge transitions on the high-poly model version.

Figure 12.20

Step 20

With that part of the shoulder complete, we need to duplicate and mirror it. To do this, just use the basic Mirror tool from the top toolbar. Next we need to align the new half of the shoulder with the first one and attach them together. Finally, we need to align the vertices and collapse them together.

Figure 12.21

Step 21

Next we will start on the armor for the lower part of the upper arm. We will start again with just one half of the armor, as we want this to be symmetrical also. Once again, we need to Cut in polygons and move vertices to match the concept. On the areas where we want a lip, we will chamfer the edges just as we have done previously.

Figure 12.22

Step 22

We need to continue to work into the details on the armor and when we're complete we need to Shift and move the edges to give it some thickness. Don't forget to Chamfer edges so they are maintained in the high-poly version when the smoothing is applied.

Once we've completed the details, we will duplicate the mesh and mirror it, and then join up each part by collapsing vertices, just as we did with the shoulder plate earlier.

Figure 12.23

Step 23

Now we will clean up both finished parts of the armor and have a look at the high-poly version to make sure that everything is looking smooth.

Figure 12.24

Step 24

Next, we are going to have a look at the fingers and some of the other nonsymmetrical parts of the armor.

We will use the same technique we used on the previous parts: Cutting for adding polygons to help build up the shape, Chamfer and Connect for making lips and edges, and Chamfer for making double edges, helping us to preserve any hard edges we don't want to lose on the high-poly version.

Figure 12.25

Step 25

For the lower arm we will follow exactly the same process as before, where we will create one side of the arm armor first and then duplicate it and mirror it.

Figure 12.26

Step 26

At this point we need to connect all of the central vertices of the armor and adjust it to match the concept.

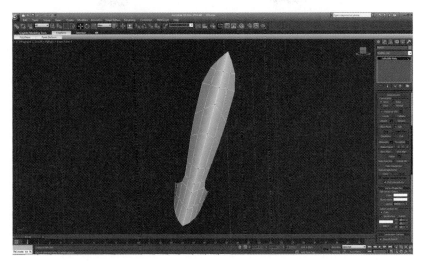

Figure 12.27

Step 27

Then we need to add the crease detailing and edge definition for the high-poly version.

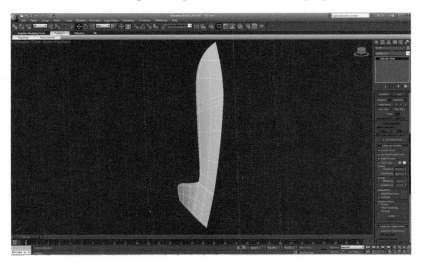

Figure 12.28

Step 28

For the upper part of the lower arm, we need to continue the same process of working in the details of one half of the part.

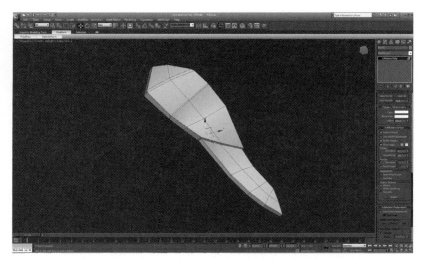

Figure 12.29

Step 29

Once again we will duplicate the finished part of the armor, Mirror it, Attach it, and Weld the vertices.

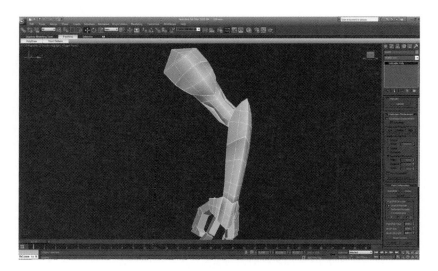

Figure 12.30

Step 30

We will leave the finger detailing for now and continue with the leg armor. Continue building up the pieces using the same techniques. I realize by now you may be looking to use some other tools, but we really only need Cut, Chamfer, and Move edges with shift for this type of modeling.

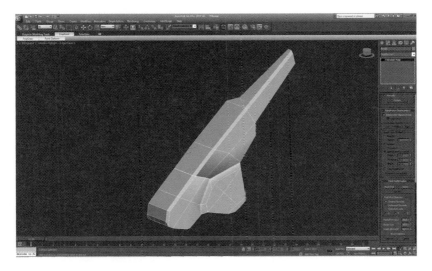

Figure 12.31

Step 31

Next, we will move on to Extruding the part for the knee armor. We just need to Copy one random face from the knee area by using Shift and Move. Then we need to shape this face to match the concept from the side. Once we have completed this, we can then Extrude it to the side, and fill the hole using Bridge (select one edge, and then the opposite).

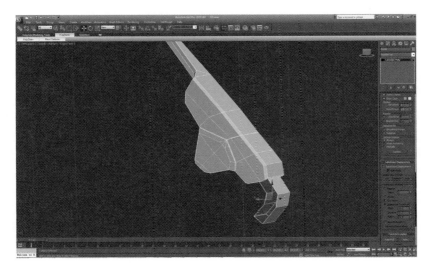

Figure 12.32

Step 32

Now we will take a look at the lower part of the leg armor. As this part of the armor is almost symmetrical, we will make one half first. Continue to Cut and Move as before.

Figure 12.33

Step 33

Continue to refine the mesh using Cut and Move. Once you are happy with the form, select the edges and move with shift to add depth to build in the toe. Then apply a Chamfer to make the edges a bit rounder.

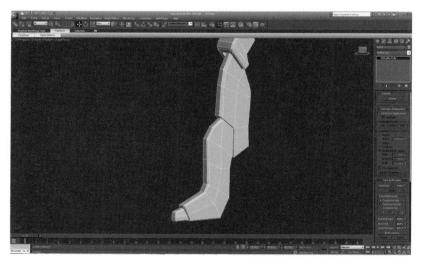

Figure 12.34

Step 34

Now we can duplicate and mirror this half of the leg and, just as we did before, Attach them together, Collapsing the vertices. At the end remove the edge running down the center, as it isn't required and it'll help to keep the poly count down.

Figure 12.35

Step 35

Finally, we just need to make any minor modifications to match the concept and modify the edges to make them look good in the high-poly version.

Figure 12.36

Step 36

Next, let's take a look at the toe on the side. Here we need to Extrude one face and move it to the side slightly. Then, just by holding Shift, Move the edge to roughly match the shape on the reference image.

Figure 12.37

Step 37

Once we're happy with the shape from the side, we can Extrude it to give it depth. Once again we need to add a Chamfer to the edges to make them look good in the high-poly version.

Figure 12.38

Step 38

Continue to build up the foot using the same tools as before.

Figure 12.39

Step 39

Modify the shape and continue with building the leg armor.

Figure 12.40

Step 40

Then duplicate the piece and Mirror it just as we did before.

Figure 12.41

Step 41

With the leg refined, we can move onto the main cockpit control bubble. To begin with, we will refine the block out around the sphere to give us a better starting point.

Figure 12.42

Step 42

We now need to create a small cylinder that will make up the small lamp on the side of the cockpit. To create a good-looking shape for the lamp, we will need to use the Extrude tool. Select the end cap and Extrude it, Scale it down slightly and Extrude again; then just continue to Scale and Extrude until you have the desired form. This is a really nice and easy way to create a cool shape. Then attach it to the body of the machine.

Figure 12.43

Step 43

Next, we are going to build up the back housing for the cockpit. We need to create a simple box, Cut in a little extra detail, and alter it to fit the rough shape.

Figure 12.44

Step 44

Then we need to cut out the top cockpit cover from our sphere. We could try to make this shape by moving faces around and cutting our way round it, but this is more effective and the output looks better.

Let's now start to finish up the rest of the main modeling and come back to this part shortly.

Figure 12.45

Step 45

We will start on finishing up the legs. We need to try to match our geometry as close to the concept art as possible, and then we need to apply a TurboSmooth modifier to the mesh.

Figure 12.46

Step 46

Next we will fill in the inner geometry on the legs. We will start with a simple Box that we will modify to fit in between the main foot area something like Figure 12.47. Refer to the max file if you can't quite see the form. For the double edges we will use the Connect tool. To do this, select a few vertical edges and press Connect tool; set the pinch to around 80.

Figure 12.47

Step 47

Now we can start to add details like the joints, etc. For parts like this we create a Cylinder that is then converted to Editable Poly, and Extrude the cap up and down along with Scale tool to create the detailing.

Figure 12.48

Step 48

We can continue to build up the inner workings of the leg with Cylinders and Boxes combined with Extrude and Scale, and for the smoother edges, Chamfer and Connect, just as before.

For the hose, we will use a simple Spline, which we check Enable in Viewport and Render under the dialogue setting and then Collapse and adjust.

Figure 12.49

Step 49

We will continue to add the mechanical workings to help the Mobile Suit look more advanced and believable. Be sure to look on the Internet for inspiration to help you create something that looks like it could really work. Think about function defining form.

Figure 12.50

Step 50

Let's continue working in the details and shaping the leg up to its final look. We are continuing to use exactly the same tools as before.

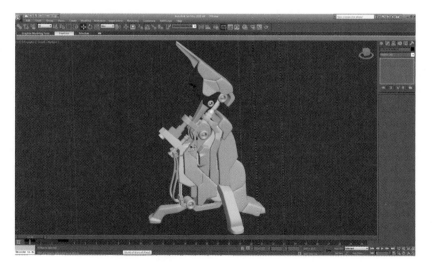

Figure 12.51

Step 51

We now add the last few details, some customized cylinders, and the leg is pretty much complete. If you struggle with this part of the build, always use reference images to help you. Think of pneumatic diggers

and construction vehicles, large robots like Ed 209 from Robocop and concept artists like Spinefinger (is he still around?) or websites like www.conceptart.org and of course companies like Massive Black. Do remember to use them just as inspiration though, and come up with your own designs.

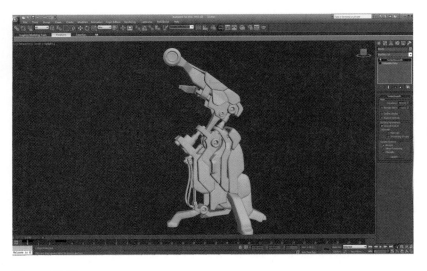

Figure 12.52

Step 52

With the leg completed we now need to Duplicate and Mirror the whole leg and have a look at the results.

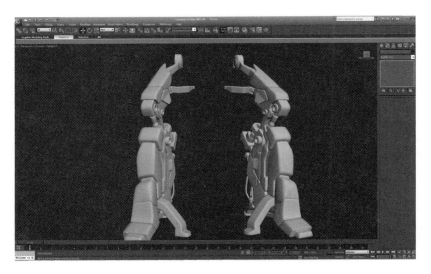

Figure 12.53

Step 53

Now we will go back and finish off the cockpit bubble. Let's start with the front section, using the rough block out as the starting point. Using the Cut tool along with Extrude, work up the mesh to resemble the concept art. Don't forget to use Chamfer on the edges to get a nice result on the high-poly model.

Figure 12.54

Step 54

Let's continue to work in the rough block out, adding details as we go. We can now Attach our new front section and continue to work in the detail along the connecting section. Still just simple Cut, Connect, and Chamfer work.

Figure 12.55

Step 55

Continue to clean up the shape of the cockpit, cutting in some finer details.

Figure 12.56

Step 56

For the extra detailing we can use the Bevel tool. It's a combination of Extrude with Scale. It's a really simple tool but very good for this type of work. Try it out on a single polygon if you've not used it before to see how it works, and remember, you can always refer to the Help section with F1.

Figure 12.57

Step 57

With the cockpit section almost complete, we need to finish adding the smaller details using Extrude, Bevel, Connect, Chamfer, and Cut tools.

Figure 12.58

Step 58

Now we can start to add some pipes and detailing parts around the back of the cockpit for the electronics systems and the life support equipment. These are all modeled from really simple objects, using the same technique we have been using throughout this tutorial.

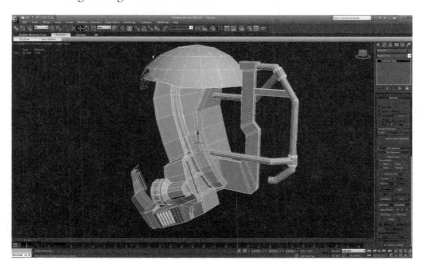

Figure 12.59

Step 59

We can create the next circular back detail part from a cylinder and the Extrude tool along with some Scaling. We can create the two small holes at the end with the Bevel tool.

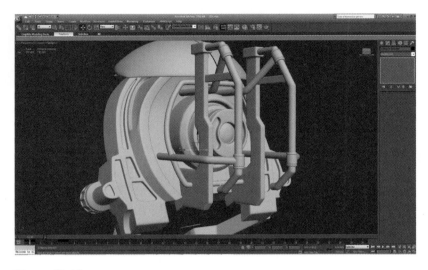

Figure 12.60

Step 60

Next we can create some of the support struts to join the legs with the cockpit. For the edges we can just use the Connect tool.

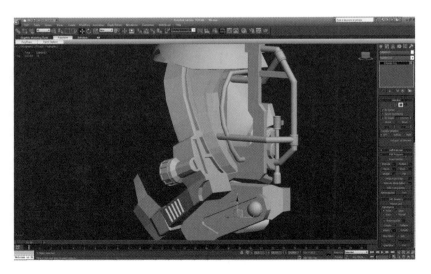

Figure 12.61

Step 61

We continue to build up the detail by adding all the small features and details that will make this look more realistic and advanced. We need to keep the details looking high tech but believable, so try not to go too far with this.

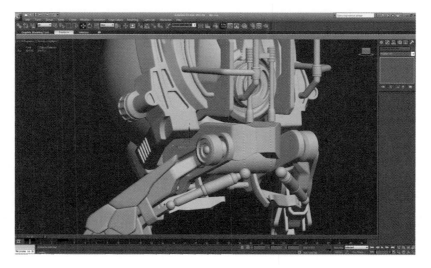

Figure 12.62

Step 62

We can build all of these small parts by just Extruding cylinders and primitive boxes. We continue to add in detail just as we did with the armored parts.

Figure 12.63

Step 63

With a few extra hydraulic rams and connecting points along with some finer tweaks to the model, we should have the legs nicely connected to the cockpit.

Figure 12.64

Step 64

Now we can focus on finishing up the details around the back of the cockpit. For these we can start with a primitive Box, use the Extrude tool, and Chamfer the edges to create the concertina effect. Be sure to check this out with a TurboSmooth before moving on, to ensure that you have nice clean geometry.

Figure 12.65

Step 65

Next, we will create a similar concertina shape to the previous one using the same technique. Once we have it built, we will connect both shapes together with a simple cylinder shape. We just need to create a Cylinder and adjust it to the correct shape. Then we create the small details on the connection pipe by adding a Bevel to four polygons at the same time. We can add the details on the top and the connector cover underneath.

Figure 12.66

Step 66

Now we can have a look at all of the mesh parts with a TurboSmooth applied to see what we have achieved so far. At this point, we can make any cosmetic changes that we'd like to, to improve the model, like the back support, for example, and any other parts that you want to change the look of. We will leave the cockpit for now, as we will focus on this in more detail shortly.

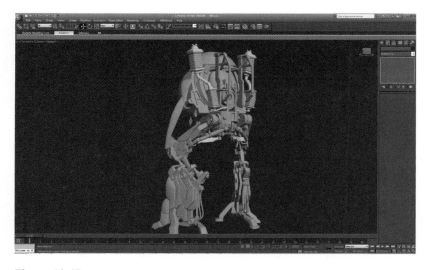

Figure 12.67

Step 67

Now, let's take a look at the fingers on the lower hand in a bit more detail. Here we can add some hydraulics and detail to the fingers. For this we will start off with some primitive boxes that we can alter by extruding various components to make them look more interesting. For the knuckles we can use cylinders that we can alter using Extrude along with Scale.

Figure 12.68

Step 68

Let's continue to add details to the lower hand by adding a few simple objects and some hoses for the hydraulic fluid. For these hoses we can use the same technique as we did on the legs, just simple splines with enabled rendering.

Figure 12.69

Step 69

Now we can move onto the upper part of the cockpit; we will need to prepare the mesh for adding details though.

Figure 12.70

Step 70

Let's make some cuts in the places where we want to add details and Extrude them up. For all these gaps we need to use the Cut tool and to Extrude them at the end. We'll need to use Extrude a few times in smaller steps to make the double edges. These double edges will give us the sharper edges in the high-poly version.

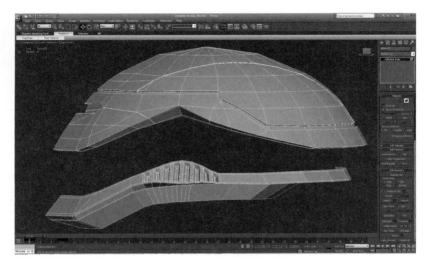

Figure 12.71

Step 71

Now we can join all the pieces together and apply a TurboSmooth modifier to see the results of our work so far. We can also make alterations that we feel are necessary at this point.

Figure 12.72

Step 72

Here we can add some small cables and pipes to the legs to enhance the look of them and give the machinery a more advanced and functional feel. Just as before, these can be created from Splines.

Figure 12.73

Step 73

Let's take the opportunity to duplicate and mirror the lower part of the Mobile Suit to see what we have so far.

Figure 12.74

Step 74

With everything starting to look good so far, we can move on to adding details to the upper part of the Mobile Suit.

Figure 12.75

Step 75

Let's start off with completing the armor on the arm. We will Cut and Detach the armor in several parts so that we can build in the thick look of the concept. Then we need to Select each of the separate parts and use the Shell modifier, with the inner amount to 0.57 and Auto smooth edges to 45. The big ball joint under the shoulder armor can once again be created from a simple cylinder, using the Extrude tool along with Scale.

Figure 12.76

Step 76

We can continue to clean up the inside of the armor on the arm and we can start to add the joint detail.

Figure 12.77

Step 77

Now we can take a look at the inner workings of the arm mechanisms that enable the Mobile Suit to move. For all these parts we can use simple primitives. As we've done throughout the build, just start with a box and Extrude sections out, moving the vertices into place to build up the model.

Figure 12.78

Step 78

Now that we have the framework in place we can add the joints and also the hydraulic ram.

Figure 12.79

Step 79

Moving down the model we can now add the detail to the hand and fingers. Here we follow exactly the same process as used on the earlier hand. Yes, you've probably guessed it—just Extrude simple primitives and Cut into them to create the detail. Feel free to add any details you like to make the Mobile Suit look cool.

Figure 12.80

Step 80

Just a few more details and the odd refinement, and the arm is almost complete.

Figure 12.81

Step 81

Now we need to add few simple splines for the control cables and hoses for the hydraulics and the arm is complete.

Figure 12.82

Step 82

With the arm finished off, we can move on to the chest armor. We need to Detach the armor plates and create the small details at the edge for the sawtooth effect and the vents. Then we need to apply a shell modifier to the mesh as we did with the hands.

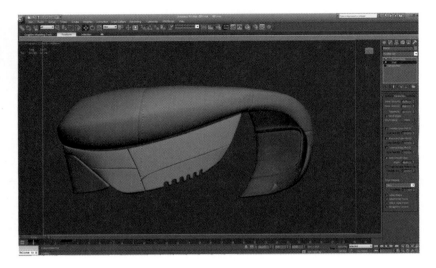

Figure 12.83

Step 83

As we progress with the build we should have a look at the high-poly version to see if there are any adjustments that need to be made.

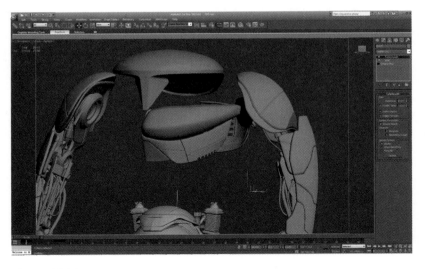

Figure 12.84

Step 84

Now that we have completed the last tweaks around the chest area, we can start to build in the main support for the arms. We can build the main joint from a Cylinder as before, and Extrude faces to create the extra details. Then using Connect to create double edges, we can add the required geometry to keep the high-res version looking sharp. We also need to create the extra hydraulic rams and Attach all the pieces together.

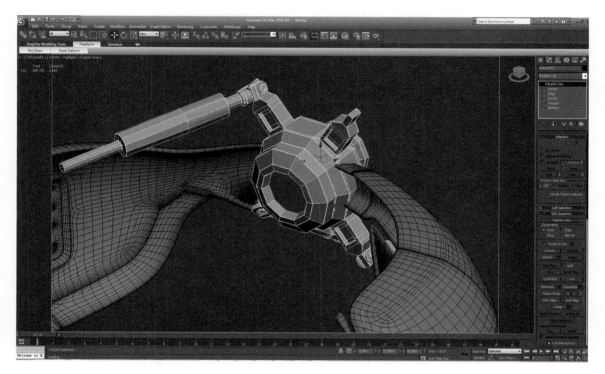

Figure 12.85

Step 85

Next we can move on to building the internal cage of the Mobile Suit. This will carry all of the mechanisms that control the Mobile Suit's movement and enable the top part of the Mobile Suit to be connected with the lower section. We can start this off with simply Extruding a box.

Figure 12.86

Step 86

Let's add a little more definition to the internal cage and then we can move on to slowly filling up the rest of the insides. As you can see, we can do all of this by Extruding and Chamfering a box.

Figure 12.87

Step 87

Now we can begin to prepare the parts for connecting the upper part of the Mobile Suit with the lower part; again we are Extruding from a box.

Figure 12.88

Step 88

Next we can add the ribs to our mesh. To do this we will need to select the middle ring of edges and apply a Connect modifier. Then we will divide the part up several times and scale down every second loop.

Figure 12.89

Step 89

We now need to build a similar rubber housing, which we will build exactly like the previous one. If you struggle with the bend, feel free to use Bend or one of the FFD Modifiers.

Figure 12.90

Step 90

Let's mirror the Mobile Suit now to see how it looks. Unless you have any issues with what you see, let's move on to the head section. I think we have just the right amount of detail to make the Mobile Suit look interesting enough as well as functional.

Figure 12.91

Step 91

As the top looks a little bare, we can add some pipes and simple parts to help make the Mobile Suit look a little more solid. We just need to use splines and extruded boxes.

Figure 12.92

Step 92

At this point it's a good idea to take a look at our Mobile Suit from a distance. This will help us to identify empty areas and areas that need more work. Let's fill these parts in using the same techniques we've used throughout the build and have another look.

Figure 12.93

Step 93

Let's move on and create the final details for the head. We also still need to separate the armor on several parts so that we can build up the details and thickness and so that they look well joined together. We will use the Shell modifier to complete this, as we did building the chest and arm plates.

Figure 12.94

Step 94

Now we just need to add a few more details for the cable housing, cables and the camera on the shoulder. To make the camera, we will start off with a box and we can create the lens from Extruding a cylinder. Have another look from a distance. I think our Mobile Suit is almost complete.

Figure 12.95

Step 95

Now we need to complete any final touches to try to get as close to the concept art as possible.

Figure 12.96

Step 96

Let's just add a few last touches and clean up the armor, and then we can move onto the UVs.

Figure 12.97

Step 97

As we've spent a lot of time on modeling, we don't need to spend much time on the UVs. We can get most of the details from the model itself and we'll generate most of the UVs automatically. We will need to make clusters of UVs which will be planar mapped and then relaxed.

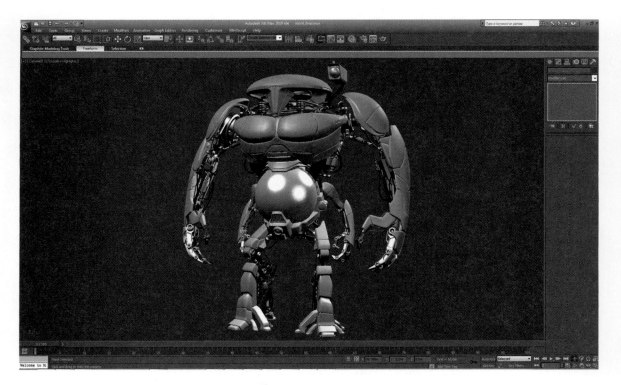

Figure 12.98

Step 98

We'll start with the upper section of the Mobile Suit and then move on to the lower section. First we'll start with the head, so select this section of the model. Don't worry too much about the inside of the armor as it's not really going to be visible.

Apply an Unwrap UVW modifier and select Quick Planar Map. Next we go to the Relax tool and set it to Relax by Face Angles and press Start Relax. After a few seconds you will have really nice, stretch-free UV cluster. You will repeat this process for each part of the armor.

Figure 12.99

Step 99

OK, repeat the previous step, but this time with a section of the chest. If you need a little guidance, refer to the images in this tutorial, or the 3ds Max files supplied with the book. Remember, you can always log on to www.3d-for-games.com/forum and post questions for me and the team there. Almost every cluster is completed by applying a quick planar map and using the Relax tool.

Figure 12.100

Step 100

Continue the unwrapping with the arms, and so on.

Figure 12.101

Step 101

Continue with this until you have UVs for almost every part of the hands. Don't forget to make reasonable clusters. By that I mean don't try to unwrap too much of the model at once. If you're not sure how much to select, just check the attached max file. Also, don't forget that you have to separate clusters for the outside and inside sections of armor. If you find that the Relax tool doesn't work as it's supposed to, you probably just need to reset Xform. You can do this under Utilities > Reset > Xform. This will reset all the transformations, etc.

Figure 12.102

Step 102

As you can see, I have unwrapped every single part by using Quick Planar Map and the Relax tool. This process works really well on parts like these. If you don't need to have straight lines on the model, it's probably the easiest way to do this. The Relax tool works really well for single-sided selections.

Figure 12.103

Step 103

Continue with the same process on the armored parts of the lower arms.

Figure 12.104

Step 104

For this next section we will need to Detach the cockpit and select portions of the model to unwrap. Then we will continue with Quick Planar Map and Relax.

Figure 12.105

Step 105

As the Quick planar tool with Relax only works on parts that don't overlap, we'll need to do the camera carefully.

We need to separate the parts as shown in Figure 12.105. We will select three sides and then use Quick Planar Map + Relax, and then we select the last remaining side and repeat the process. We then adjust the scaling and join them together.

Figure 12.106

Step 106

As you can see, we can unwrap a fairly complex-looking model by following a fairly simple process. Next we need to join them together and adjust the UV scaling and fit them to one square.

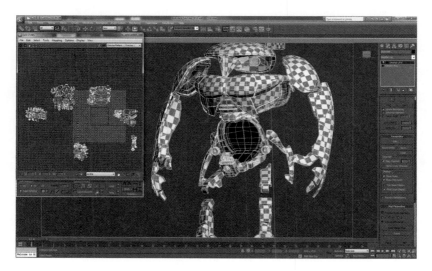

Figure 12.107

Step 107

When you have completed this, your UVs should look something like Figure 12.107. Remember that the inside parts of the armor don't need very much space on the texture space, as they are not really visible.

That's it for the modeling and unwrapping. For anything else, we can make textures for the rest of the objects with procedural mapping.

Now we are ready to start with the texture map. We will start with Render to Texture from the Rendering menu.

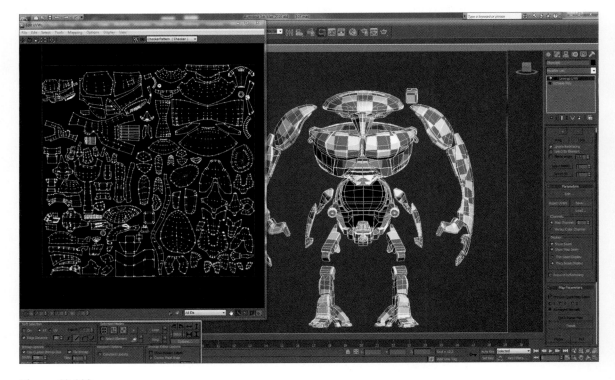

Figure 12.108

Step 108

Next we need to add a Skylight to the scene from the Standard Lights menu. Go to the rendering menu and select Light Tracer. Check the light tracer to Active and set up the values as you can see them in Figure 12.108.

Figure 12.109

Step 109

Apply a standard material to the armor parts and set the diffuse color to white. Then apply Turbo Smooth to them from the modifier list, and go to the Render to Texture menu under Rendering.

Figure 12.110

Step 110

Set up the Render to Texture as you can see in Figure 12.110 and choose the location on your hard disc where you want to save the occlusion texture.

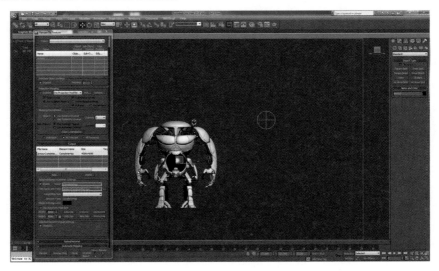

Figure 12.111

Step 111

Apply an Unwrap UVW to the armor parts and render UV layout. Set the resolution to 4096 × 4096 and save it to the texture that we just created.

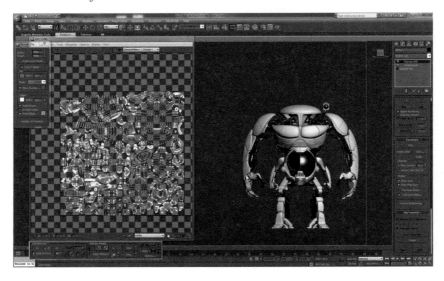

Figure 12.112

Step 112

Next we need to open up Photoshop. In Photoshop, create a new texture sheet, with a resolution of 4096 × 4096. Then set the background to white. Copy and Paste the UV layout that we created in 3ds Max and set the layer opacity to 5–10%.

Figure 12.113

Step 113

Next we need to Copy and Paste the baked texture to another layer and set the Blend mode to Multiply.

Figure 12.114

Step 114

If you have a current version of 3ds Max you can also generate a cavity map, which will help us to create nice bright edges. If you can't do this, don't worry; it won't make the texture look too different.

Figure 12.115

Step 115

Next, find a metal plate texture from somewhere like CG textures, as I have here on Layer 3, and set the layer to Multiply with the Opacity set to around 30%. This will help us to create a nice battered look for the armor plate.

Figure 12.116

Step 116

Next we can start adding color to the armor. Create a copy of the background layer and start to color the parts of the armor that need to be green and dark gray. Use the UV layout as a guide to where to add color as well as the reference images.

Figure 12.117

Step 117

When you have completed this, make a quick layer mask and erase the areas where you would like to create scratches and marks. Once you have done this, apply a drop shadow effect on the layer as you can see in the image.

Figure 12.118

Step 118

Next, create a sign similar to the one on the concept image (signs copy layer) and make a quick mask for it to add some scratches.

Figure 12.119

Step 119

Next we need to add the thick paint look in some areas (layer 3 copy).

Figure 12.120

Step 120

Now we need to make some brown surface dust for the model to give it a more realistic look. This is fairly simple; just pick your desired brush, set the opacity to 10%, and paint in some subtle dust around the edges of the armor. This is shown in the brown dust channel of the Armor.psd file.

Figure 12.121

Step 121

In this step we will create some small decals and place them on the upper arm as shown in the concept.

Figure 12.122

Step 122

Next we can make the tiny details on the shoulder parts, notches, etc.

Figure 12.123

Step 123

Next we can make a darker dust to create extra depth. We will follow the same process as we did creating the brown dust.

Figure 12.124

Step 124

Try to bring out some depth by adjusting the brightness and contrast. Paint the dust in manually just as we did earlier with a brush.

Figure 12.125

Step 125

To create a specular texture we will use the diffuse texture as a starting point.

Figure 12.126

Step 126

We will then duplicate the dark dust layer and de-saturate both the dark dust and dark dust copy layers.

Figure 12.127

Step 127

Next we will de-saturate the background copy layer and we will also adjust the lightness of the background copy layer to −50.

Figure 12.128

Step 128

We will set the opacity of the signs copy layer to 13%.

Figure 12.129

Step 129

Next, we will also de-saturate the brown dust layer.

Figure 12.130

Step 130

We will also de-saturate Layer 3 copy and also adjust the lightness to −56, as we don't want to have too much shine on the middle part of the chest.

Figure 12.131

Step 131

As the Background layer is the base for the scratches and we want to see them, we need to increase the lightness of this layer to +100.

Figure 12.132

Step 132

And the last step is to de-saturate the brown dust layer, as we don't want to have any shine where the dirt is. Set the lightness to -100.

Now we need to assign materials to the separate parts of the mesh, as you can see in the final .max file.

Add the lights to the scene and the build is complete.

Figure 12.133

Index

Index

Index

Index